Bob Marley
The Illustrated Biography

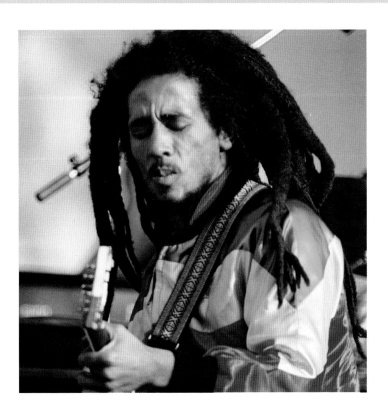

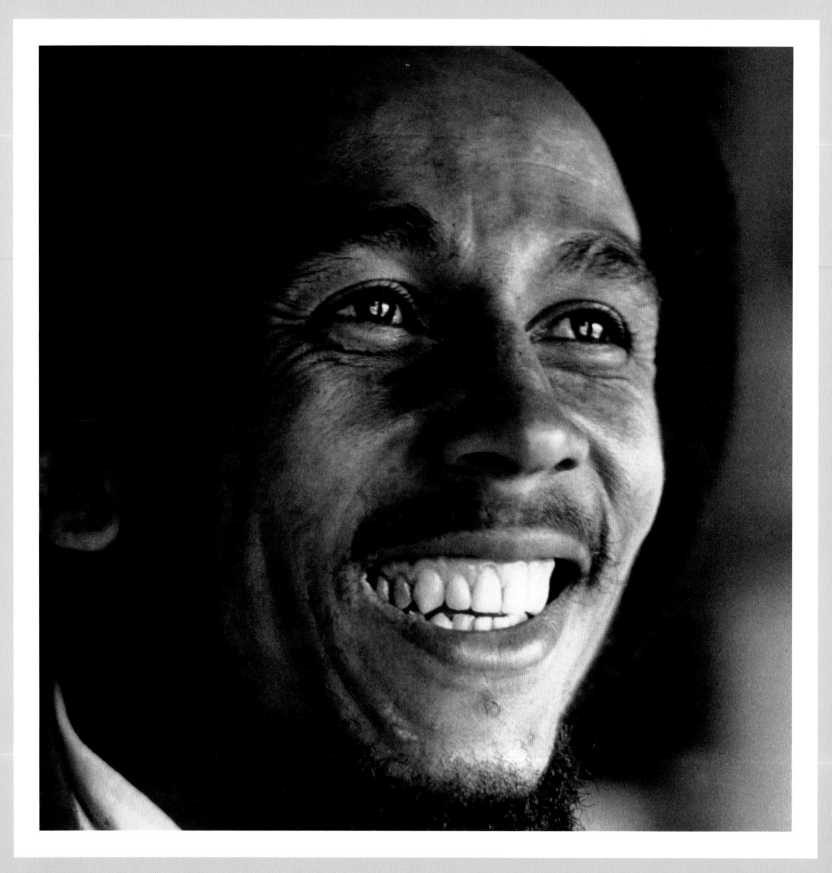

Bob Marley
The Illustrated Biography

MARTIN ANDERSEN

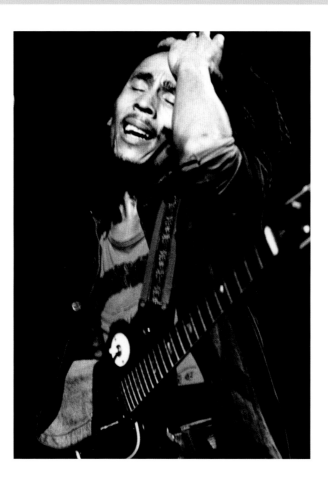

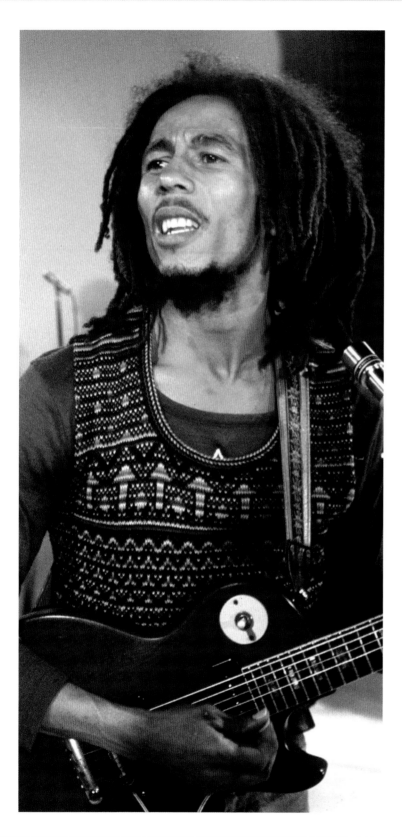

This edition published by Welcome Rain Publishers LLC 2011
First published by Transatlantic Press in 2011

Transatlantic Press
38 Copthorne Road
Croxley Green
Hertfordshire
WD3 4AQ, UK

© Transatlantic Press

All images © Getty Images except those listed below:

Corbis: 12-13. 15, 28, 29, 30, 31, 50, 71, 77, 105, 119, 120, 121, 149,
150, 151, 176, 177, 178, 180, 181, 182, 184, 185, 186, 188, 190, 191,
201, 202, 203, 204 and 206

London International Features: 4, 78-9, 80, 81, 82-3, 84, 87
and 88-9, 94 and 223

Atlantic Publishing: 72, 74, 75, 76 and 193

ISBN 978-1-56649-095-5

Printed and bound in China

Contents

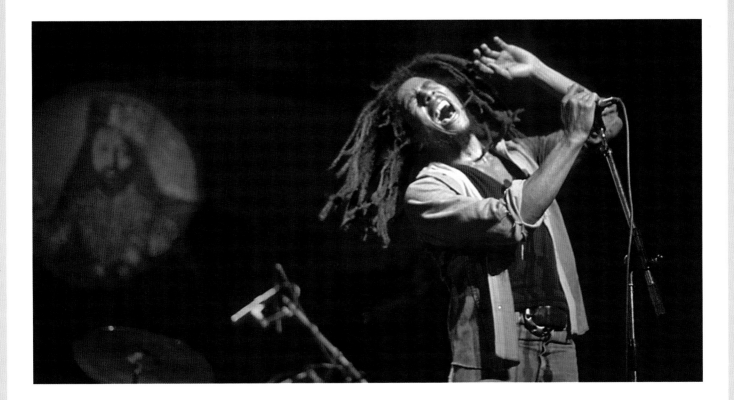

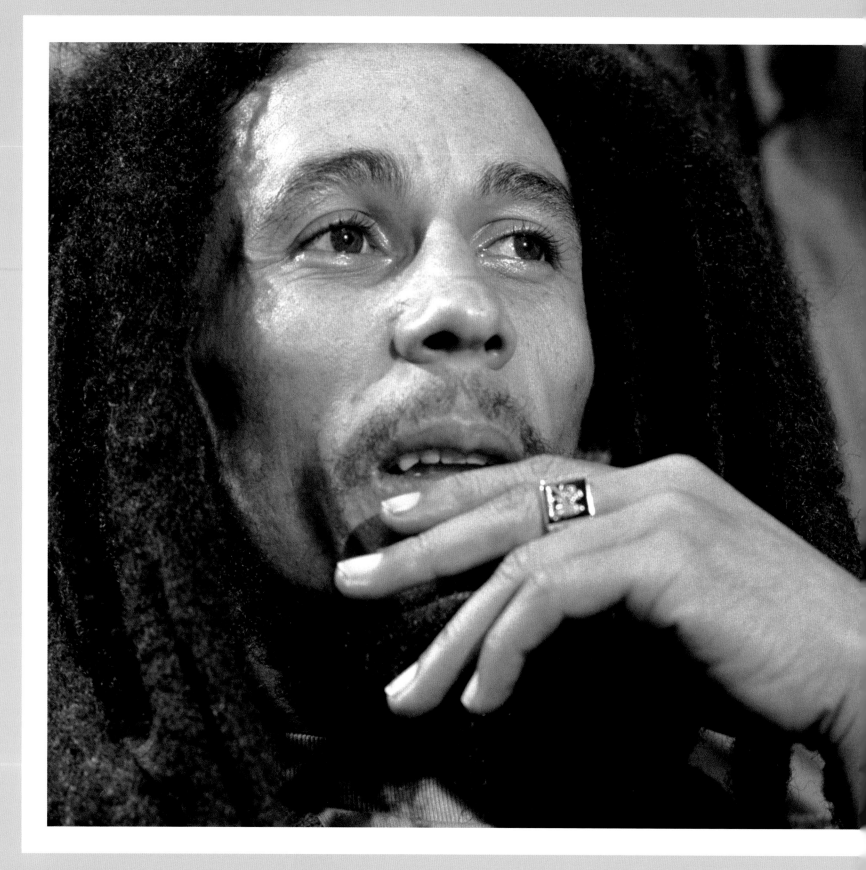

Introduction

Born Robert Nesta Marley on 11 February 1945, to Cedella Malcolm and her white Jamaican husband Norval Marley, Bob Marley would become one of the most revered and original musicians of the twentieth century. Cedella brought Bob up in Nine Mile, a small hamlet in the Parish of St Ann, a two-hour journey by road from Kingston, Jamaica. His parents never lived together and Bob had little to do with his father or his side of the family.

Bob found friendship and a step-brother in Neville Livingston when the younger boy and his father Thaddeus ("Toddy") moved in with Cedella in Nine Mile. Eventually they moved together to the Trenchtown suburb of Kingston. A few years later, after leaving school aged fourteen to be coached by "Father of Reggae" Joe Higgs, Bob met Winston Hubert McIntosh in a jamming session in Higgs's yard. Bob Marley, Bunny Wailer and Pete Tosh, as they became known, would form the original core of The Wailers.

Jamaican society of the 1950s into which Marley was born had a widespread gang culture arising from the general poverty of the population: in common with other countries, tough young men dressed in the latest fashion, mimicking their richer counterparts in the USA. Although they put on a slick appearance many behaved as thugs, contributing to an environment of intimidation. These sharp dressers went by the name of RudeBoys and RudeGirls – or just Rudies; their favoured style of locally produced music was called ska and gave rise to rocksteady. The origin of the name ska is unknown – it could be mimicking the sound made by the main instruments of piano and guitar, and as for musical antecedents, a possible explanation is a hybridization of imported rhythm and blues from the USA encountering the local calypso style, with a shift to the upbeat giving a new dance music sound. Ska didn't entirely fall out of fashion but did give rise to a short-lived rocksteady movement around 1962 which was embraced by artists such as Toots and the Maytals. The rocksteady sound achieved popularity in the UK during the 1960s, adopted first by mods and then by skinheads who strongly identified with the Rudie culture at its root.

The Jamaican music scene in the sixties was dominated by various entrepreneurs, who controlled record production on a local but prolific scale; the movers and shakers such as Clement "Coxsone" Dodd operated mobile sound systems that played events in halls, outdoor stadia and beach venues around the island. The sound system men and the local radio lived on a singles market. These could sell many copies, as did The Wailing Wailers' first big single with Coxsone Dodd, "Simmer Down", which sold 80,000. With substantial earnings possible the sound system men often adopted dirty tricks to stay ahead of the competition. A good sideline for the RudeBoys was to take money to disrupt sound system shows by starting a fight.

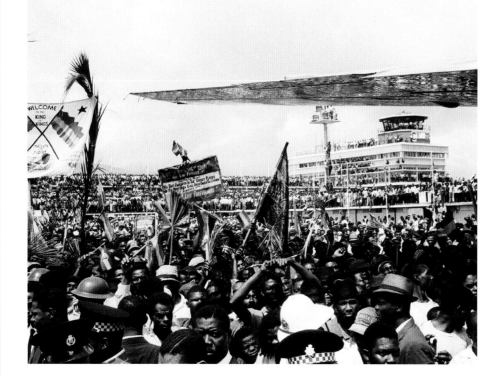

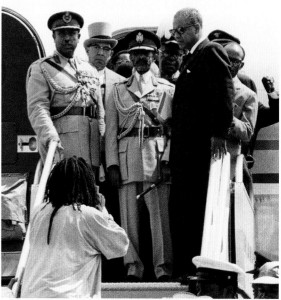

In the mid-sixties the ultimate ambition for most Jamaican musical artists was to get to the top of the local market by covering a song from the US or UK; the wildest dream was to have a hit single in those markets themselves. During a visit to Jamaica American soul singer Johnny Nash recognized Bob Marley's talent and by 1971, with Nash's patronage, Bob and The Wailers were breaking out of Jamaica into the USA and UK. The turning point was 1972, when Bob, Tosh and Bunny put together their first album with Island Records founded by white Jamaican entrepreneur Chris Blackwell, who had been a champion of Caribbean music for many years and now had his HQ and a recording studio in London. *Catch A Fire* was released internationally in April 1973. Blackwell was not the only one to be captivated by the new reggae sound from The Wailers, but many hurdles had to be cleared before they achieved success in the superstar league. All three original Wailers were very talented musicians and although Bob kept his position as frontman after Bunny and Tosh went solo, each had his own success with Bunny winning three Grammys and Tosh one.

If Bob Marley were judged simply as an artist he would be adjudged great: his recording and performance career developed slowly perhaps – especially in the USA – but once he had the audience with him they were entirely under his spell. And part of that spell was the complex nature of his message: on the one hand he wanted liberalization of marijuana, on the other he wished to bring the world together in spiritual and racial harmony;

Above left: The visit of Emperor Haile Selassie, Ras Tafari, to Jamaica in April 1966 drew thousands of ecstatic supporters to welcome him at Kingston airport. In addition to the government officials, local Rastafarian elder Mortimer Planner (above right) greeted him on the steps of the plane, urging the crowds to calm down and allow the Emperor to pass through the chanting multitude.
Opposite: Bob abandoned his RudeBoy look when he became a follower of Rastafari: he grew the dreadlocks that would be a distinguishing feature of his appearance for the rest of his life.

he sought justice, political and economic emancipation for the segregated black nations of Africa but would spend his days happily on the football field or jogging on his favourite beach.

Growing up in Trenchtown it was impossible for some of the street culture not to rub off on Bob and his peers and accounts of episodes later in Bob's life indicate he knew how to handle himself. But certainly Bob could have gone the way of others of his peers, a victim of street gun crime. Meeting Joe Higgs and the resulting career trajectory kept young Marley out of the worst trouble. Although the RudeBoy culture was strong, the Rastafarian movement was just as powerful on the island and was a leading influence in Bob's life from 1966.

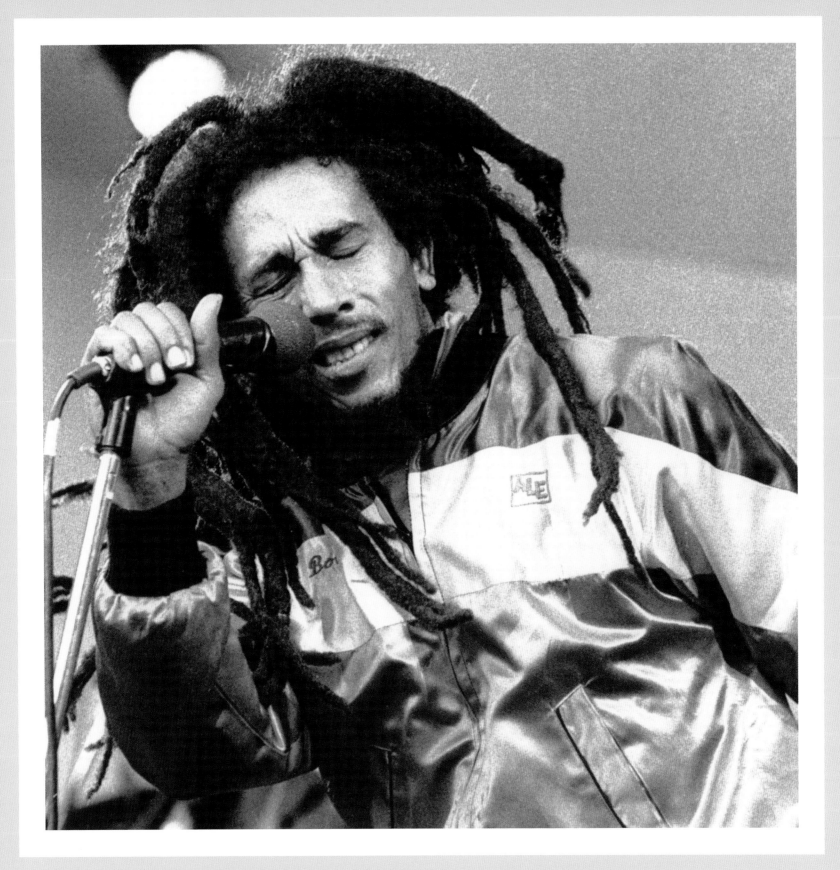

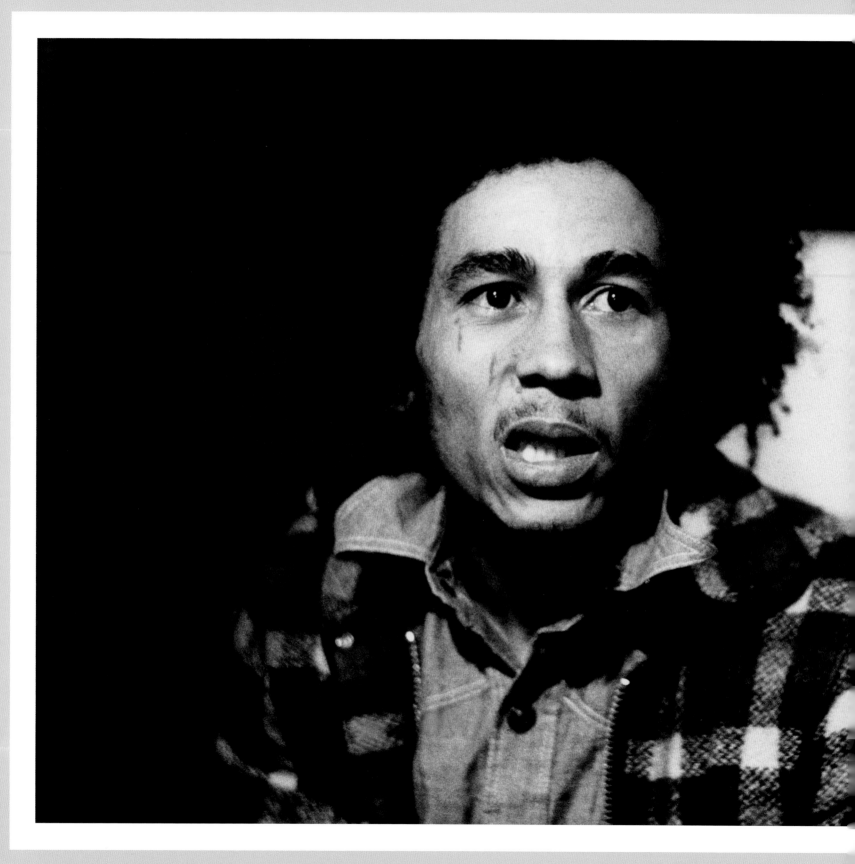

The word "Rastafarian" derived from Ras Tafari, Emperor Haile Selassie of Ethiopia's name before he acceded to his throne. The people of Jamaica, descended from African slaves, looked towards their original native land for inspiration and conflated Selassie with the Biblical heritage, regarding him as the new incarnation of God and Jesus, the Lion of Judah. The Rastafarian movement had many interpretations and leaders, among them one cult composed of the Twelve Tribes – into which Bob was baptized – and another that followed the Nyahbinghi tradition. The African drums that were a distinctive feature of The Wailers' music were Nyahbingi instruments associated with the rituals of Rastafarianism called grounations in which the followers came together to worship their god Jah, pore over scripture and chant to the rhythm of the drums. Two other aspects of the Rastafarian movement would influence Bob's life: his commitment to a strict Ital diet, interpreted variously as vegetarianism or even the following of the Levitical dietary laws of Judaism, and the frequent smoking of cannabis.

Bob's magnetic personality wooed and won audiences as well as many, many women. His roots established him in a world of relaxed and informal relationships which applied not only to women but put him in the centre of a group of people, many of them men, who were attracted to his philosophy, his music, the football he loved and his joy in jogging on the beach or bathing afterwards in the Cane River Falls. Some of his closest associates such as Gilbert "Gilly" Antonio and Allan "Skill" Cole entered his life through their enthusiasm for football – and never left. Others like Lee Jaffe were seeking an alternative lifestyle which Bob epitomized for many.

Bob Marley's status as a leader verges on the messianic: he left disciples in the form of eleven children; they have kept the tradition and the music alive with Damian and Ziggy picking up Grammys in their own right. Around the world a huge fanbase continues to be transported by the music. Others enjoy the forbidden weed in his name, and yet others see him as a prophet of liberation and renewal. Unlike other legends of rock who died young, Marley's philosophy and values still feed and keep alive today his iconic musical persona.

Left: Bob pictured in the early 1970s.

Chapter One

Jamaica Roots

In 1962 at the age of 16 Bob cut his first recordings for Leslie Kong's Beverley's label. Put out on a single, the two tracks were "Judge Not" on the A side and "One Cup of Coffee" on the B side. Kong gave him the artist surname "Martell". The single met with little success, prompting Bob to return to coaching by Joe Higgs in his yard, where he, Bunny Livingston and Peter Tosh became the nascent Wailers

In 1963 the three started a group with Junior Braithwaite, Beverley Kelso and Cherry Smith which they initially called The Teenagers, then the Wailing Rudeboys and eventually The Wailing Wailers. Playing ska and rocksteady, they were introduced in summer of 1964 by Alvin "Seeco" Patterson to Jamaica's legendary producer of the time, Clement "Sir Coxsone" Dodd whose Studio One label was responsible for many successes, not just because of the artists' talent but also because Dodd had a performance circuit which promoted his recordings. Dodd signed the band up and they began recording immediately as The Wailers with "Simmer Down", which went to number one in Jamaica and sold over 80,000 copies.

Coxsone used Bob to audition and coach new acts, one of which was a vocal trio which became known as The Soulettes. Their line-up included Rita Anderson and, after singing with Dodd, she shared some duets with Bob, making a few stage appearances together. The Wailers brought Rita into their line-up and later added Beverley Kelso and Cherry Green. The Soulettes would continue to perform as a separate act.

Right: Bob Marley, then still known as Robert Marley, poses shoulder to shoulder with his mentor the Jamaican producer Clement "Coxsone" Dodd in West Kingston in 1964.

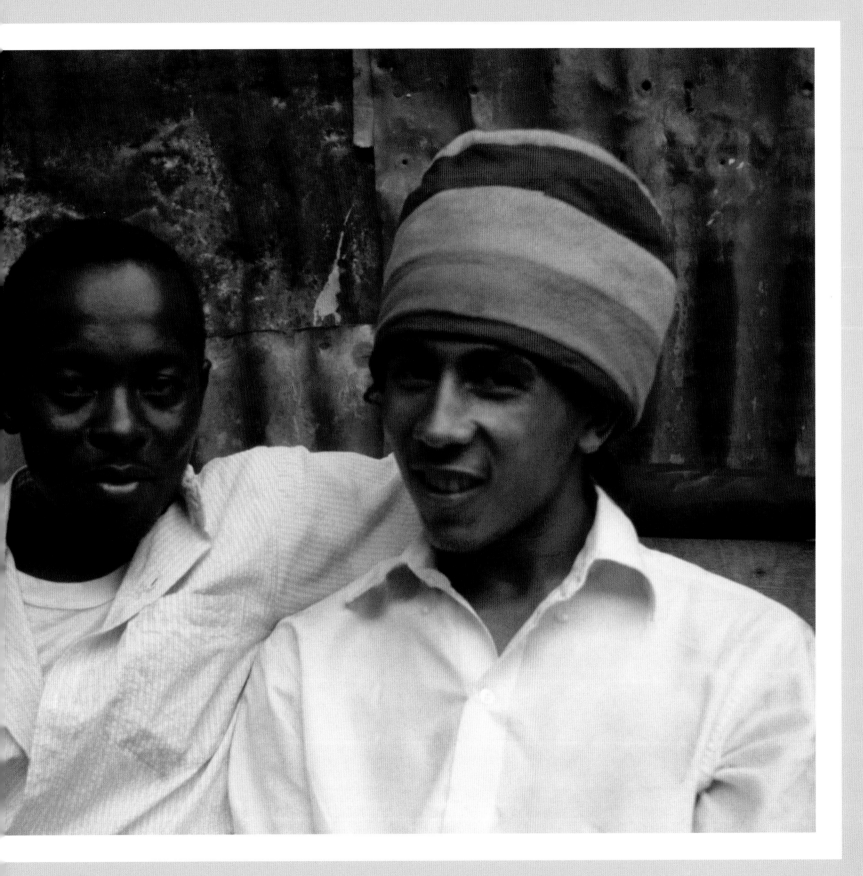

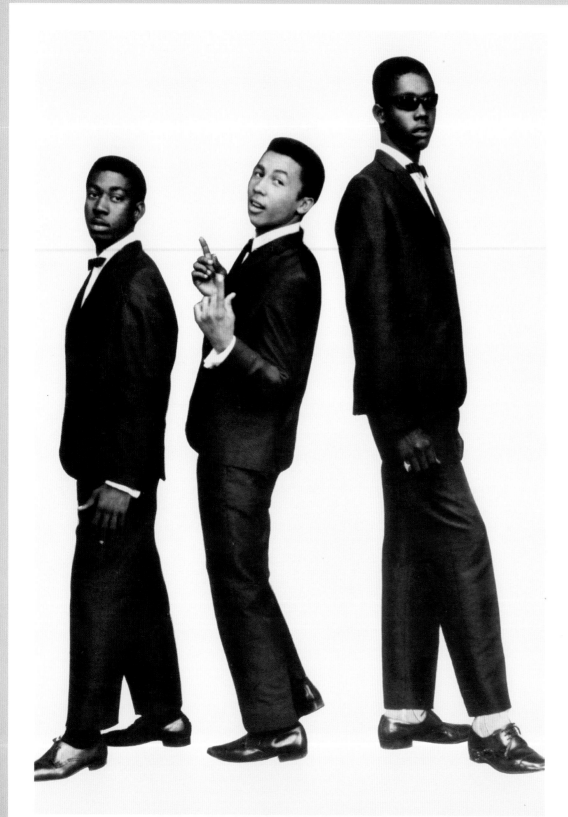

First Wailing

Left: The Wailing Wailers c.1964.
Bunny, Bob and Tosh strike a pose for the cover photo of their first album, *The Wailing Wailers*, which was released on the Studio One label in 1965 and produced by Coxsone Dodd. It was mostly a compilation of their 1960s singles and although fronted by Bob, Bunny Livingston, Peter Tosh, Beverley Kelso and Rita Anderson, Studio One's backing musicians provided a solid and professional support. Dodd's session band was led by keyboard player Jackie Mittoo and went under the umbrella name of The Soul Brothers; they were the best of Jamaica's musicians and generally earned more than the so-called stars.

Bob's deal with Coxsone made him work the band hard and by the end of the year, 1965, they had five hits in the local top ten at the same time. It proved too much pressure for Beverley Kelso who quit the band. As well as recording their own material they were performing many different covers from Tom Jones' "What's New Pussycat?" to Beatles songs and even "White Christmas". The Wailers were also backing other artists such as Jackie Opel and Lee Perry. Bob became so busy in the studio that he moved in there as he had no permanent place to live.

The hits begin

Above: Joe Higgs in a soulful moment. Higgs was described by Jimmy Cliff, Jamaica's foremost star of the time, as "the father of reggae". Cliff himself had only recently started his professional recording career in 1961 with Leslie Kong's Beverley's label.

Despite their prodigious output with Studio One neither Bob nor The Wailers were earning enough money to live. Bob's mother had now successfully put down roots in the USA, having married and set up home with her new husband Edward Booker. She sent Bob money and an air ticket for him to fly over to Wilmington, Delaware, in February 1966. Bob and Rita, now in a long-term relationship, had nowhere of their own to live. They needed money and they decided Bob should accept his mother's invitation. Bob's only condition was that they marry, which they did on 10 February 1966, the day before his flight.

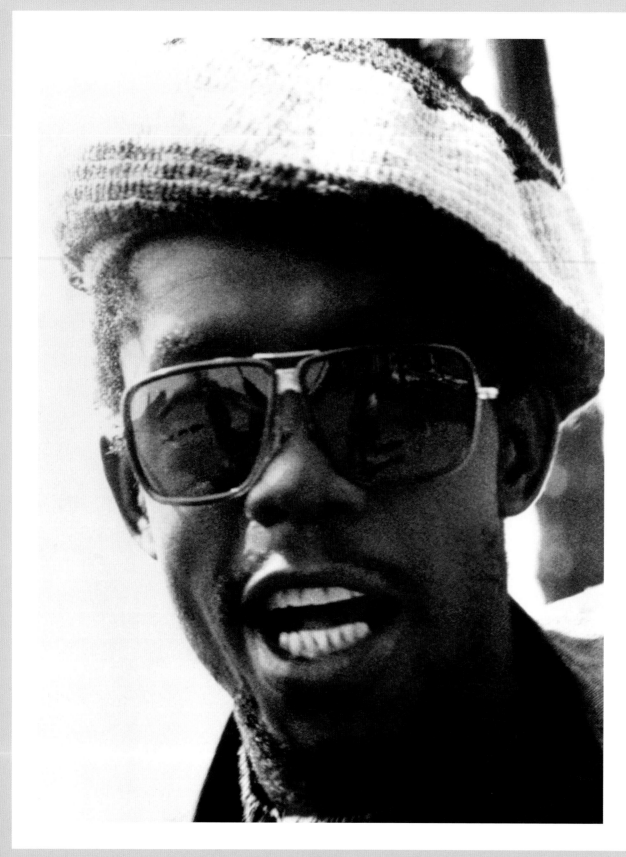

Original Wailers

Left: Pete Tosh, the mercurial guitarist in the original Wailers was born Winston Hubert McIntosh in Petersfield, Jamaica on 16 October 1944.

With Bob now living in Wilmington, Rita's cousin Constantine "Dream" Walker took over lead vocals in The Wailers. Bob found shift work at the Chrysler assembly plant, continuing to work on new songs in his free time. When Rita and Dream visited the Booker household in the summer, Dream introduced Bob to The Beatles' latest album *Revolver*, mesmerizing Bob with "Eleanor Rigby".

Bob was laid off and became eligible for the Draft so in October 1966 he boarded a plane back to Kingston with savings of $700 in cash and his electric guitar. On his return Bob found Rita had become a follower of the Rastafarian faith, under the influence of Mortimer Planner – "Planno" – a Rasta elder. Bob also became a devotee and began to grow dreadlocks. In August 1967 Rita gave birth to her first child with Bob, Cedella, named after his mother.

Bunny Wailer

Right: Neville O'Riley Livingston, known professionally as Bunny Wailer. Bunny and Bob were first close neighbours then lived in the same household for some years when Bunny's father, Toddy, moved in with Bob's mother, Cedella, who gave birth to Toddy's child, Pearl, in 1962.

Now with a child of his own to support in addition to Rita's daughter, Sharon, Bob invested his savings in developing the record label he had started earlier – Wail 'n' Soul 'm– and produced The Wailers' music while Bob and Rita and others sold the records from a makeshift stall erected as a lean-to on Rita's Aunt Viola's house.

In January 1968 The Wailers' career took a significant turn when they were discovered by American soul singer Johnny Nash at a Rastafarian "Grounation". With no big hits to his name as yet, Nash had formed a record production company called JAD with Danny Sims and Arthur Jenkins, a record producer. Nash wanted to break the rocksteady sound in the USA while his partners were seeking security in Kingston, fearing the rising racial tension in the USA. Happily for JAD, recording studio time was also cheaper in Jamaica.

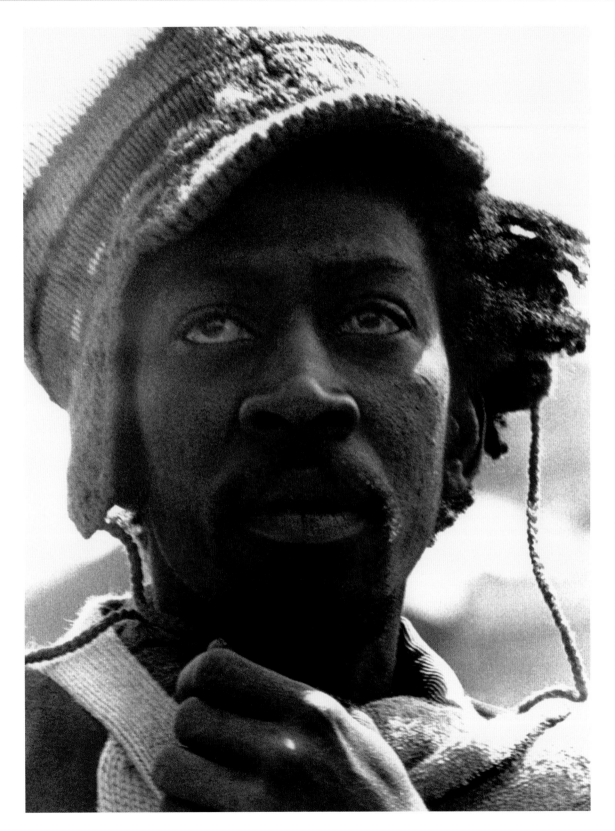

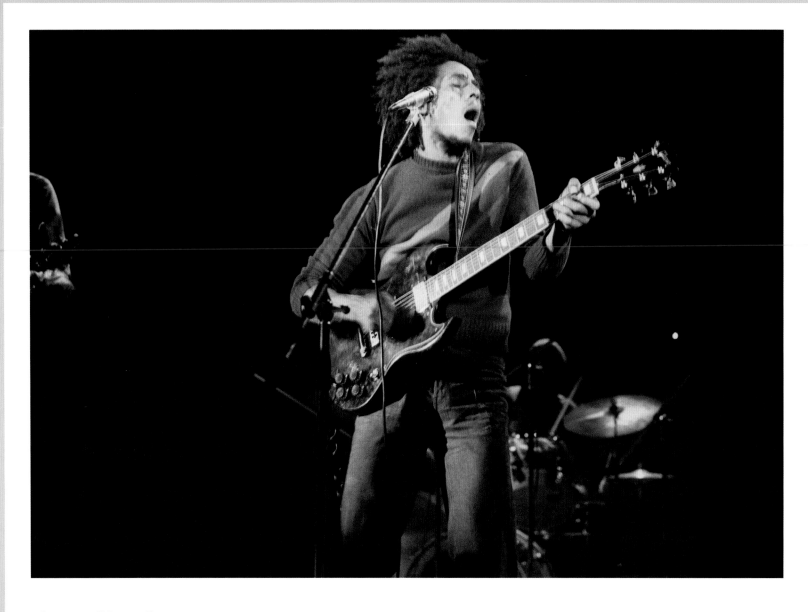

The Best of the Wailers

Above: Bob on stage in one of his earliest UK appearances. His dreadlocks haven't yet grown.

JAD had signed Bob Marley and Pete Tosh with song-writing contracts along with performing rights to The Wailers and began recording their raw music which was then polished up by experienced session artists in the USA. Little of this music would ever be released but Bob spent time at Nash and Sims' house in Russell Heights – a well-to-do neighbourhood of Kingston – which attracted a variety of musicians and socialites, among whom was local beauty Cindy Breakspeare.

In the spring of 1970 The Wailers agreed to record an album with Leslie Kong, now a millionaire thanks to international hits such as Millie's "My Boy Lollipop" and Desmond Dekker's "Israelites". The result, the first true reggae album, was released by Kong with the title *The Best of The Wailers*.

After the break with Dodd and the dalliance with Kong, Bob fell into an alliance with another Coxsone migrant, Lee "Scratch" Perry and his studio band The Upsetters. Scratch would have an ongoing musical influence on Marley and in the year they worked closely together they recorded some of The Wailers' finest music. At the core of Perry's sound were the Barrett brothers: Aston "Family Man" on bass and Carlton on drums. Bob had already heard Aston's distinctive bass lines and wanted to replicate that sound in his own music.

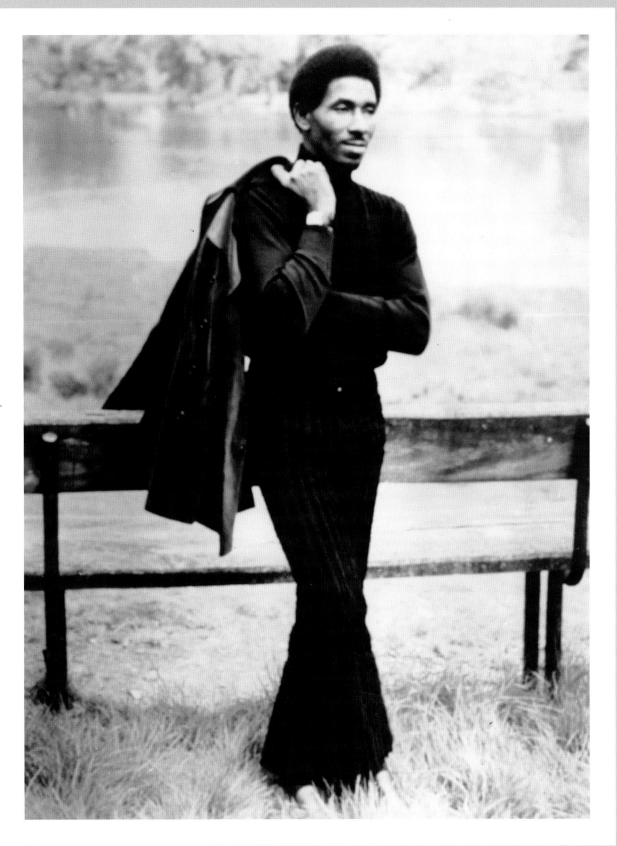

Working with Lee Perry

Right: Lee Perry pictured in the early 1970s. During this first association with Perry, Bob and The Wailers recorded enough material for three albums, the first of which was *Soul Rebels*, released in December 1970 on Perry's own Upsetter label in Jamaica and Trojan in the UK. *Soul Revolution* would follow the next year and move through different guises until appearing as *African Herbsman* with five extra tracks in 1973.

The highly productive collaboration with Lee Perry Productions ended after a financial dispute, which prompted The Wailers to set up their own recording label, Tuff Gong, with Bob's football and Rastafarian buddy Allan "Skill" Cole as their business manager. Perry lost the Barrett brothers, who became the backbone of The Wailers' instrumental line-up, with Family Man the band's musical anchor.

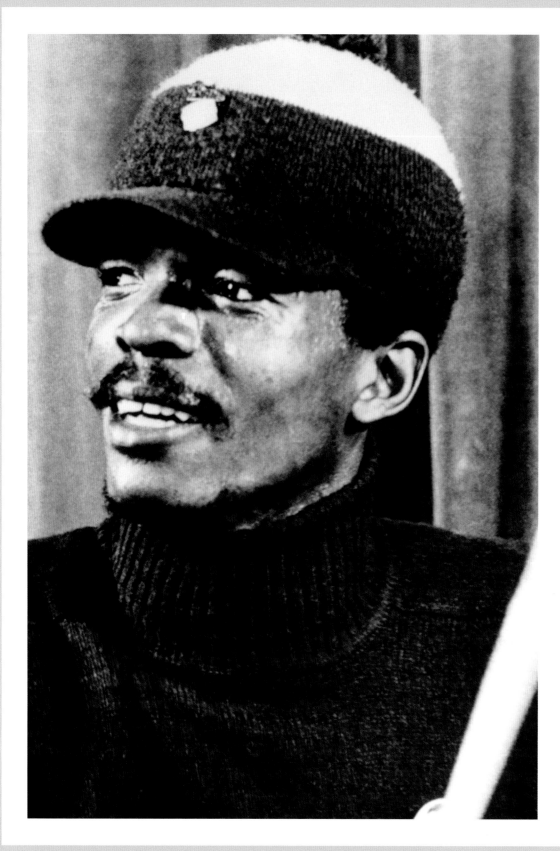

Beyond Jamaica

Left: Carlton "Carly" Barrett, four years younger than his brother, developed the one drop rhythm drumming style. This and Family Man's bass lines, put an individual stamp on The Wailers' brand of reggae, helping to take it into the international arena.

Bob's Tuff Gong record label was now releasing regular hit singles in Jamaica such as "Screw Face", "Trench Town Rock", "Guava Jelly" (to be recorded later by Johnny Nash and Barbra Streisand) and "Lively Up Yourself". However, his ambitions lay further afield so Bob and Rita travelled to New York where Bob took up his writing contract with Johnny Nash who at the time was producing and acting in a movie, set in Sweden. Bob moved to Sweden with Nash spending several months of 1971 there.

In February 1972 Bob left Kingston for London with a possible recording contract waiting for him, lined up by Danny Sims. Initially Bob worked with Johnny Nash in CBS's new studios in Soho, where Nash was recording his new album *I Can See Clearly Now*. Marley lived in a flat in Ridgmount Gardens in Camden until The Wailers joined him for extensive touring around the UK with Johnny Nash, performing in small venues and clubs specializing in reggae. In April Nash released his own version of the Marley song "Stir It Up" as a single giving the American his first chart success since 1969 and Bob his first hit single outside Jamaica.

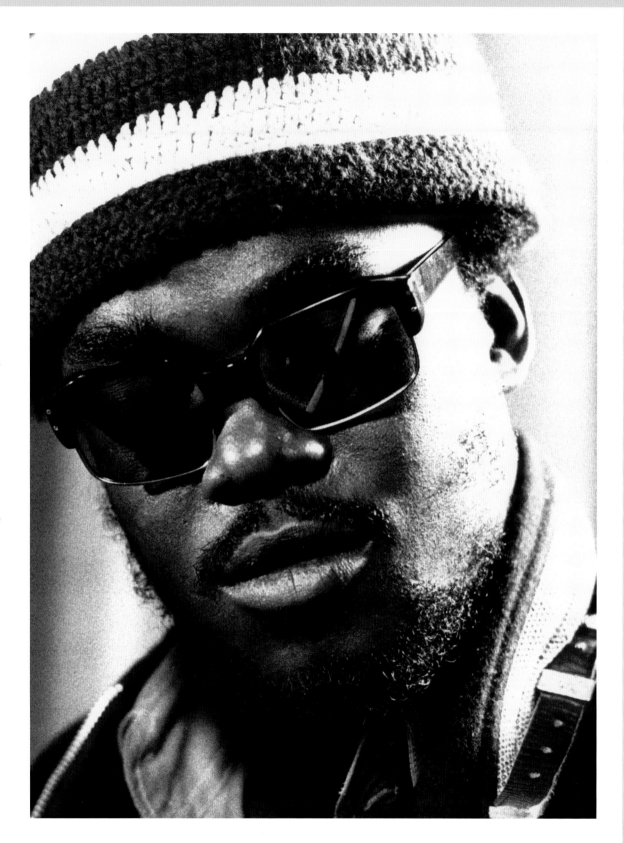

Family men

Right: Aston "Family Man" Barrett was born in November 1946 and from 1971 became a core member of The Wailers with great musical influence on the overall sound as well as Bob's individual songs. His nickname derived from his early success in fathering children. However, Bob's charisma also attracted many women and an enthusiastic generosity with his sexual favours bore much fruit in the early 1970s with the birth of Stephen to Rita on 20 April 1972, followed by Robert "Robbie" to Pat Williams on 16 May and, days later, Rohan to Janet Hunt on 19 May. Bob's family now extended to six children, three of them with Rita. Stephen was born in Wilmington, where Rita had gone to live when Bob left for the UK in February 1972.

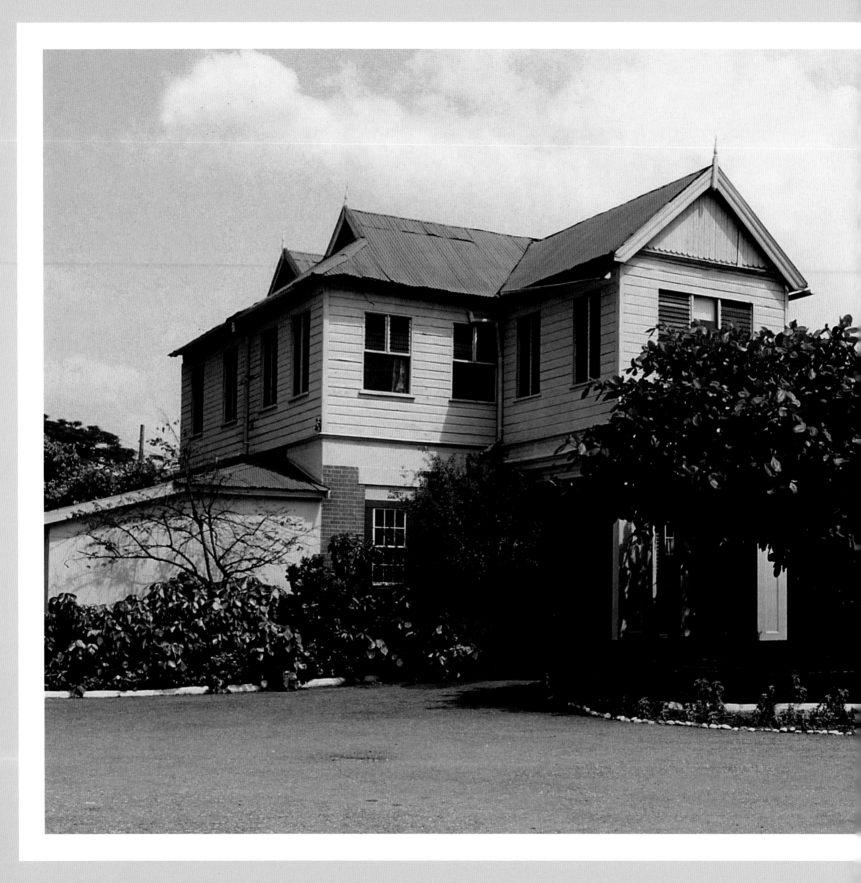

Chapter Two

Island Years

While they were in London together Johnny Nash promoted Bob's career within CBS and in April provided his own backing band to play on a recording Bob made of "Reggae on Broadway" in CBS's London studios. Nash also introduced Bob widely around the music and arts scene in London, in the way of a protégé.

In the meantime, during April Bob and the band moved into more salubrious and convenient quarters in Queensborough Terrace, London, W2. Here a constant stream of fans, mostly female, came visiting, seeking the attentions of Bob and The Wailers. Happy as they might be to oblige, the band found the visitors interfered with their work and duly moved further out into a house in Neasden, which was more anonymous and helped keep their energy focused on the studio work.

In September 1972 *The Harder They Come*, the movie starring reggae's first big success story, Jimmy Cliff, had its first showing at the Notting Hill Gaumont cinema. I ts depiction of lowlife in Jamaica and its engaging reggae sound track had the effect of elevating reggae into a sound track of rebellion and counterculture. Playing outside of mainstream movie theatres in the USA, the film contributed more than any other factor to the rising popularity of reggae with American audiences. As Cliff was the leading reggae artist signed to Chris Blackwell's Island Records, the success of the movie was a huge marketing breakthrough. However. the fame generated by the movie made Cliff decide to move out of the small specialist stable at Island, despite Blackwell's reasoning and pleading.

At the end of a frustrating summer for Marley – with very hard work and lean pickings from the studio and small-venue performances around the UK, he visited Island's offices in Basing Street, London, and mooted a deal with Blackwell. The timing could not have been better: Blackwell had invested in the Jimmy Cliff movie, was impressed by it and believed that reggae had a strong future. Without anything in writing, Blackwell handed Bob a cheque for £4,000 and promised a further £4,000 advance when the tapes were handed over.

Left: The house at 56 Hope Road, Kingston, Island Records' Jamaican HQ and later Bob's residence.

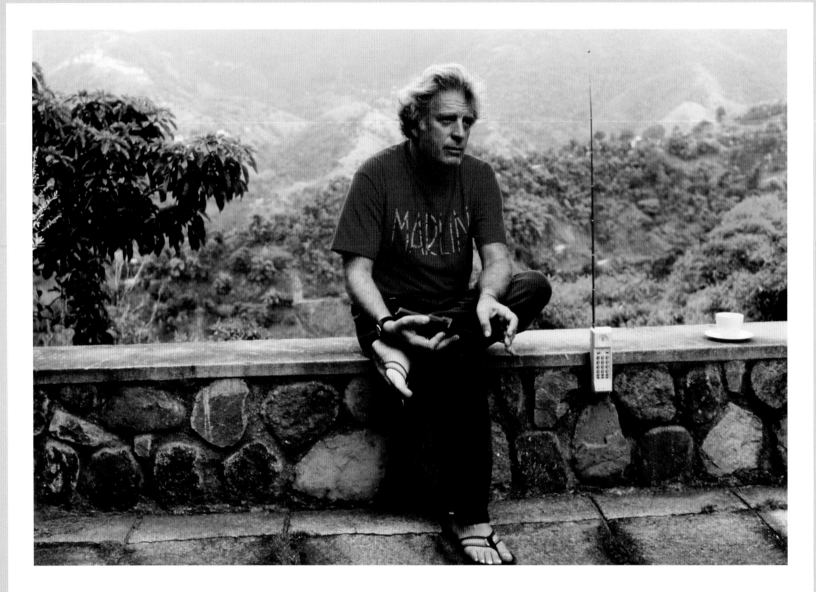

Catch A Fire

Above: Chris Blackwell, founder of Island Records photographed in the Blue Mountains, Jamaica in the 1990s. Hardly any photos were taken of Bob Marley with Blackwell even though he was one of Island's most important artists.

The Wailers returned to Jamaica at the end of September 1972 to find that at last their records were getting airtime, thanks to the efforts of Skill Cole. The frustrations of the preceding months disappeared with intensive sessions in Harry J's studio in New Kingston and, with many of the songs already written – some previously recorded – the base tracks of the album were quickly laid down. Blackwell, pleased with what he hears in the studio, doesn't wait for the final tapes to sign Bob and The Wailers for their first Island album, *Catch A Fire* – the title he himself suggested,

taken from the chorus line of the song "Slave Driver". Meanwhile he has negotiated with Danny Sims to release Bob from his CBS commitments, which cost Island another £4,000 and points on the earnings from some songs which had to be paid over to Sims.

The album, released in December 1972, was not an overnight success: Blackwell recalls the sales were slow but steadily grew thanks to excellent reviews hailing it as the latest in the newly fashionable Caribbean sound. The album artwork designed by graphic artists Rod Dyer and Bob Weiner, was innovative, mimicking a Zippo lighter with a hand riveted outer sleeve. Only the first 20,000 had this sleeve which was expensive to produce; it was later replaced by a cover that used the iconic Esther Anderson photograph of Bob smoking an enormous spliff.

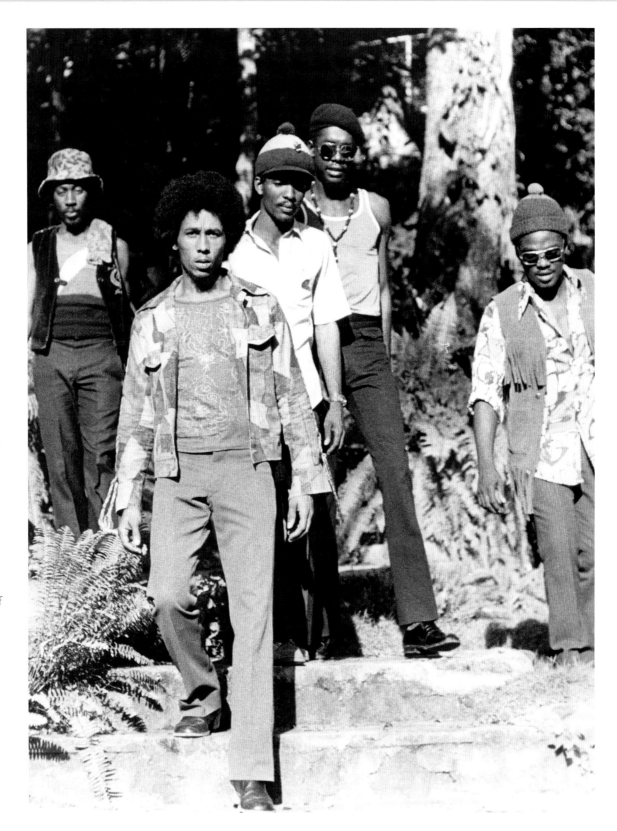

The full line-up

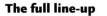

Right: L-R: Bunny, Bob, Carlton
Barrett, Pete Tosh, Family Man.
Shot by local photographer,
Cookie Kincaid, in the foothills
of the Blue Mountains, it took
her three days to organize
the session, shepherding the
various band members together
one at a time in her mini-moke.
The photograph was to be used
in the cover art of *Catch A Fire*.

The album line-up included
the three Wailers with the
Barrett Brothers supported by
bassist Robbie Shakespeare
and keyboards player Tyrone
Downie. Marcia Griffiths, herself
something of a star supported
Rita Marley on vocals. Taking
the base tracks back to Island's
studios in London, Blackwell
added further touches from
guitarist Wayne Perkins
and more keyboard backing
from John Rabbit Bundrick –
musicians not in the reggae
frame but whose additions
helped create a distinctive
commercial sound.

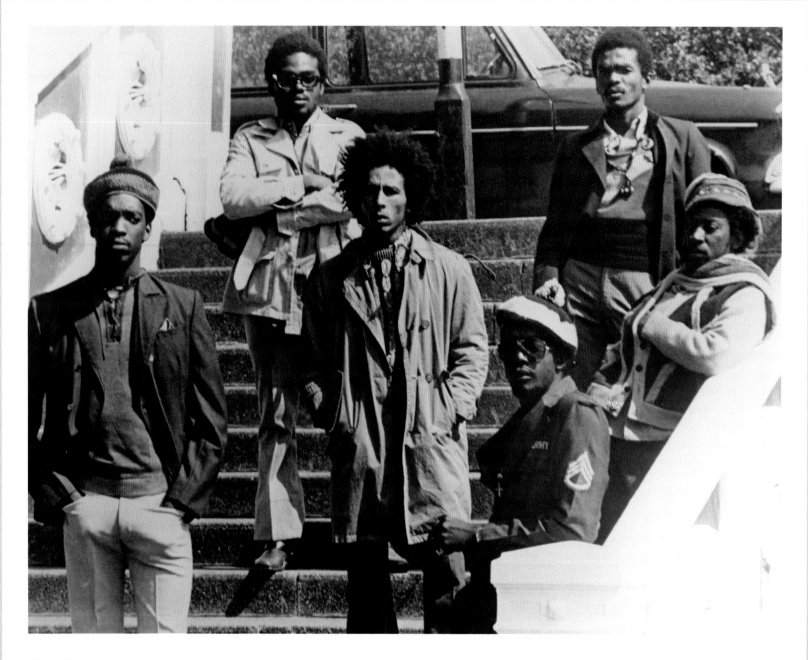

First album tour

Above: The Wailers, photographed on London's Chelsea Embankment during the UK leg of Catch A Fire tour, including all the original members. L-R: Earl "Wire" Lindo, Family Man, Bob, Tosh, Carly and Bunny. Timed with the international release of *Catch A Fire,* Bob Marley and The Wailers began their first album tour in the UK, kicking off at the Coleman Club in Nottingham on 27 April. Nearly 30 gigs followed across the country, many in colleges and universities. Tour organizer Mick Cater had his doubts when Blackwell played a demo tape but the venues booked were better than many modern day debut tours. High points in the tour were a performance on BBC2's elite music show *The Old Grey Whistle Test* on 1 May and four nights at London's Speakeasy 15–18 May; here music industry stars turned up to hear the band, bringing with them glitterati such as Bianca Jagger. Over the four nights Bryan Ferry, Brian Eno, members of Traffic accompanied by Blackwell, Eric Clapton, Jeff Beck and elements of The Who gave The Wailers a riotous reception.

Burnin'

Right: Bob at one of his early gigs in England: these first shows were attended by mainly black audiences with only a handful of white people.

In addition to their tour dates in May, the band were working on their next album in Island's Notting Hill studios, adding to the base tracks that had been laid down in Harry J's back in Kingston the previous autumn. In the studio next door the Rolling Stones were putting the finishing touches to their *Goat's Head Soup* album, also recorded in Jamaica.

The new album, *Burnin'* opened with the track "Get Up, Stand Up"; it was written jointly by Marley and Tosh and expressed Tosh's more militant stance on personal and political freedoms – a recurring theme in Bob and The Wailers' music. A new song on the album which later would give the band a major boost was "I Shot the Sheriff". Studio work continued through June and while the band lived in an apartment in King Street, Hammersmith, Bob found a warmer welcome in lover Esther Anderson's nearby apartment.

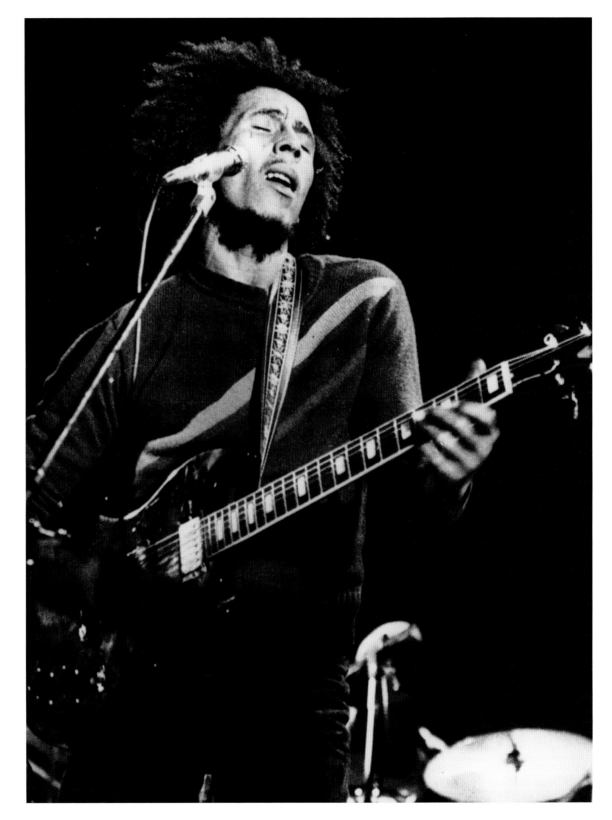

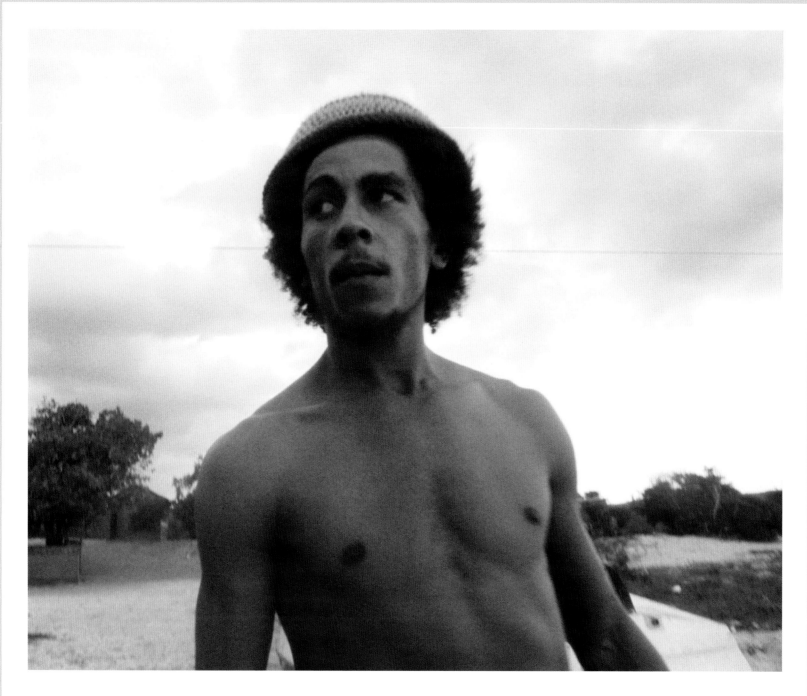

Separate lives

In early 1973, Bob was back in Kingston. He and Rita now were living separate lives though still maintaining a shared family household. Under the pretext of work, Bob spent most of his time at Chris Blackwell's Island HQ, 56 Hope Road, where Lee Jaffe, Esther Anderson and Cindy Breakspeare were also house guests. Bob had originally met 22-year-old Lee Jaffe at the New York premiere of *Last Tango in Paris* in January also attended by Esther. Jaffe noted the chemistry between Bob and Esther who soon became lovers. Jaffe, himself an able harmonica player, followed Marley back to Jamaica to become part of his entourage.

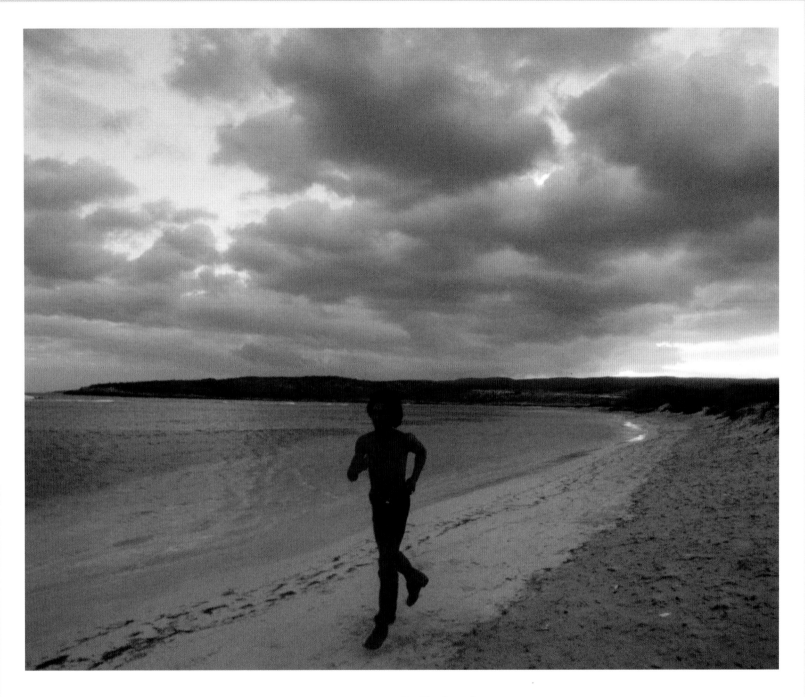

On the beach

Fitness training came as second nature to Bob and he had regular routines of early morning runs, often with a group of friends, on his favourite beaches – here, in a solo session with Esther Anderson, she photographed him jogging on Hellshire Beach in 1973. Anderson was an associate of Island Records and handled PR for the Jamaican signees for Blackwell. A striking beauty, she also had a career as an actress and dancer.

Supporting Sly

Left: Bob on the beach in Jamaica. The new album *Burnin'* was released on Island/Tuff Gong on 19 October 1973 and a tour was arranged to promote the album with the US leg setting out from Homestead, Florida in early October. The band was booked to open for Sly and the Family Stone touring his latest album. Although Sly's music had been influential on The Wailers, there was no similarity between their musical styles and reggae was generally unknown to Sly Stone's audiences. At this point in his career, Sly's act was suffering from drug use and his gigs were often disrupted or cancelled. The Wailers were abruptly sacked from the tour after five gigs and left to fend for themselves in Las Vegas.

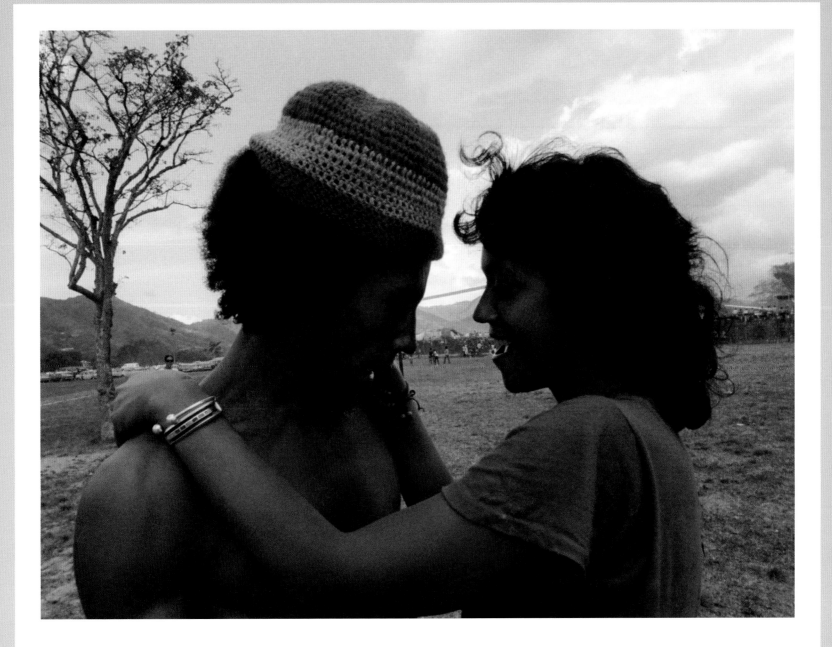

A change of plan

Above: Bob and Esther Anderson share an intimate moment at Carnival in Trinidad in 1973.

With their plans to tour with Sly cancelled, Bob and The Wailers were forced to swiftly rearrange their tour schedule, They picked up two nights at San Francisco's Matrix Club and a further two on 29 and 30 October; the following day, while in the neighbourhood, The Wailers played a live session in Sausalito's Plant Studios for the legendary rock music station KSAN, whose reputation at the time for counterculture leanings had won considerable influence in the younger adult audience nationwide.

Tosh and Bunny burned out

The Wailers returned to the UK in November to complete their Burnin' tour. The cold wintry weather didn't suit the band who travelled to mainly north country gigs each day, returning to London accommodation at night in freezing conditions. Pete Tosh was struggling with a bad throat infection and, after getting a sick note from a London doctor, got on a plane back to Jamaica, thereby ending the tour. The last gig was at Northampton on 30 November.

Although Bob managed to maintain his relationship with Bunny Wailer, Tosh was now struggling with his own ambition, wanting to be an artist in his own right, which no doubt he was. Both he and Bunny had started their own record labels and would record their own material but they were second to Bob when it came to The Wailers – that was certainly Blackwell's opinion when he turned down Tosh as a recording artist for Island. Blackwell had good reason to turn down Pete, The Wailers' first two Island albums were still in the red at this time, despite heavy marketing commitment and the tours.

As the three original Wailers spent time apart, many in their circle assumed that they just needed space from each other – but it proved more serious. The musical partnerhsip was over for the three original Wailers but they would play together again. A couple of benefit shows were mounted in May 1974 for The Trenchtown Comprehensive Sports Centre and the socially and racially-conscious Motown star Marvin Gaye agreed to top the bill, with The Wailers in support. Part of Gaye's entourage was Don Taylor who was already managing at least one other act; Marley persuaded Taylor to become The Wailers' business manager.

Left: Rita photographed in the early 1970s.

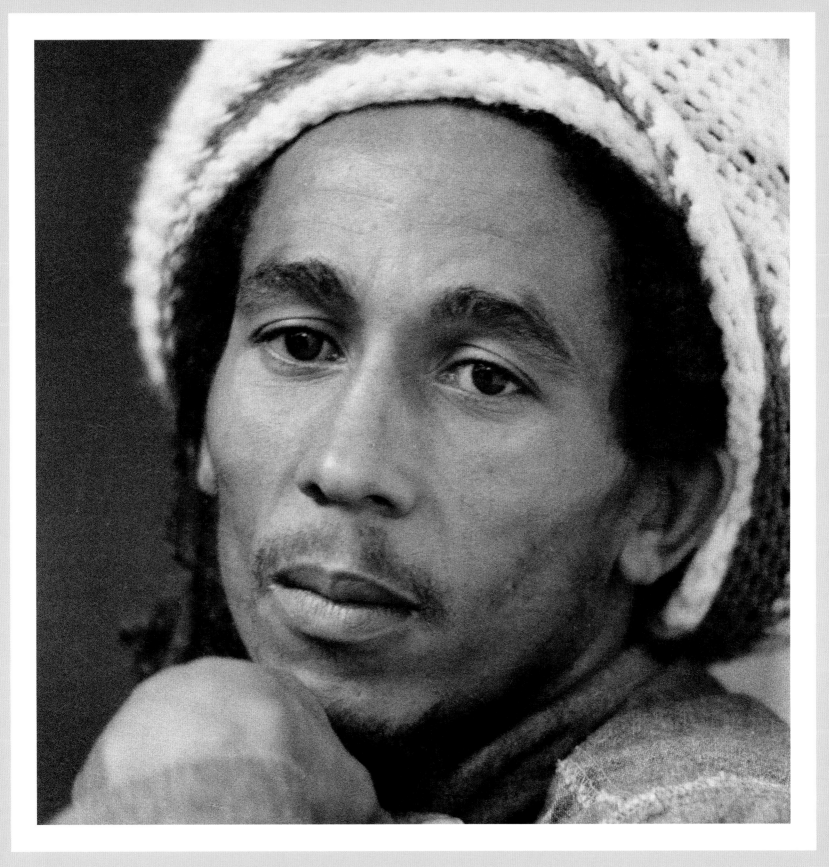

Natty Dread

Natty Dread was released on 25 October 1974 on Island and Tuff Gong but the promotional tour didn't take place until summer the following year; the album peaked at 43 in the UK album chart but got no higher than 44 in the US. Its best known track, "No Woman No Cry" was a breakthrough for the band now officially titled Bob Marley and The Wailers. Likewise the three female backing vocalists now were known as the I-Threes. The chart performance of the album could be considered disappointing after Eric Clapton's chart success in summer 1974 with "I Shot the Sheriff" – a song taken from The Wailers' *Burnin'* album. However the reggae sound was now steadily establishing a core following in North America.

In May 1975 Martha Velez arrived in Kingston and spent three weeks recording her new album with Bob and Lee Perry collaborating as producers and The Wailers providing backing. *Escape From Babylon* was Bob's only studio collaboration with an American artist and the successful album features covers of two Wailers' songs and a composition by Bob and Martha, credited to Rita, reportedly to avoid rights being acquired by Bob's publisher.

The Natty Dread North American tour launched in Miami, Florida on 5 June followed by a further 26 US dates and a single performance in Toronto on the second night. The tour continued with a 7-night/14-show stint at Boston's Paul's Mall. Moving to the West Coast on 4 July, performances were concentrated at the Boarding House in San Francisco and the Roxy Theater in Los Angeles.

According to Lee Jaffe, who was a regular member of Bob's entourage at this time, things were far from perfect as the band struggled for success. Two albums were still commercial failures and Island didn't want a third; the album Bob sent off for pressing was called *Knotty Dread*. Jaffe was appalled that the title was changed to *Natty Dread* without consultation. Marley's opinion was that Jaffe, who had not been credited for his role in the composition of "I Shot the Sheriff" or his playing with the band, was more concerned with a personal credit. This quarrel ended in a fist fight and Jaffe departing the band. Jaffe was reconciled when Bob took care of him after he was arrested and jailed in Jamaica and Lee showed up to play harmonica at the Central Park performance in June – the last time he was to play with The Wailers.

Left: The Jackson Five and The Wailers pose for the camera when the Jacksons visit Jamaica in 1975 to perform at the National Heroes Stadium on 8 March. The Wailers open for them with Bunny and Tosh in the line-up.

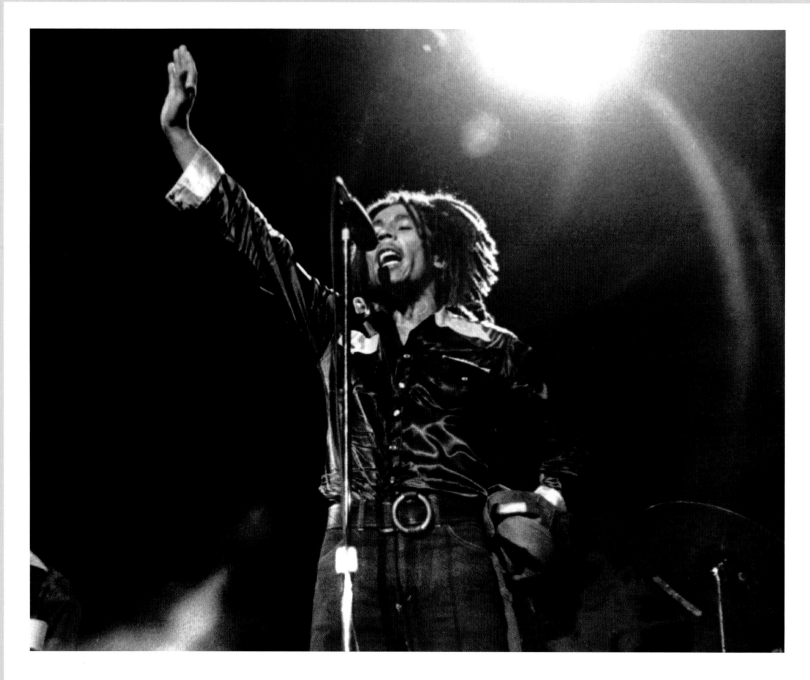

Dancing on the tables at the Roxy

Four nights at the Boarding House in San Francisco were followed by a show at the
Paramount in Oakland, CA then, from 9 July five consecutive nights at LA's legendary
Roxy Theater where music industry glitterati got up and danced on the tables while stars
like Dylan, Jack Nicholson, Ringo and George Harrison looked on.

Above: On stage at Detroit's Showcase Theater, 14 June 1975.
Opposite: Bob Marley and The Wailers open at the Roxy Theater, Los Angeles on 9 July.

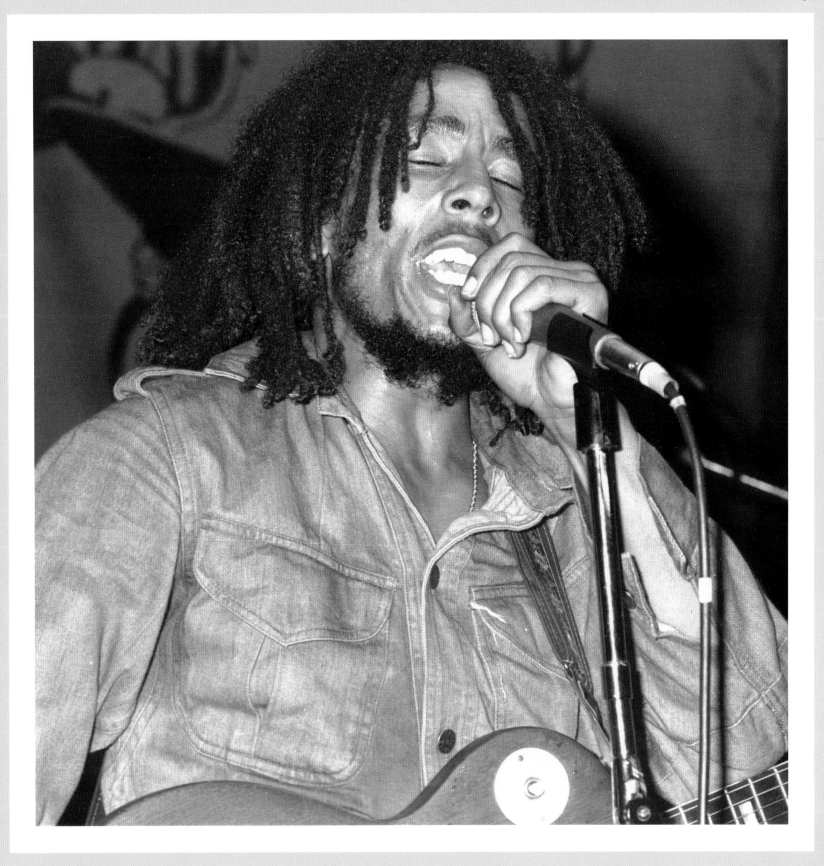

Visual energy

The band's stage act was supported by
massive banners of Rastafarian heroes
– Haile Selassie and Marcus Garvey in
particular. The artist responsible was Neville
Garrick who joined Bob's Hope Road
entourage during 1973 in the loose role of
creative director. The visual impact of the
shows added further energy to the music.

Garrick recalls: "I feel I coloured the
music. I coloured Bob's music from a
visual perspective. What I basically was
trying to do with my life was to set a visual
interpretation of the mood of where Bob
was taking the music...I started thinking
about having Marcus Garvey and Haile
Selassie and African symbols...That was
my projection, to add to the whole thing
by visually projecting what the music was
dealing with by using symbology and with
light and stage decor."

Right: On stage at the Roxy, L-R, Tyrone
Downie on keyboards, Al Anderson lead
guitar, Family Man bass, Carly drums, Bob
lead vocals, Seeco percussion, Judy and Rita
of the I-Threes backing vocals.

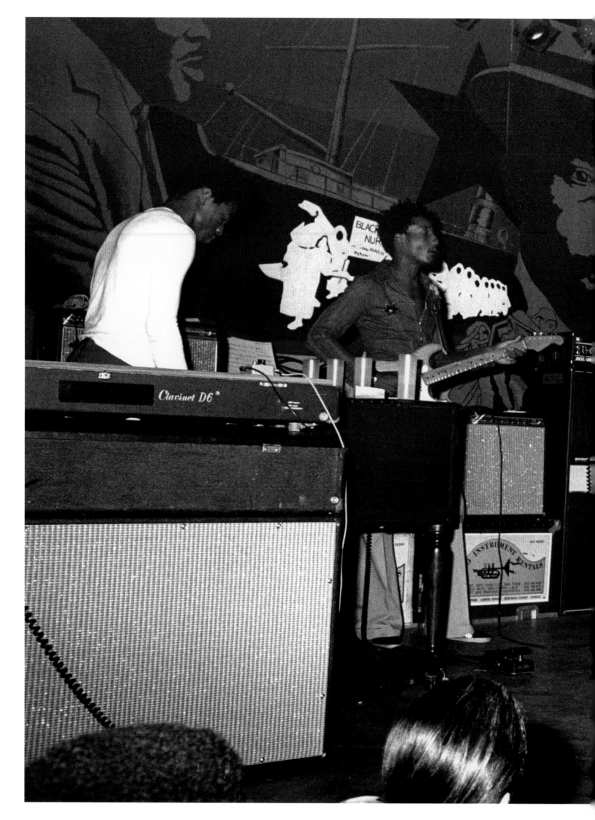

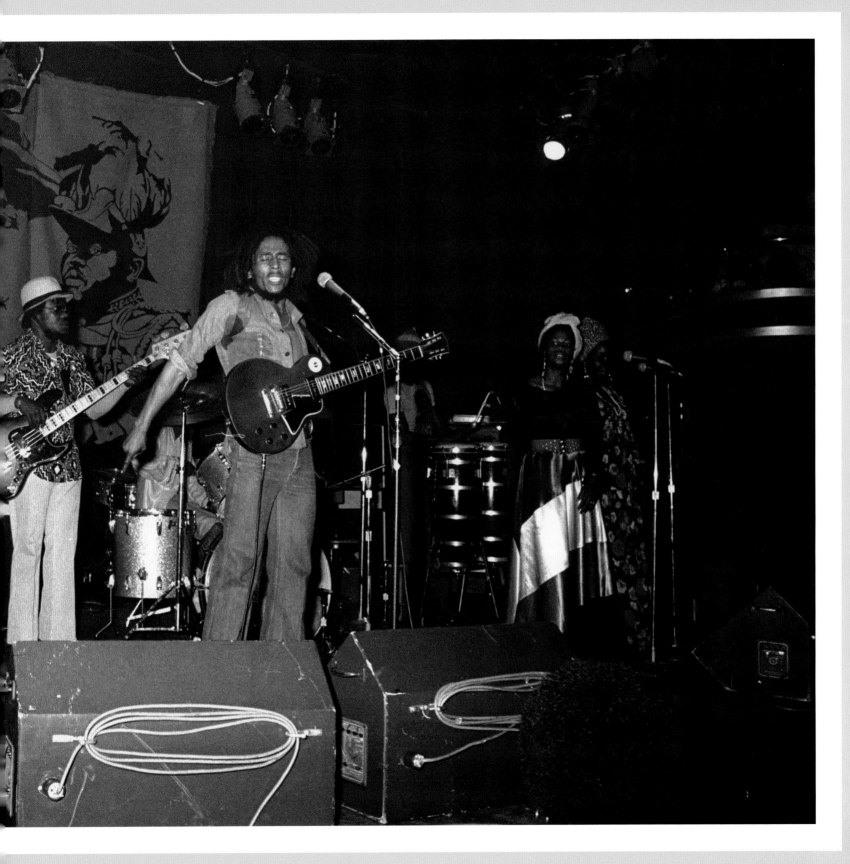

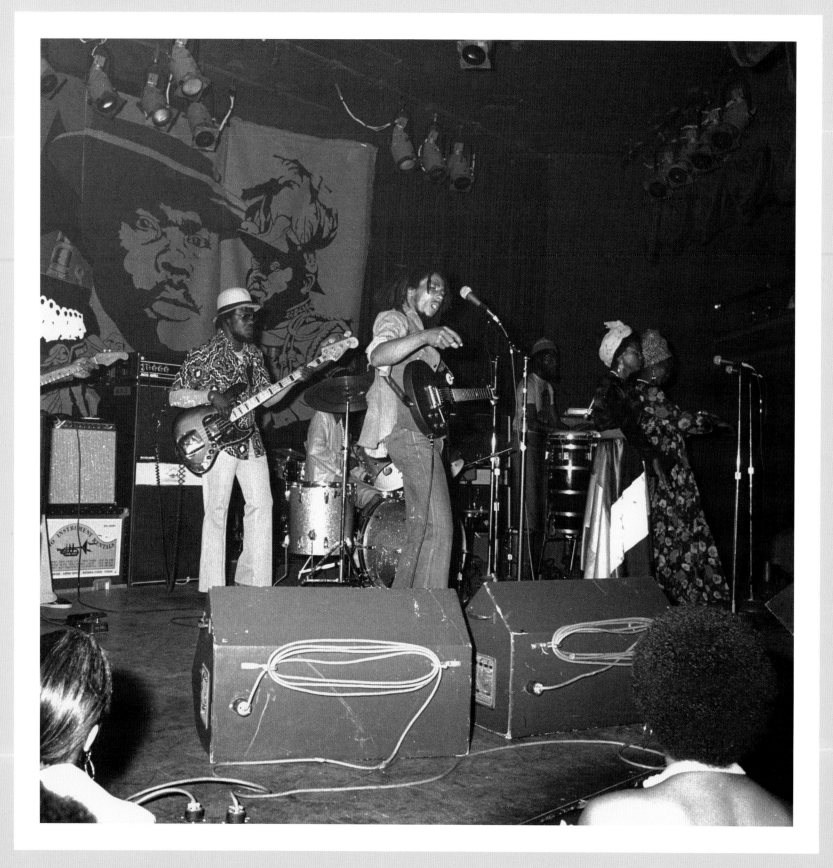

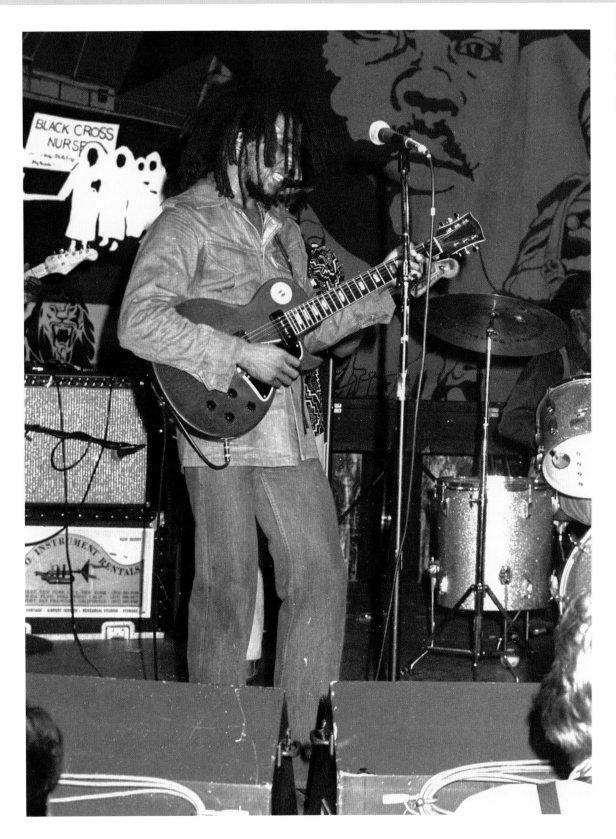

Rocking the Roxy

Opposite and right: On stage at the Roxy Theater in Los Angeles. According to Garrick he and Family Man were responsible for writing out the set lists for the shows; they might be produced as late as 10 minutes before going onstage; with no computers or xerox machines to hand it could be stressful to write out the individual sheets for the band... However, Bob would freely change the set list during a show if he thought the crowd hadn't reached the right level of participation – namely frenzy! "Lively Up Yourself" would usually deliver the desired effect. Bob would also make an on-the-spot decision about the song length – whether it would be the five minute version of a particular song or the eight-minute one. Shows generally consisted of 14–15 songs and ended with the rousing "Get Up, Stand Up".

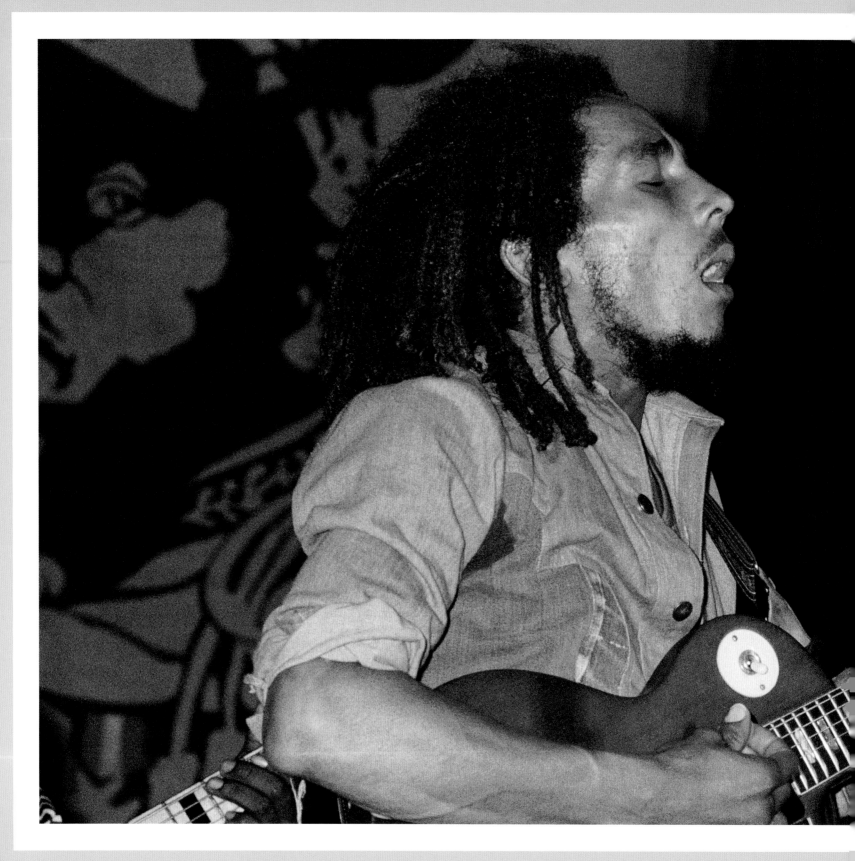

Live at London Lyceum

The US tour wound up at the Roxy on 13 July and the band flew to the UK the following day in time to perform a legendary pair of sellout shows on 17/18 July at the Lyceum Ballroom in London, where they were recorded for the album *Live!* that was later released in December that year. Tour promoter Cater was frustrated that both gigs sold out on the first day the tickets went on sale; he knew he could have filled a larger venue for several nights in a row.

Natty Dread tour ends

Right: Bob arrives at the stage door of the Birmingham Odeon on 19 July 1975. (L–R) Tyrone Downie, a young female fan, a member of the road crew, Gilly Dread, Bob and Al Anderson.

Although Bob's stage performance at this time was generally more introvert, during the performance at the Lyceum on 18 July he connected animatedly with the audience, establishing a spiritual as well as musical rapport. It seems he was now feeling more at home with a British audience – probably helped by the increasing presence of Caribbean people in the capacity crowds.

After the Lyceum dates, Bob played two more UK gigs in Birmingham and Manchester. Back in Kingston in August he hears rumours of the death of Haile Selassie on 27 August.

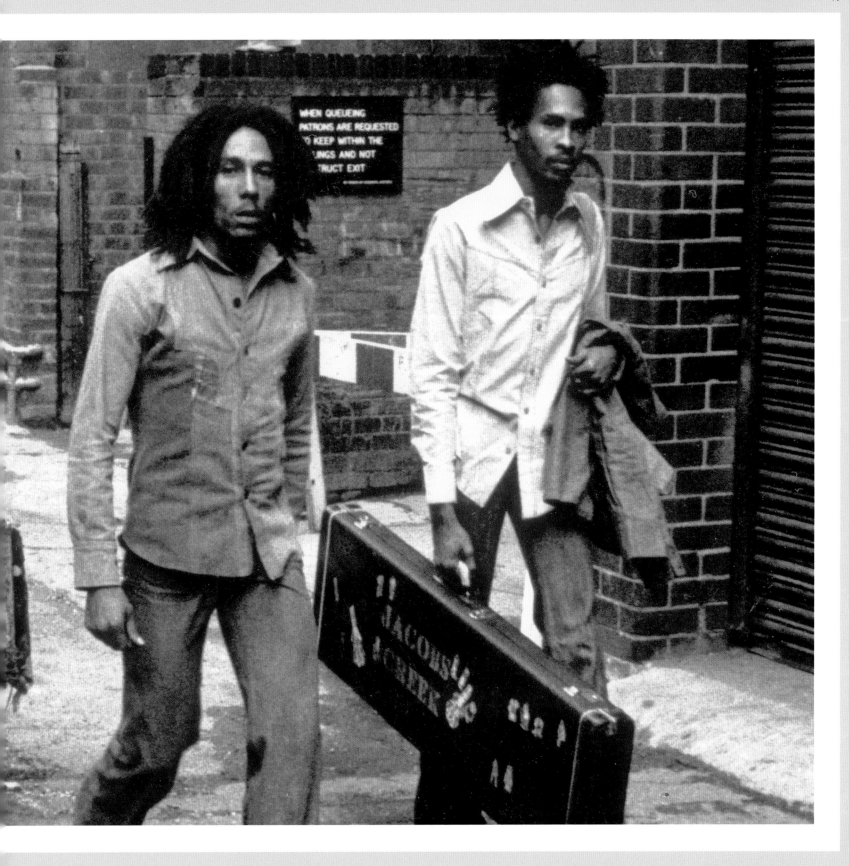

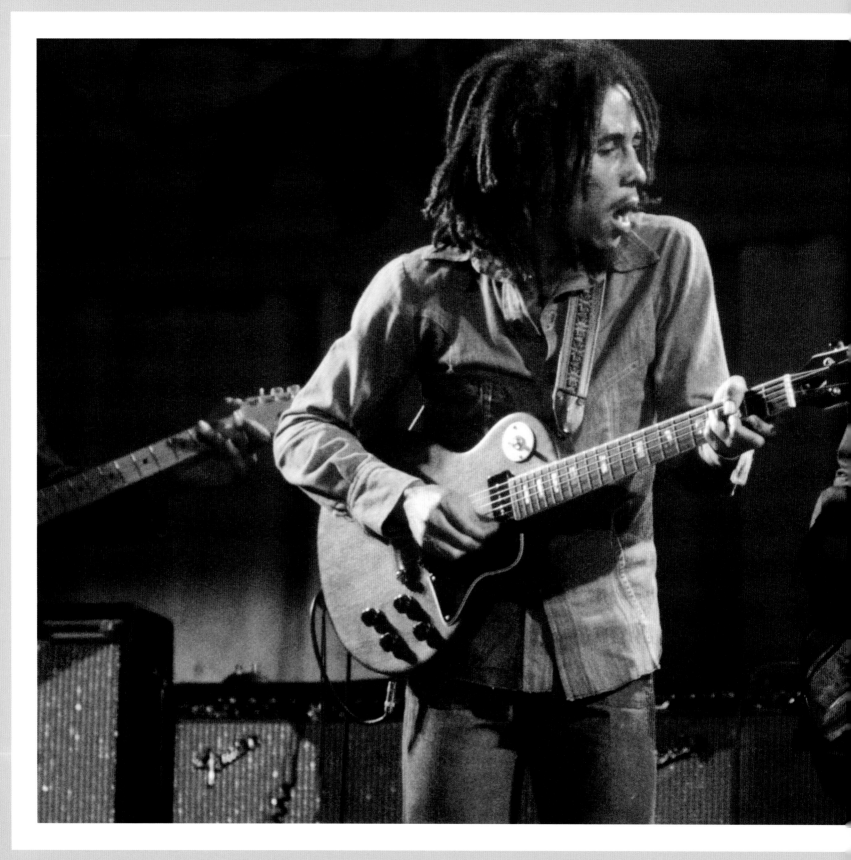

Jah Live

Left: Bob and Family Man on stage. Bob, back in Kingston was recording *Rastaman Vibration,* when the earlier rumours of the Emperor Haile Selassie's death were finally verified, although no body could be produced. Within days, in collaboration with Scratch Perry, Bob recorded homage single, "Jah Live", proclaiming that Selassie, incarnation of God, is not dead. The single received huge acclaim in Jamaica.

Bob included another homage track "War" on the new album which used the text of Selassie's speech to the United Nations in October 1963 for the song's lyrics. "War" was credited to Allan Cole and Carlton Barrett reportedly to circumvent the unfavourable royalty agreement Bob had with his publishing company Cayman with which he signed in 1968.

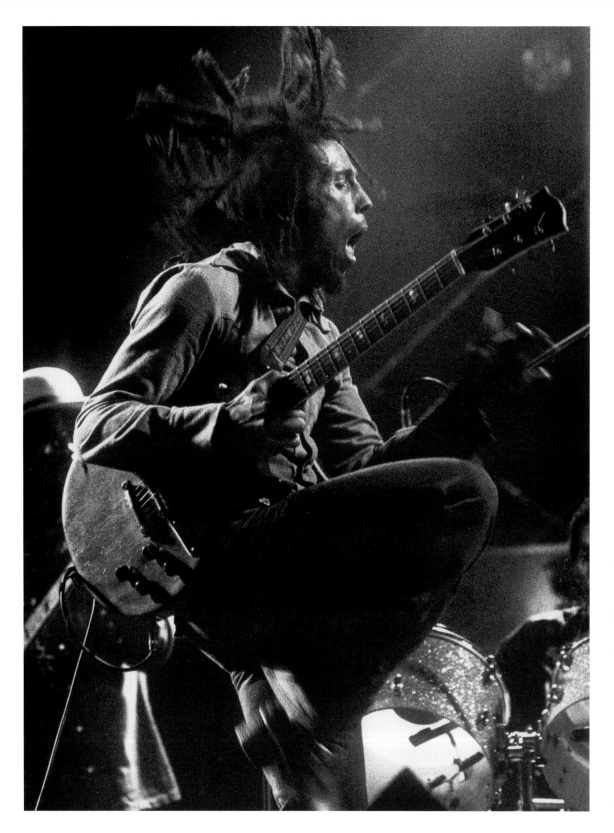

Dancing to his own beat

Left: Bob in hyper skanking mode on stage at the Birmingham Odeon. Bob's dancing to his own music was freely expressive and used his own rules of coordination. Rocksteady and ska, from which reggae derived had their specific dance moves; skanking was a dance that mimicked an exagerrated style of walking but in time with the strong beat of the music.

Opposite: An animated Bob Marley at Island Records London 1975. He has a number of very distinctive expressions; this is one of them.

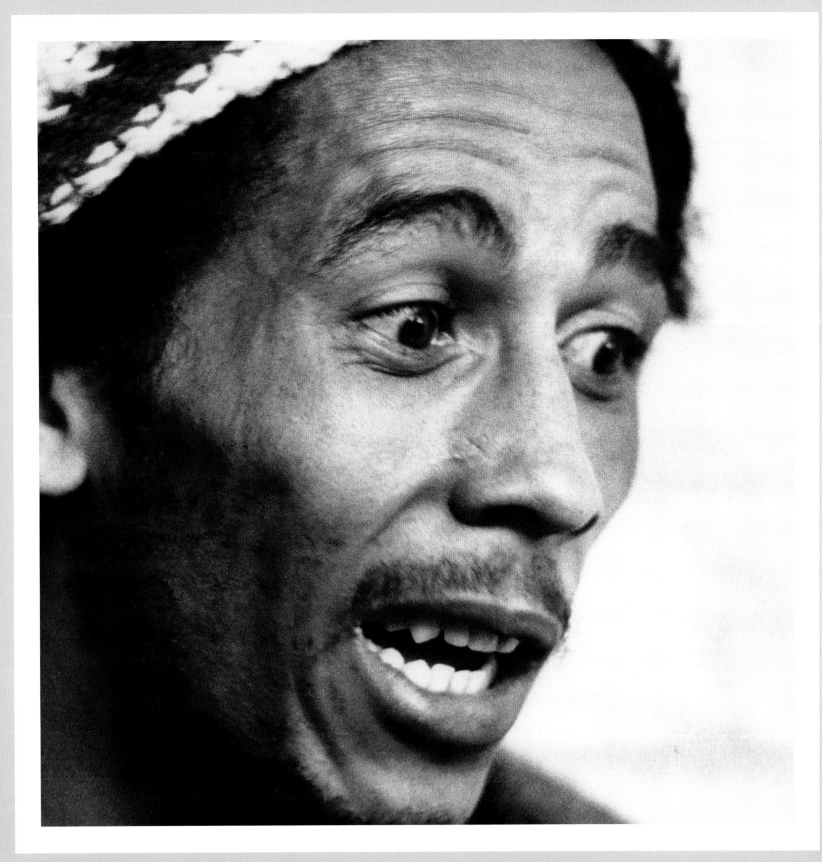

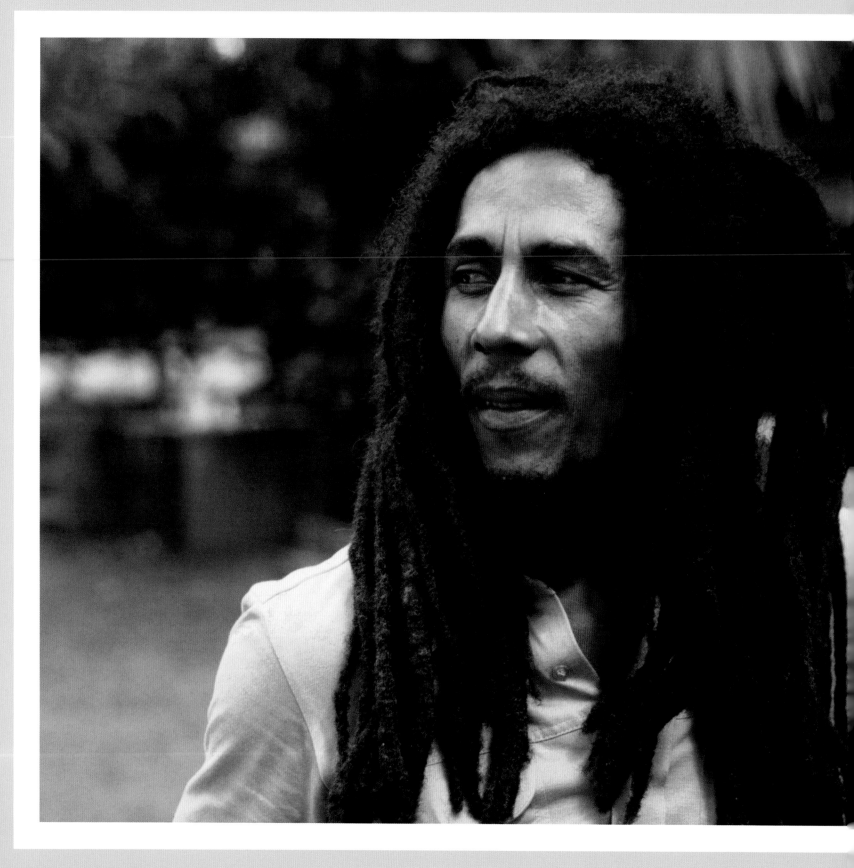

First UK hit single

Left: Bob looks regal leaning against an open window. The other side of the Atlantic, in the UK, Bob's single "No Woman No Cry" was released in early September to chart at No. 22. Bob with his brand of reggae is now reaching superstar heights, though the US market has some way to go.

On 4 October Stevie Wonder played to a sold-out National Arena in Kingston; the event, called The Wonder Dream Concert, was part of a tourism promotion to encourage visitors to Jamaica in December and January. The Wailers, including Bunny and Tosh were playing together for the last time and although in support of Wonder, they now enjoyed their own international stardom. Stevie Wonder's encore brought The Wailers back on stage to perform together, singing their own hit "I Shot the Sheriff" as well as Wonder's "Superstition".

1975 had been an epic year for Bob Marley and The Wailers and to round it off on 5 December the *Live!* album was released on Tuff Gong and Island to become an immediate classic in Europe. Island chose not to release the *Live!* album in the States for some time but after it became really popular on radio stations that mainly played white rock music, and as the demand for import copies grew, Island finally released the album to the hungry US audience.

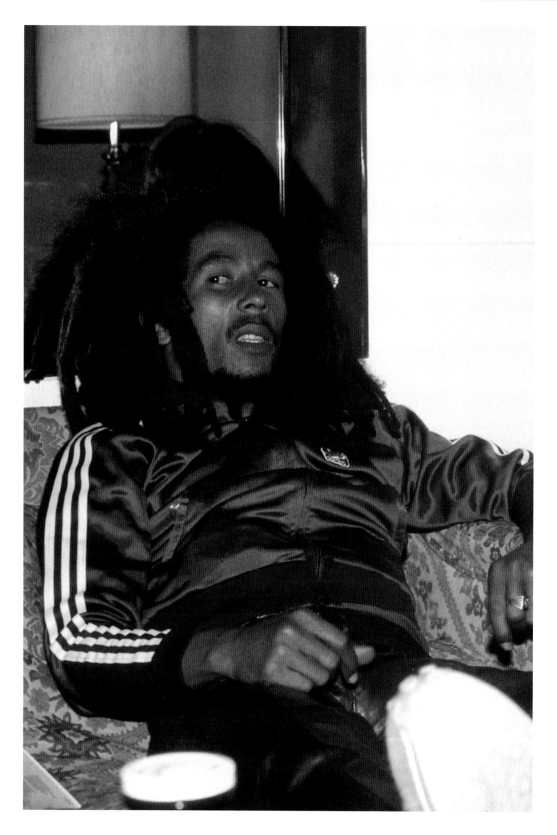

Rastaman breakthrough

The follow-up studio album to *Live!* was *Rastaman Vibration* which typically recycled some earlier numbers and added some new compositions. The same studio team was used as in the making of *Natty Dread* – production by Bob with input from Scratch Perry and recorded in Harry J's with Sylvan Morris as sound engineer; the core line-up of Bob, the Barrett brothers and the I-Threes was again unchanged but the sound differed significantly from *Natty Dread*, perhaps because Al Anderson, fallen out of favour, was replaced by Chinna Smith (who had been part of the session team for the *Escape From Babylon* recordings) and the American blues virtuoso guitarist Donald Kinsey brought in to strengthen the guitar rock sound. This Island album, unlike its predecessors, was mixed in Miami. Whatever the production formula, *Rastaman Vibration*, released in April 1976, went on to spend four weeks in the *Billboard* Hot 100 album chart, making it Bob's breakthrough US album.

Left and opposite: Bob relaxes in his room in the Plaza Hotel, New York City at the end of April 1976 during the Rastaman Vibration tour. He was staying there while performing at New York's Beacon Theater on 30 April and 1 May.

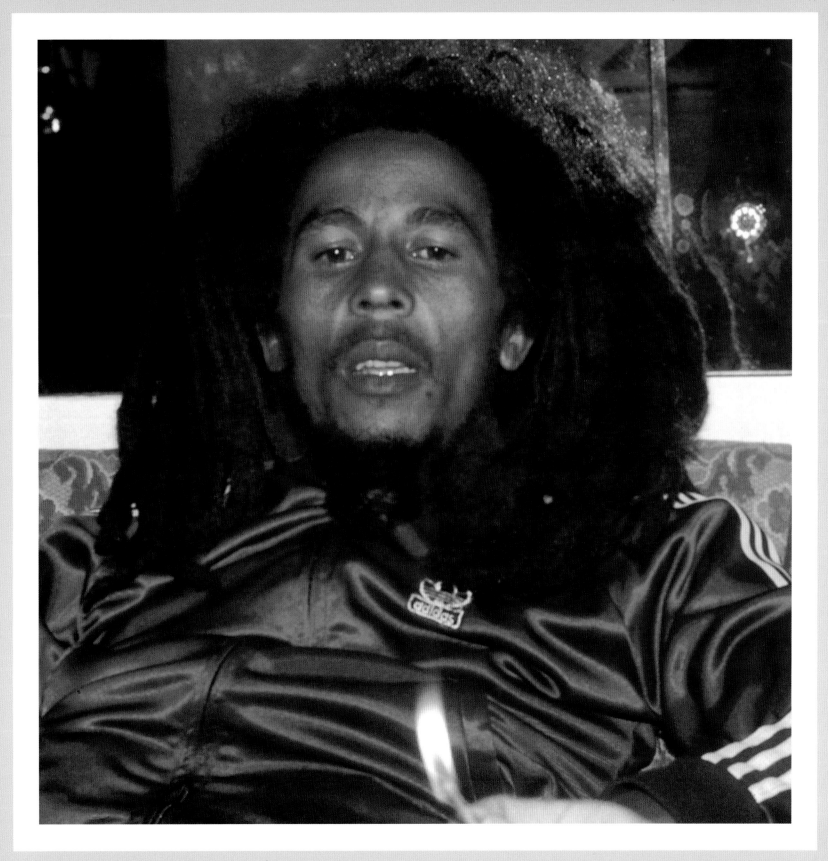

Positive vibration

Right: Bob performs at the Beacon Theater, New York. The Rastaman Vibration tour set out from its opening performance in the Tower Theater, Upper Darby, Pennsylvania on 23 April 1976. The North American leg comprised around 30 shows with gigs in Montreal and Toronto, Canada in early May, ending up in Miami in early June. The opening performance gave Bob's mother, Cedella Booker, first sight of her now famous son performing in front of a rapturous audience; she was ecstatic with pride.

The Beacon Theater on Broadway in New York where The Wailers played two dates at the end of April was originally built as a movie theatre in ornate style. It was growing in popularity as a music venue for rock bands. In June 1976 the Grateful Dead played a week of concerts there, just over a month after The Wailers. Lee Jaffe recounts how around this time, Bob was wooed by the Dead who were big fans. There had been a faint possibility of Bill Graham, the Grateful Dead's manager, taking on management of The Wailers and possibly signing to the Dead's new record label. In the end Marley couldn't conceive of joining an artist stable with 'Dead' so prominent when the sanctity of life was such a key part of Rastafarian philosophy. The same mindset would lead later to Bob resisting radical surgery on the cancer that killed him.

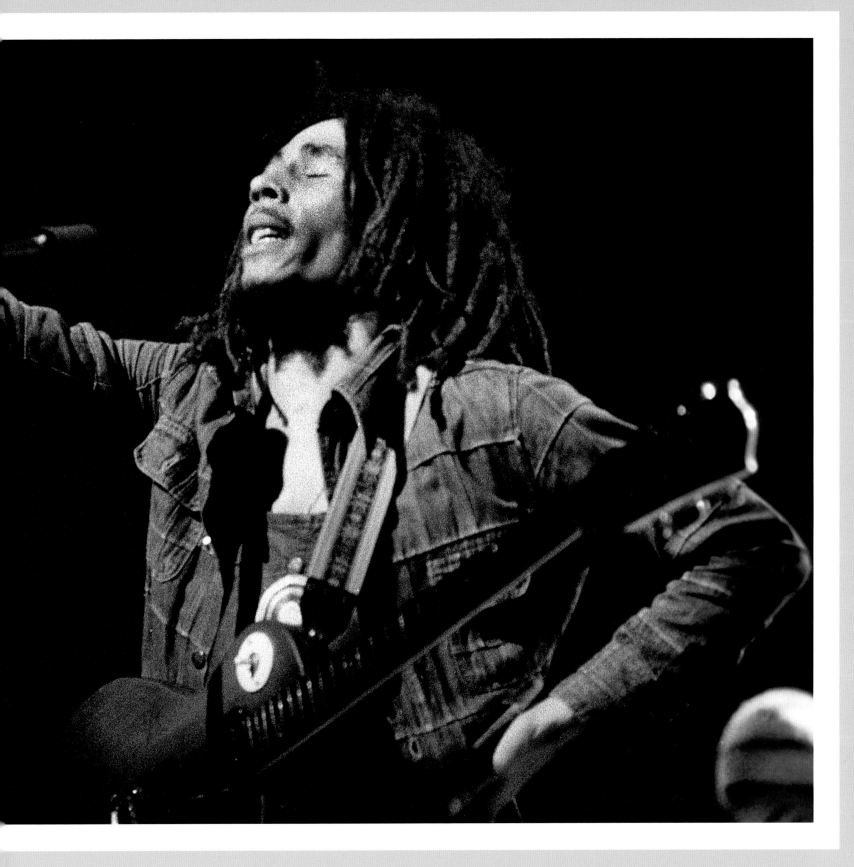

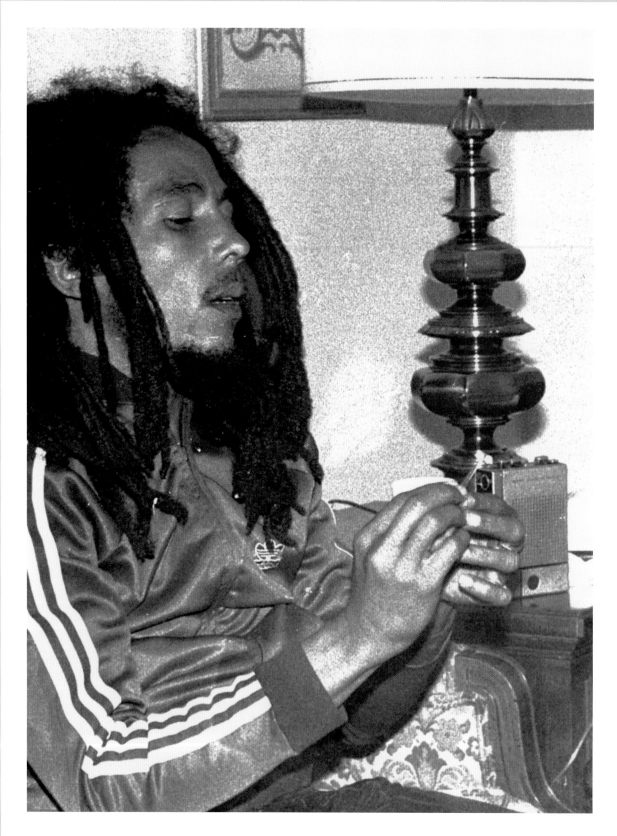

High standards

Opposite: An intense moment onstage at the Beacon Theater, NY, during the Rastaman Vibration tour, which also took in some cities new to the band in the USA including Washington DC, where Bob and The Wailers played Georgetown University. The album *Live At the Roxy* was recorded during this tour, on 26 May.

Island had worked hard on marketing the latest album: *Rolling Stone* and *High Times* were primed and ready for the album; for once the US tour went according to plan. The band surfed a wave of brilliantly orchestrated marketing and publicity, taking the new album to No. 8 in the US album chart.

Left: Bob meditatively rolls a joint in his Plaza hotel room while listening to a portable cassette tape player. From early days it was his habit to listen to recordings of his shows to check on the quality of the performance: as with his recordings and rehearsals, he insisted his shows meet the highest quality standards.

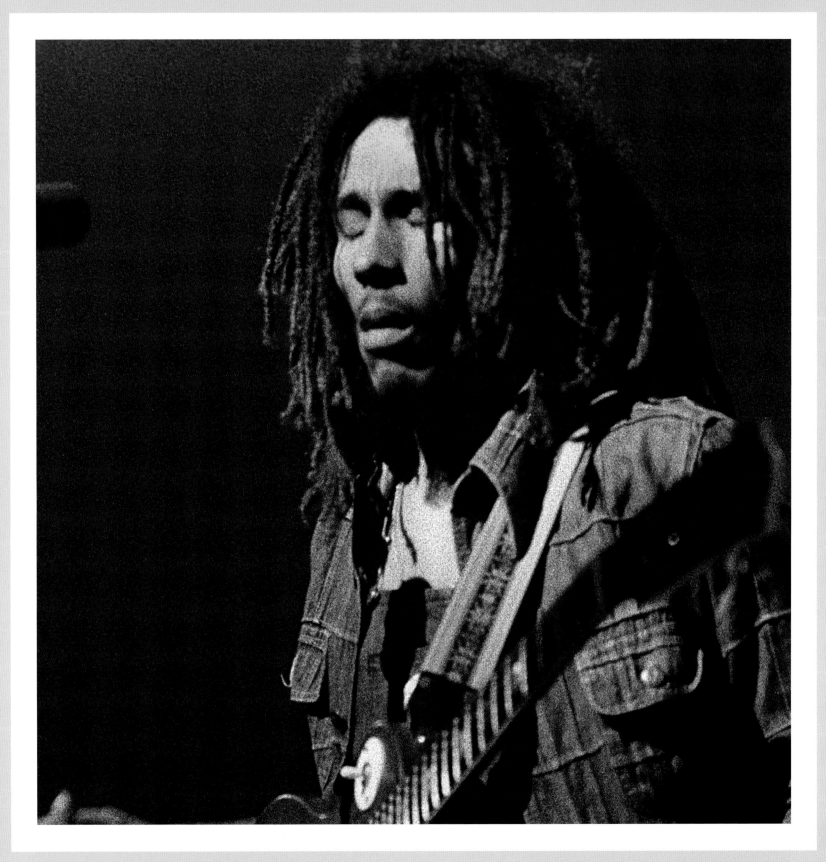

Rastaman goes to Europe and Scandinavia

Right: Bob is interviewed while on a canal trip in
Amsterdam, where the band played Jaap Edenhall on
13 June. The European leg of the Rastaman Vibration
tour kicked off on 6 June with the Sunrise Festival in
Offenburg, Germany – Bob's first ever performance in
continental Europe – and was followed by two more
concerts in Germany then three dates in Sweden,
Netherlands and France.

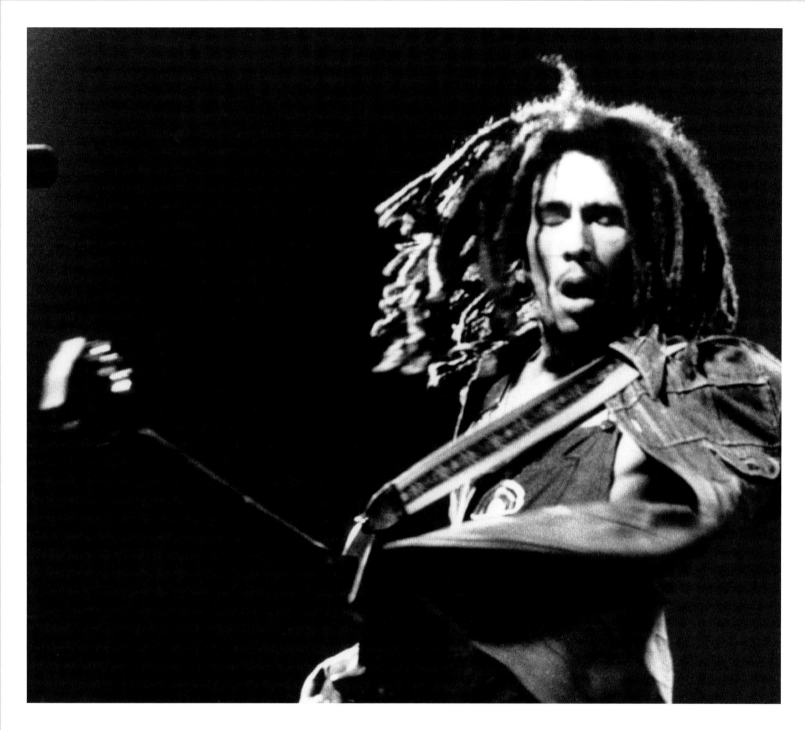

Smokin' Amsterdam

Above and opposite: Bob live on stage at Edenhall, Amsterdam; Bob's connection with The Netherlands was natural and long-lasting: the liberalization of cannabis use by the Dutch authorities guaranteed a good audience for the reggae star and his debut concert in the country at the Edenhall stadium – a regular venue for rock performances – was greeted enthusiastically.

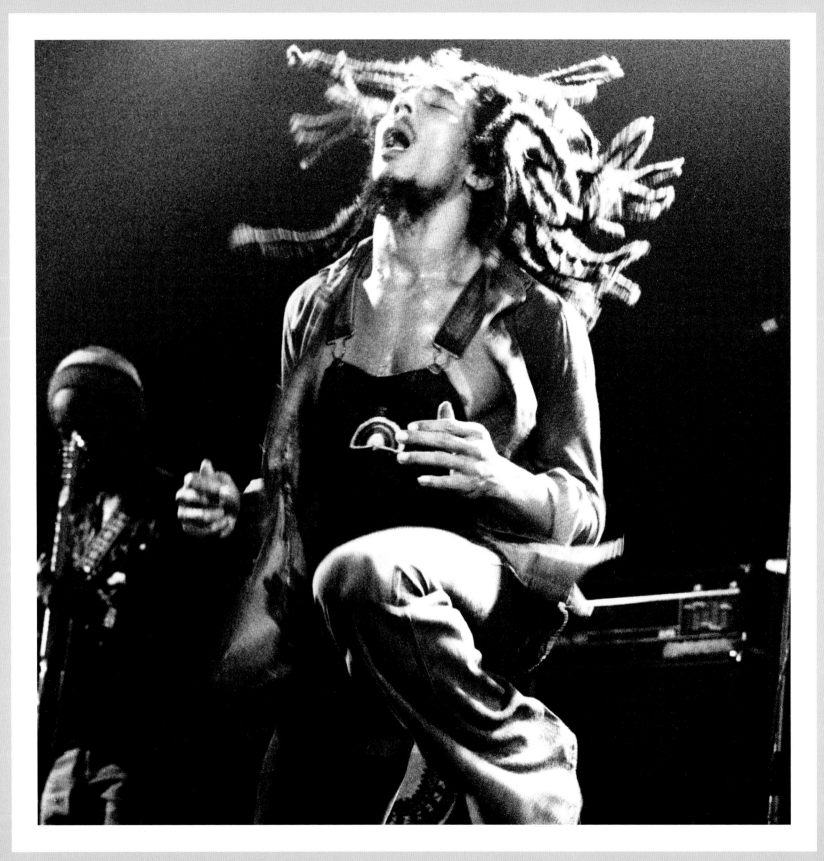

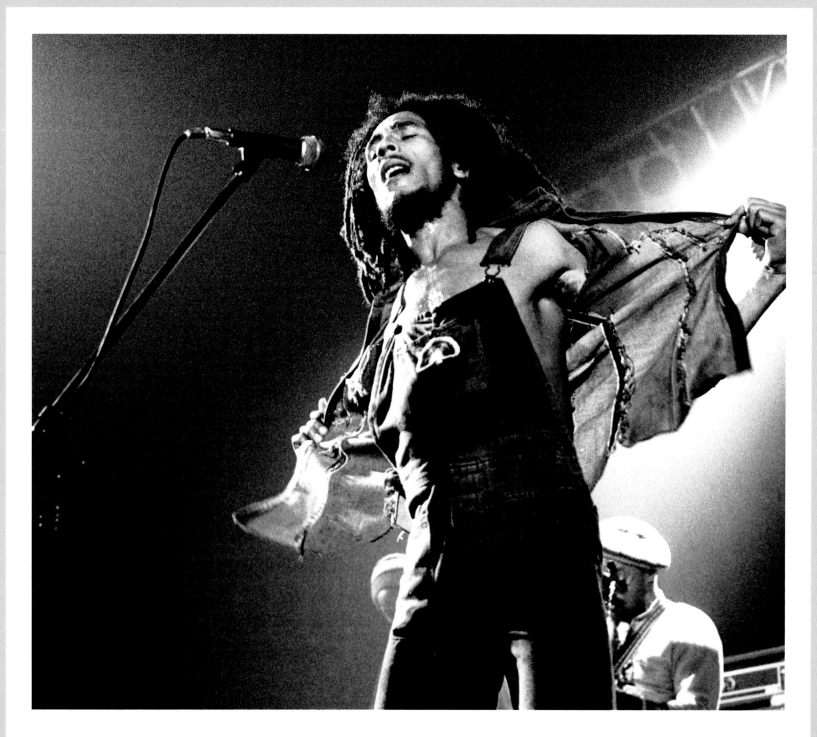

Cool in Germany

Above and opposite: Bob is transported during the Edenhall concert. Despite the warm reception in The Netherlands, not all the audiences were so enthusiastic: at one gig in Germany The Wailers followed Jethro Tull on stage only to find that half the audience had gone home.

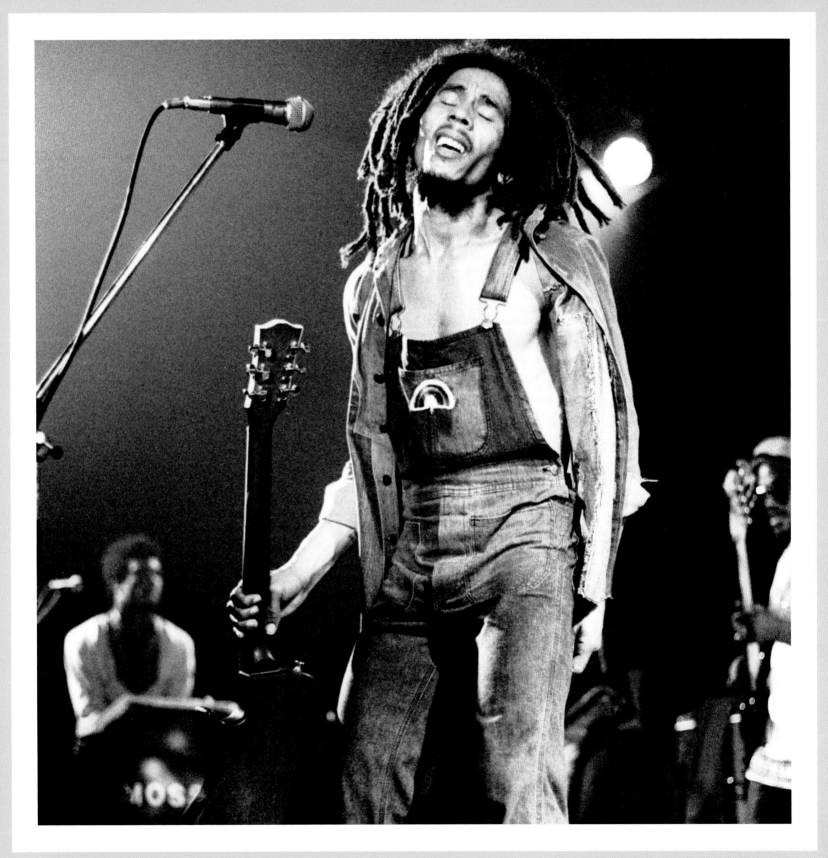

Four nights at Hammersmith Odeon

Right: Bob relaxes during the Rastaman Vibration tour. The tour moved from Paris to the UK, opening on 15 June with four sold-out dates at the Hammersmith Odeon. Frustrated by his inability to meet ticket demand on the previous tour, organizer Mick Cater had booked four consecutive dates from 15–18 June – a total of six shows – at one of London's biggest concert venues. Remembering the chaos surrounding the Lyceum gigs the year before, Cater warned the Odeon's management to lay on extra security when the tickets went on sale and during the shows. His advice was ignored and even though there were plenty of tickets available the houses were unruly, with the audience refusing to sit in their allocated seats. However, most of the trouble at Hammersmith was not to do with the behaviour of the crowd but was straightforward crime – pickpockets worked the crowd stealing wallets and handbags while fraudsters relieved some audience members of their tickets before they entered the venue.

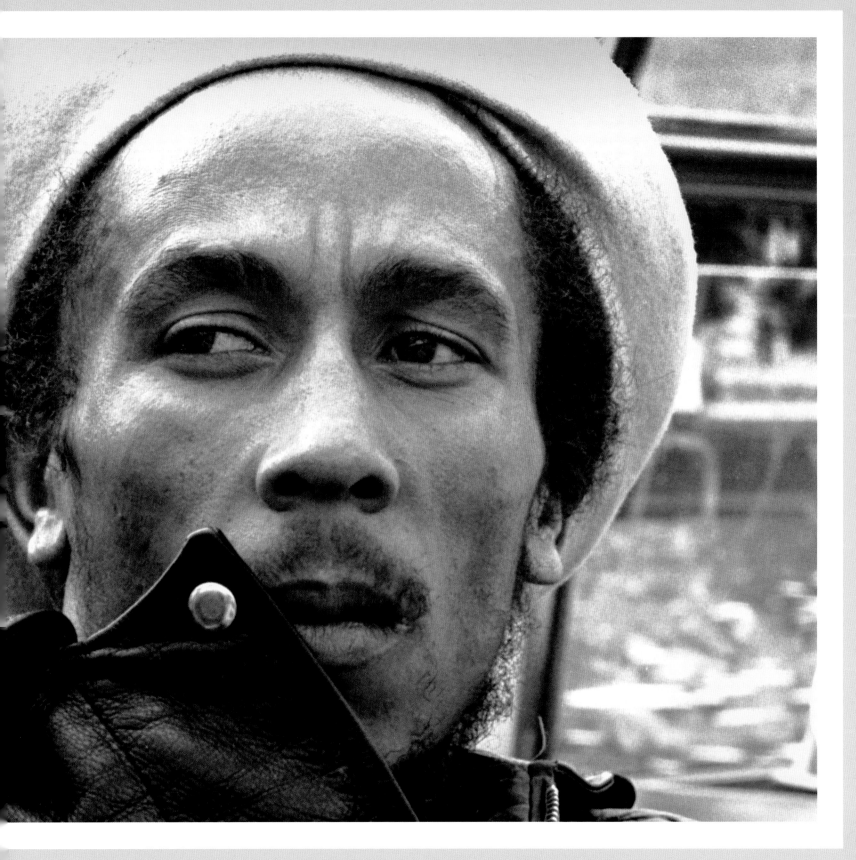

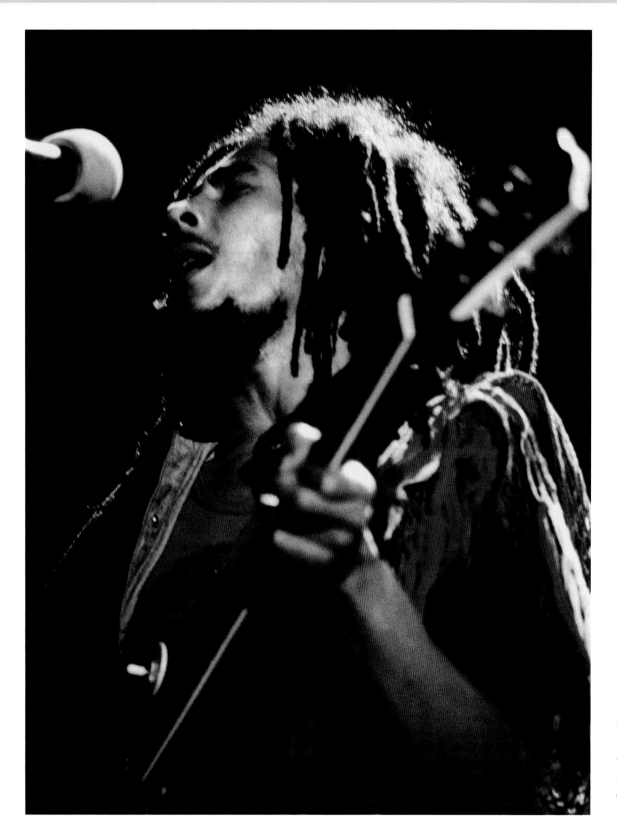

London Dreads

Opposite and right: Like the Lyceum concerts before them, the Hammersmith shows were a sell-out success and would become a legend in the reggae community. No doubt Bob Marley provided a figurehead for discontented young blacks at this unsettling time and his rising authority and presence in the UK brought new converts to the Rastafari movement.

After the six Hammersmith Odeon shows there followed another eight gigs across the country, the tour ending in Manchester at the end of June.

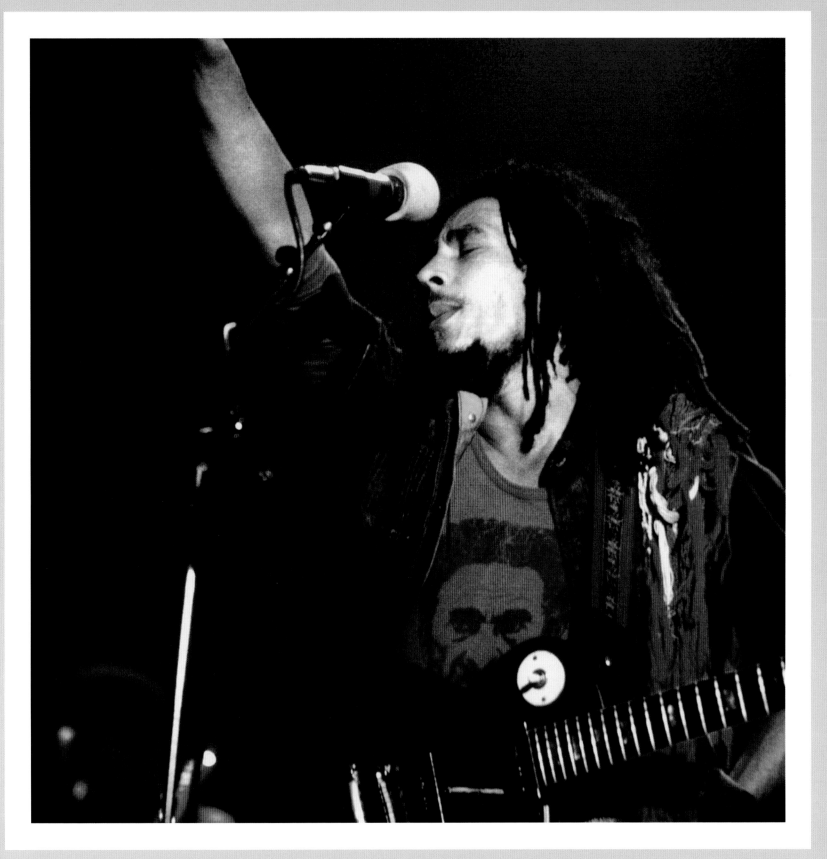

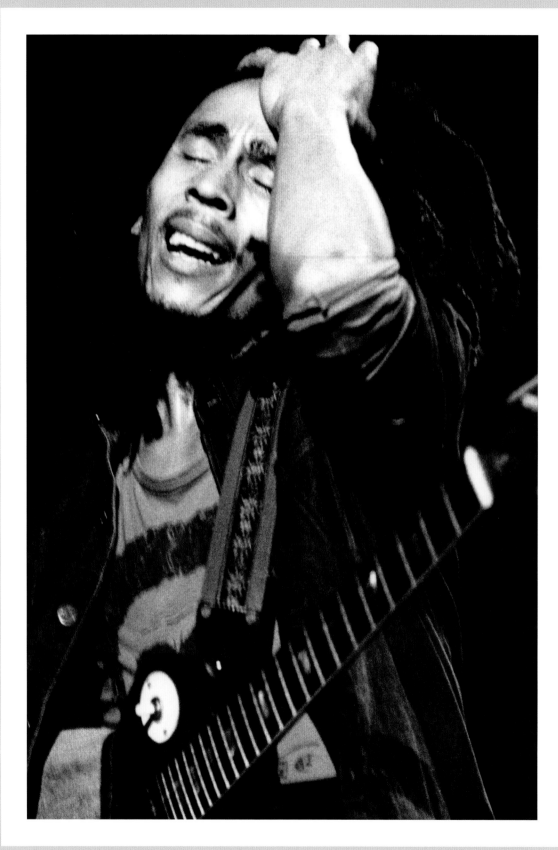

State of Emergency

Left: Onstage at Hammersmith Odeon. While Marley was still on tour in the UK, on 19 June a state of emergency was declared by the Governor-General of Jamaica; Bob returned to his island home when the Rastaman Vibration tour ended to find political and social chaos with the ruling Manley government (PNP) claiming the CIA are supporting the opposition party, JLP, headed by Edward Seaga. In October Manley sent his musclemen to "request" Marley and The Wailers to stage a concert titled Smile Jamaica in early December – although there were potentially sensitive political implications, Bob was assured the event would be non-political.

As 5 December drew near, the venue was fixed at the National Heroes Circle. The tense political situation caused stress among the band members. A troop of PNP vigilantes descended on 56 Hope Road to guard the neighbourhood, armed with automatic rifles. Marcia Griffiths was unable to stand it any longer and left for the safety of America.

Opposite: Another of Bob's characteristic expressions. His earnest looks and tone won him the patience of the many who interviewed him yet found his strong Jamaican accent and patois virtually impossible to understand. Here a typical look of enquiry and consideration is spread over his features.

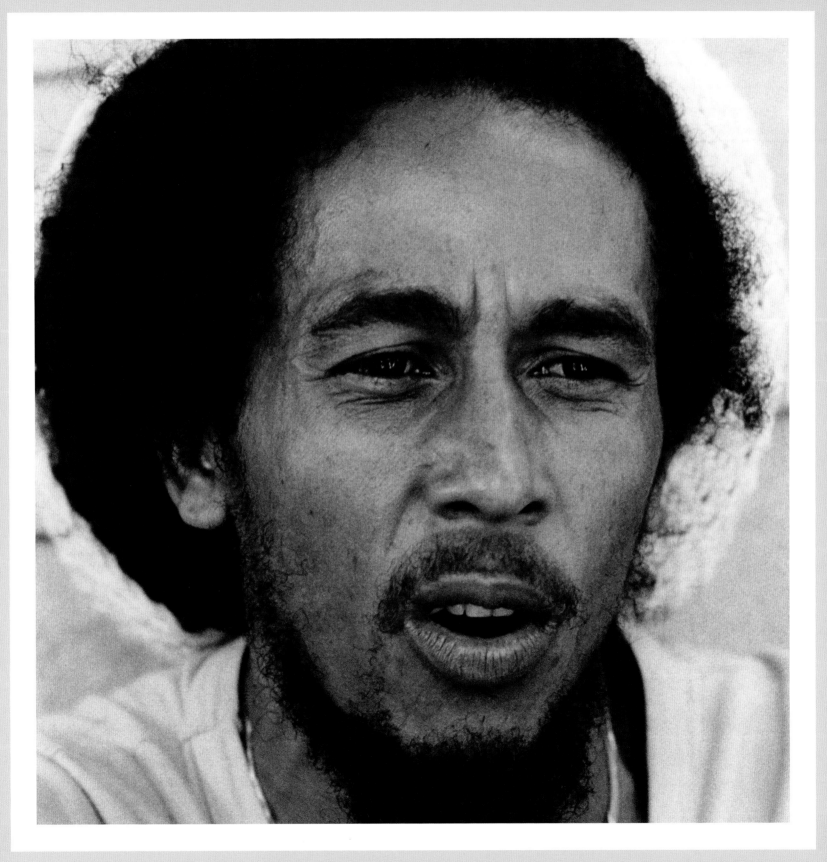

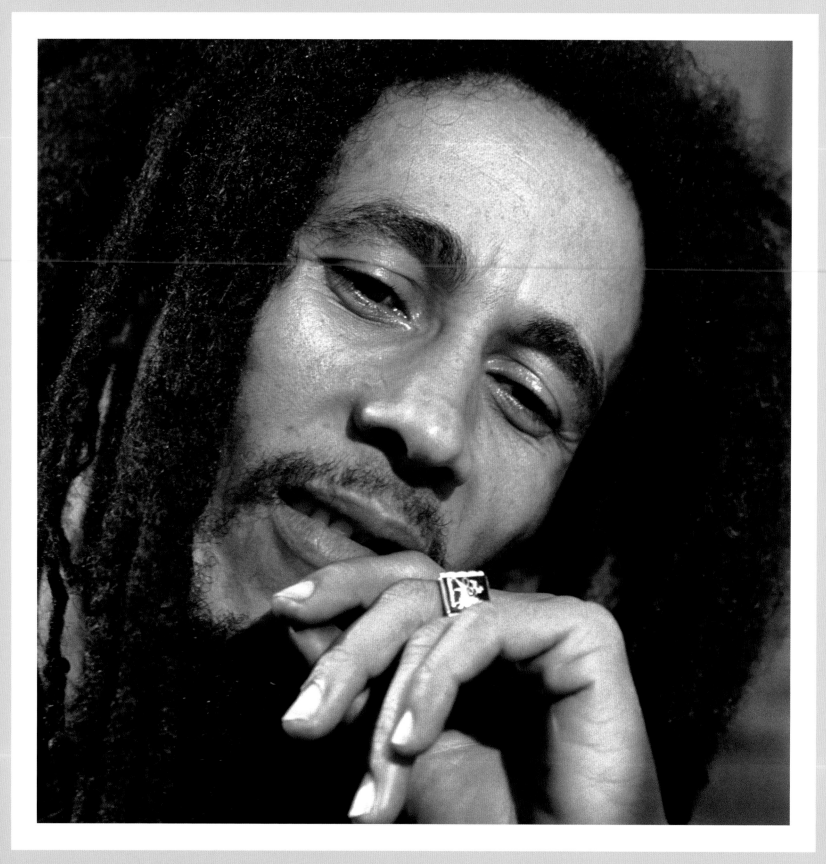

Hope Road shooting

Right: The Friday before the Smile Jamaica concert was due to take place, a gang of heavily armed gunmen entered the Hope Road property. Bob was the target but the shooting was indiscriminate and although he was wounded in the chest and arm, Don Taylor suffered the most serious injury, taking several bullets to his legs and lower abdomen. In fact he screened Marley from more serious wounds. Rita took a shot to her head but the bullet just skimmed her skull, lodging under her scalp. Bob received emergency treatment then was whisked away by the PNP to a mountain retreat. Here he is pictured outside the x-ray department of Kingston's University Hospital waiting for treatment.

After much discussion, Bob insisted that his performance should go ahead and he was greeted with a roar of applause from 80,000 people when he performed a 90-minute set, after first displaying his wounds to the crowd. Rita also performed, still wearing her hospital gown. The uncertainty leading up to the concert, the shooting and subsequent landslide victory by Manley in the elections on 16 December prompted Bob to leave the island after the concert, taking refuge for a month in Blackwell's Compass Point Studios in Nassau, Bahamas, where he recuperated from his wounds and worked on his music.

Opposite: Bob strikes a characteristic pose, displaying the signet ring which was passed on to him by Haile Selassie's family and allegedly was worn by Ras Tafari himself.

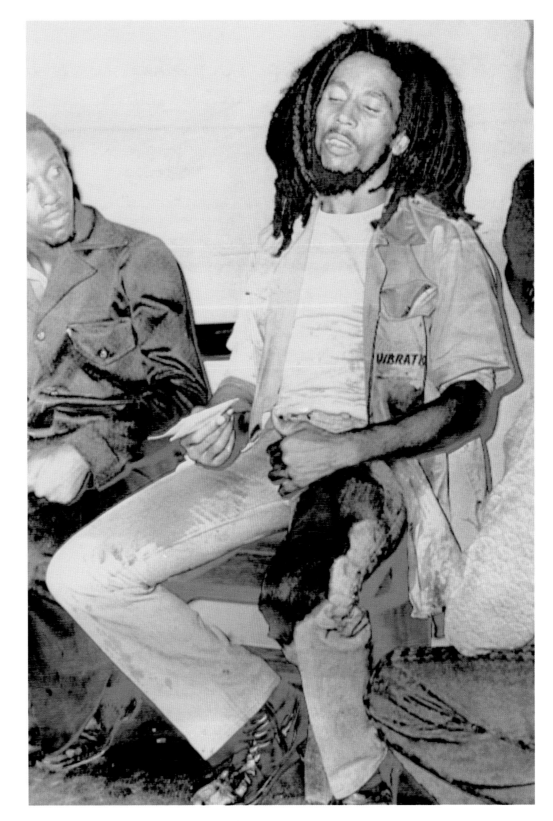

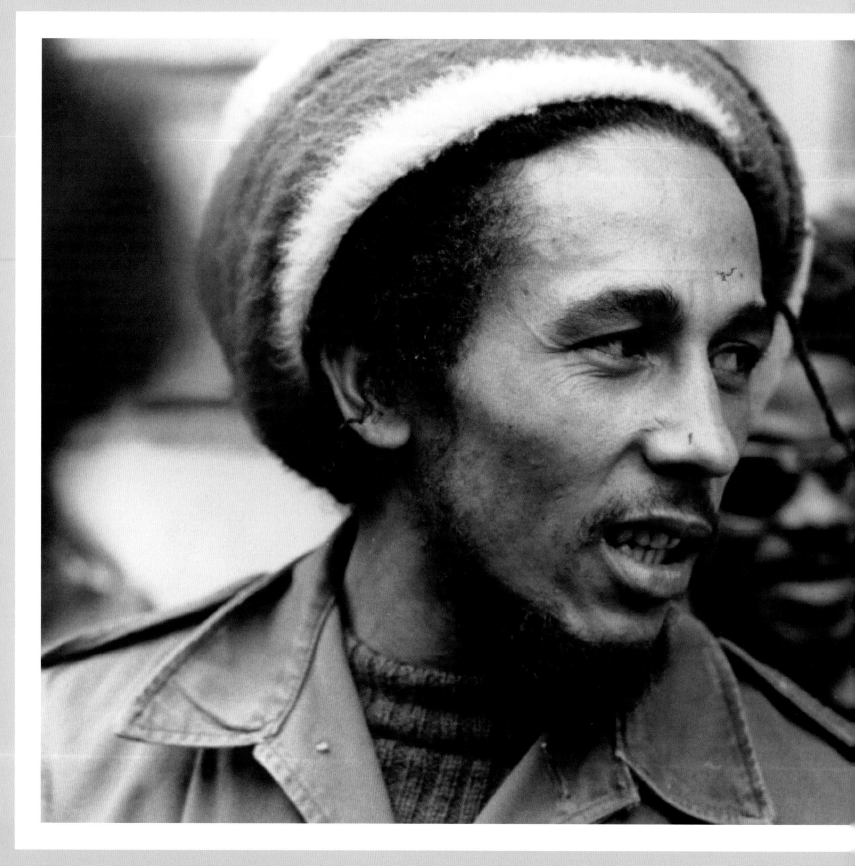

Kinsey moves on

Left: Bob and Family Man, London, April 1977. After his sojourn in Nassau, Bob took up residence as an exile in the UK where he went on to record his next two albums. In February the rest of The Wailers, including the I-Threes flew discreetly into London. There was considerable concern for Bob's safety so he and the rest of the band kept a low profile with The Wailers living in Oakley Street, Chelsea while the I-Threes were housed in Harrington Street. Bob is effectively living with Cindy Breakspeare but that doesn't stop him from continuing a sort of domestic intimacy with Rita or from showing more than passing interest in other women.

After the years of Family Man being the musical anchor, now Bob started working more closely with Tyrone Downie, the keyboards player. On the guitar side, Donald Kinsey had left the band, following Al Anderson to join Pete Tosh. Fellow Island artist Steve Winwood introduced Jamaican-born guitarist Junior Marvin to Marley. Marvin's extensive experience of the US black music scene, touring with the likes of Ike & Tina Turner, enabled him quickly to connect with Bob musically. At the same time Bob took increasing interest in the British punk movement with its anti-establishment stance and anarchic musical style.

The band initially used Island's office basement for rehearsing then moved into Basing Street studios to record at the end of February. By the end of March there was enough recorded material for the basis of an album but Bob kept working in the studio, ending up with 24 tracks laid down. Bob had already decided the title of the album would be *Exodus* but the title track was the last of the 10 songs on the album to be written. *Exodus* was released on 3 June – rushed into record shops while the band was already touring.

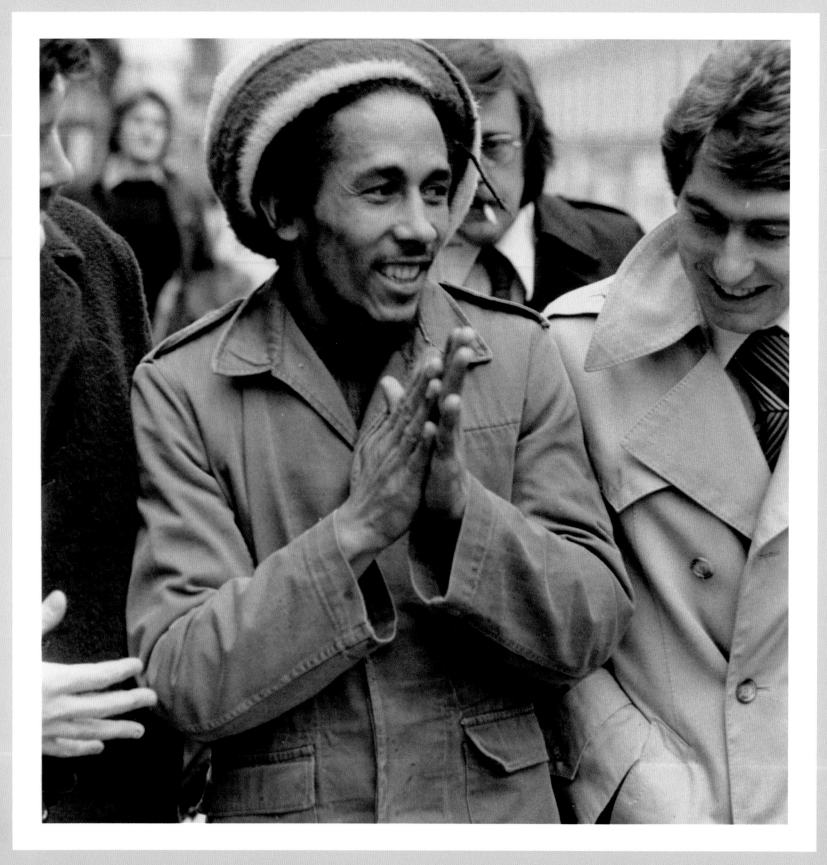

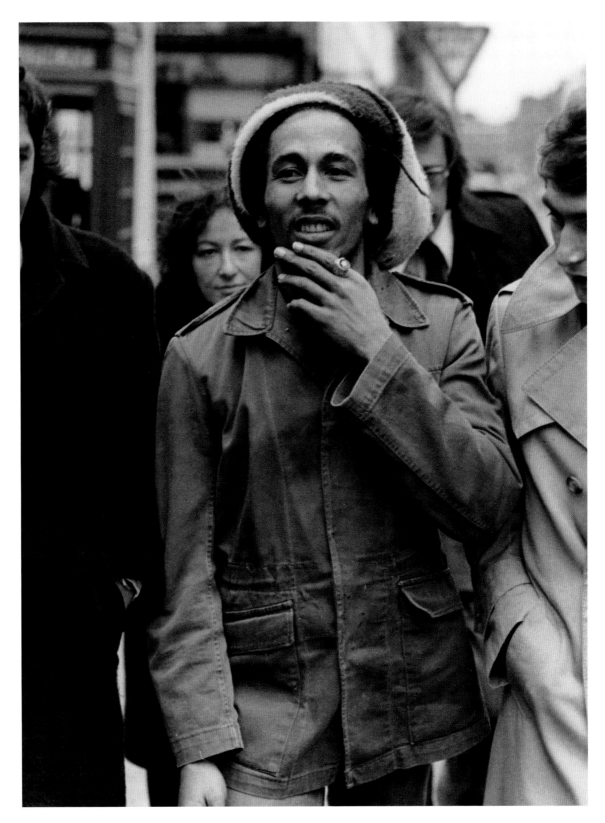

Busted

Opposite and right: Surrounded by journalists, Bob and Family Man leave Marylebone Magistrates Court on 6 April 1977 after being found guilty of possession of cannabis and receiving fines. Driving back to Oakley Street after a late night studio session in April, Bob and Family Man were pulled over by police in London and found to be in possession of cannabis. This provided good material for the media which were already enjoying the plentiful opportunities afforded by stories of Marley's relationship with Miss World.

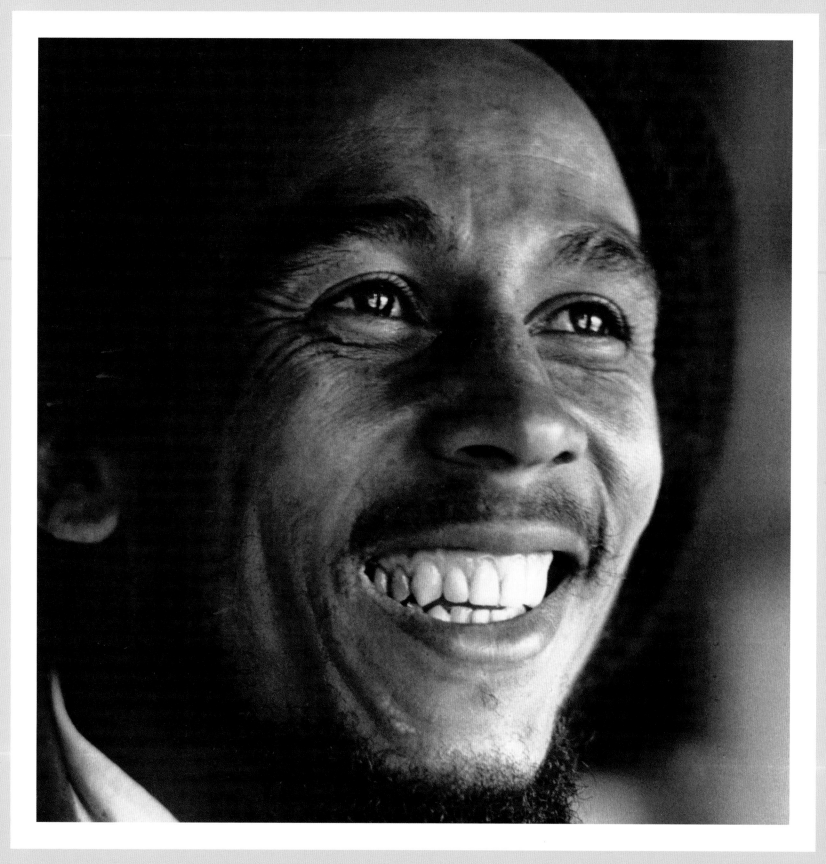

Bob and Cindy

Cindy Breakspeare had been featuring in Bob's life for some time but they had entered a more intimate relationship probably in late 1974 or early 1975 as Bob transferred his affections from Esther Anderson. In the autumn of 1976, Breakspeare, who held several local beauty queen titles in her home island of Jamaica, was invited to enter the Miss World contest. Bob funded her air fare and on 19 November she called to tell him she had won the contest. When Bob was shot before the Smile Jamaica concert she anxiously announced to the press that she had to get back to her wounded boyfriend's side. This relaxed domestic picture shows Cindy and Bob together in Kingston in spring 1980; by now she had given birth to Damian (born July 1978) fathered by Bob; the prominence of the ring displayed on her finger seems too much of a coincidence: was she trying to give a message to the world?

Opposite: Bob has many things to be happy about in 1976 but the following year would bring him tribulation, of which he was yet unaware.

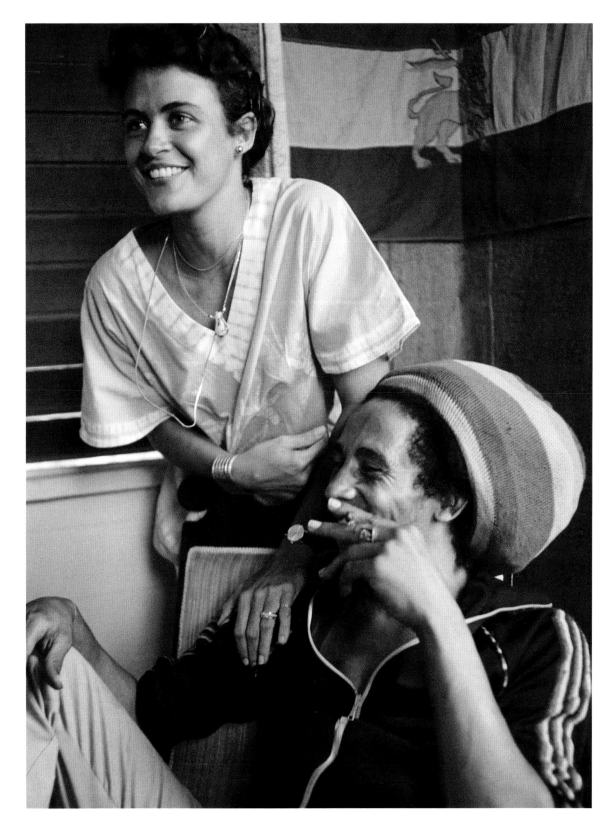

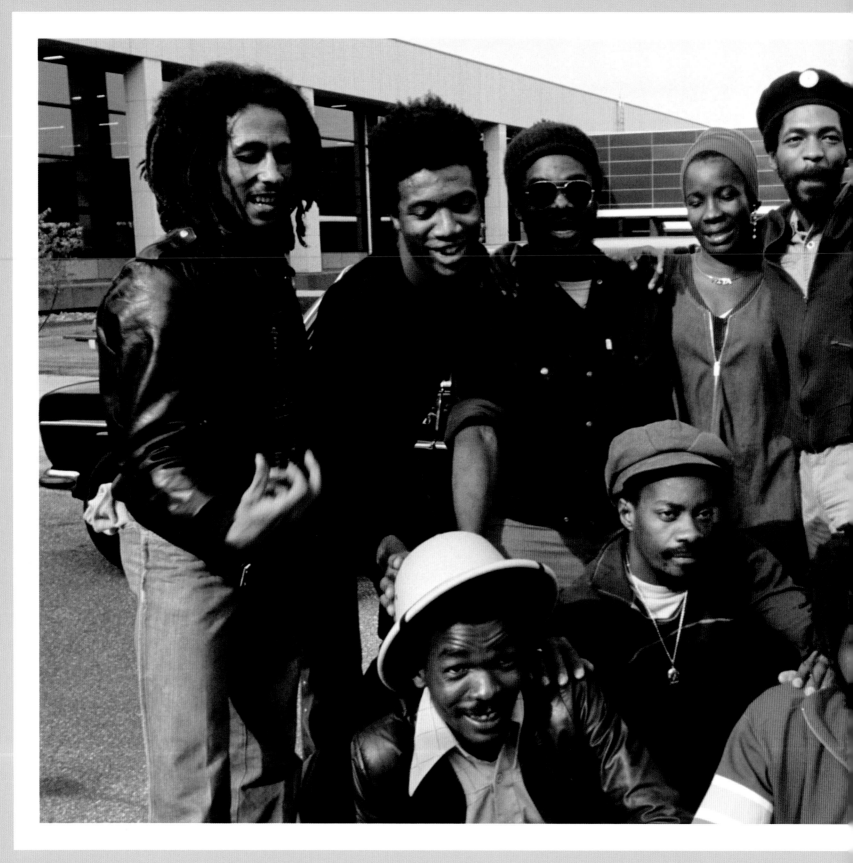

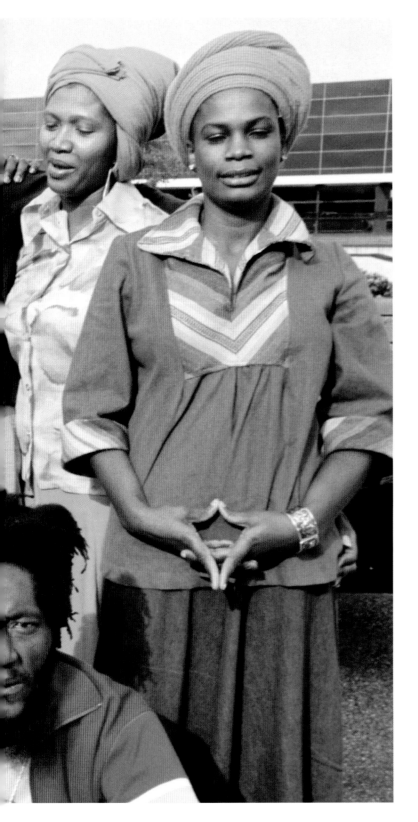

Exodus Tour

The European leg of the Exodus tour started off in Paris with a concert in the Pavillion Baltard on 10 May but the tour would be cut short by a severe injury that occurred the day before the first concert when Bob was engaged in a friendly soccer match with French journalists, one of whom stamped painfully on Bob's big toe, badly damaging the nail on the foot that had already seen much previous injury. The attending French doctor removed the damaged nail and instructed Bob to stay off that foot. His response was to sport a big bandage on his toe and to continue playing football in sandals, despite considerable discomfort.

Left: Bob with The Wailers' line-up for the Exodus tour. In addition to Carlton and Aston Barrett and the I-Threes, Tyrone Downie (front centre) was on keyboards, Junior Marvin (next to Bob) played lead guitar and Seeco Patterson (front right) was on percussion. Joe Higgs (rear third from right) joins them in this photograph.

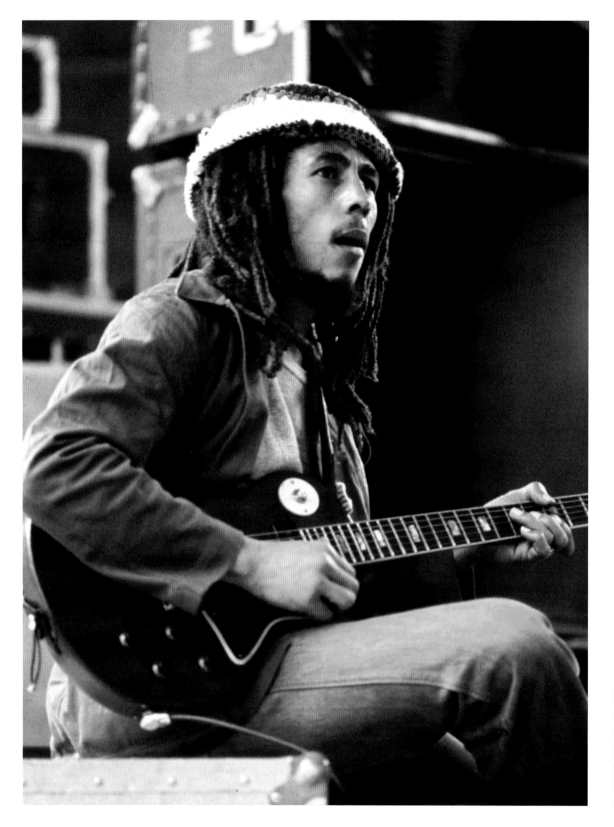

Belgium debut

Left and opposite: Bob warms up during a sound check at the second venue of the Exodus tour – the Forest National in Brussels, Bob's debut concert in Belgium.

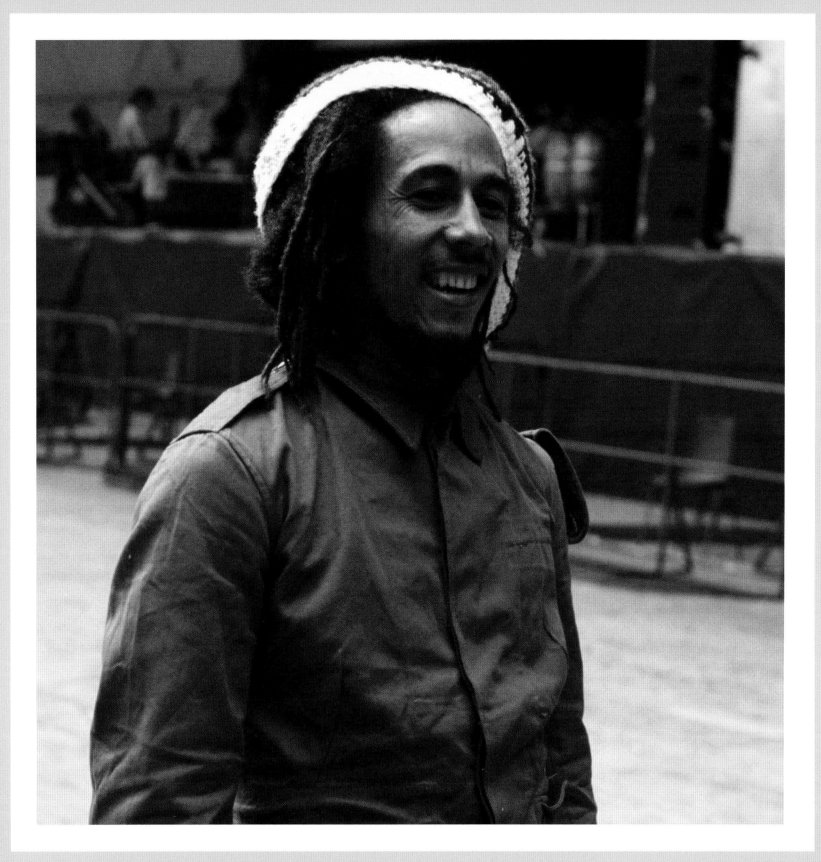

Relaxing with a football

Left: Two days after his big toe has been severely injured Bob enjoys a knockabout game during the sound check at Forest National, Brussels on 11 May. Wearing sandals to accommodate the bandage on his right foot, Bob plays on regardless. In the red sweatshirt is Antonio 'Gilly Dread' Gilbert, road manager for the tour, a good cook and longstanding member of Bob's entourage after they became acquainted in 1969. Like Skill Cole he got close to Bob through football; Gilly used to play for Jamaica's national team.

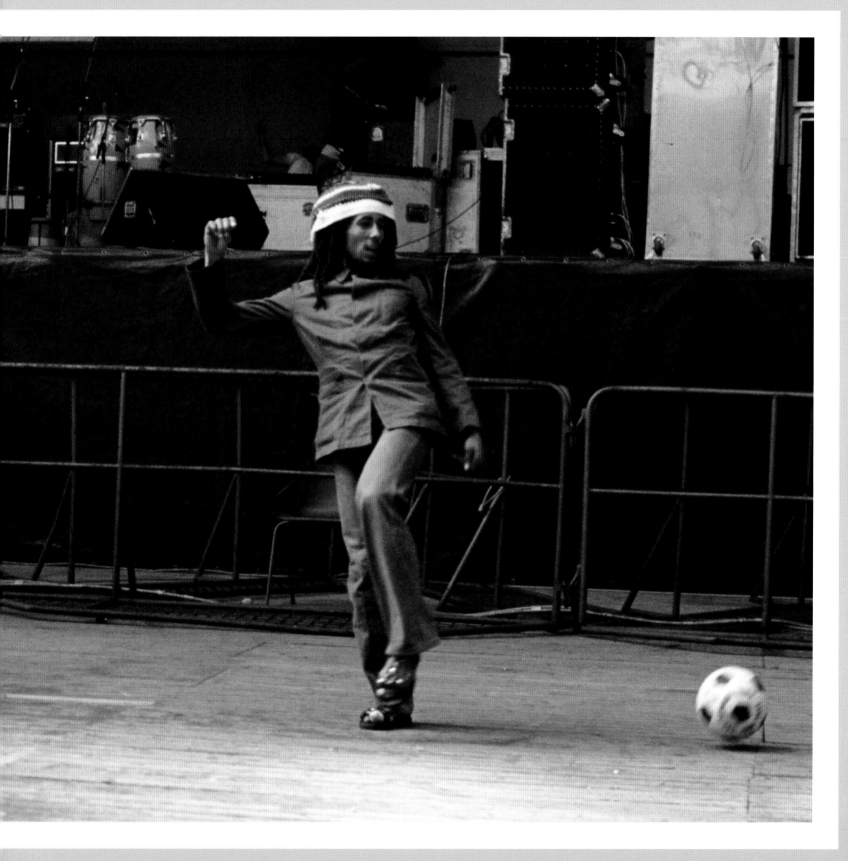

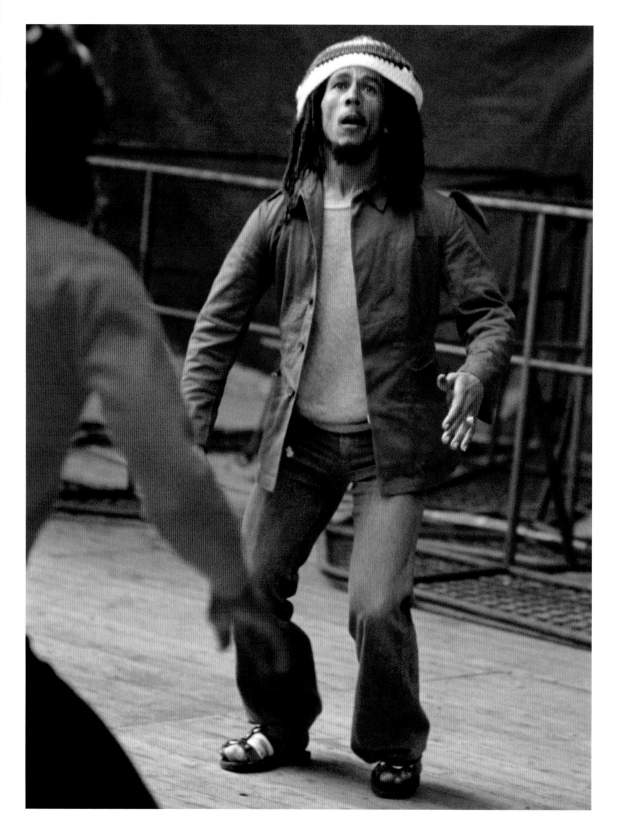

Lively Up Yourself

Left: An even clearer view of Bob's bandaged big toe as he prepares to head the ball.

Opposite: From Brussels the band headed on to The Netherlands to play Houtrust Hallen in The Hague.

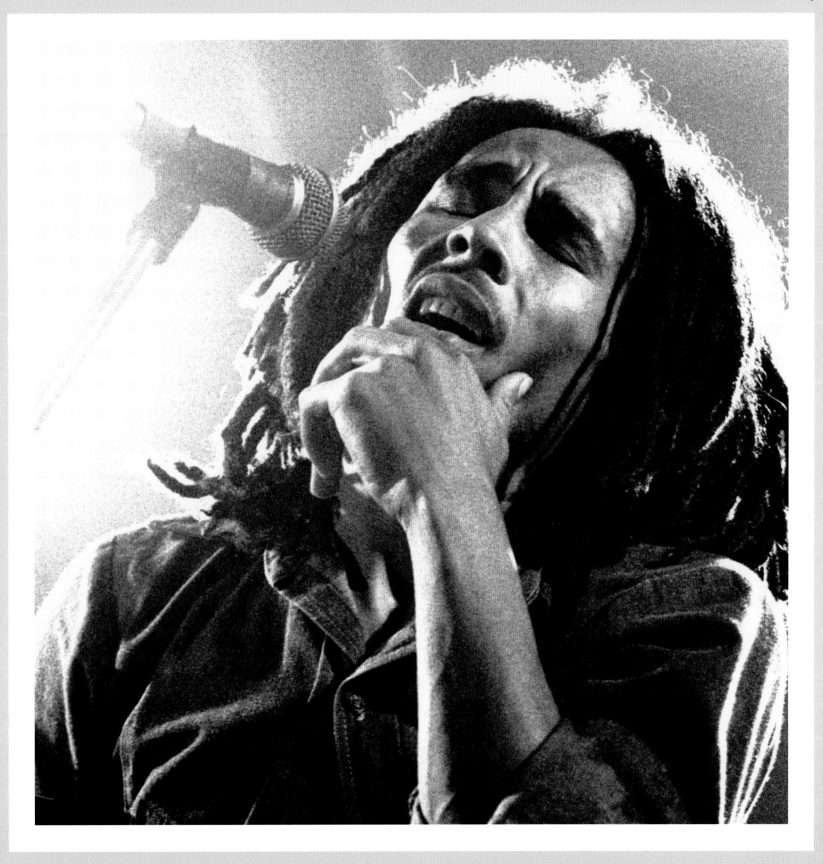

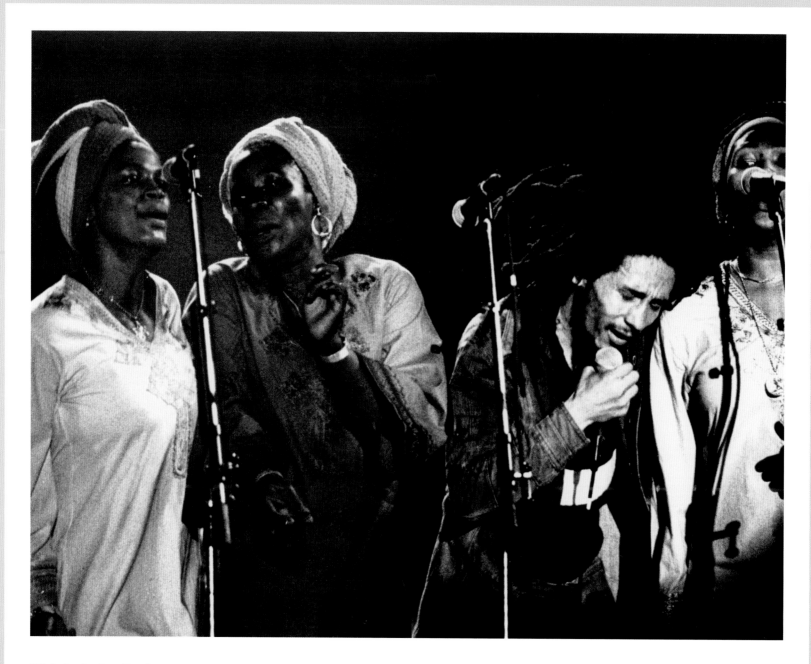

High in the Lowlands

Above: Bob mingles with the I-Threes onstage at Houtrust Hallen, The Hague, on 13 May. The Exodus tour continued with great success. Crossing the border into Germany from The Netherlands in their tour bus the band gave it a careful clean to remove traces of cannabis, leaving the windows wide open for half an hour before entering the less liberal neighbouring country. Four dates in Germany were followed by three Scandinavian gigs, two in Sweden, the other the band's Danish debut.

Opposite: Bob and the band take a break in studio rehearsals. A great view of his favourite performance guitar– a lightweight Gibson Les Paul Special, with a beautiful cherry finish on natural mahogany. Bob modified it by removing the original wraparound tailpiece and inserting dowels in the fill holes, substituting a stop bar tailpiece. The guitar also bore his trademark white binding on the headstock and fingerboard – the latter with small pearl block inlays. Gibson later manufactured a limited edition replica of the guitar, the original of which is displayed in the Bob Marley Museum.

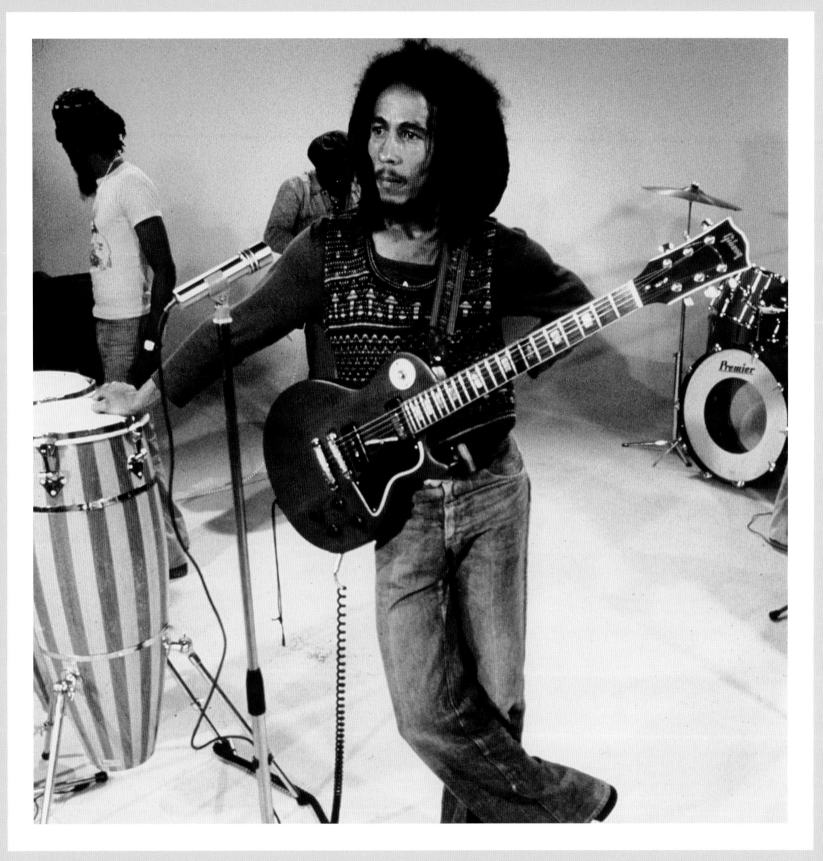

Broadcast

Right: A rare photograph of Bob and The Wailers performing under well-lit studio conditions during the European leg of the Exodus tour, summer 1977.

Back in the UK on 9 June the band performed "Exodus" on BBC TV's *Top of the Pops*; sharing the studio bill in that broadcast were Osibisa, Rod Stewart and The Stranglers.

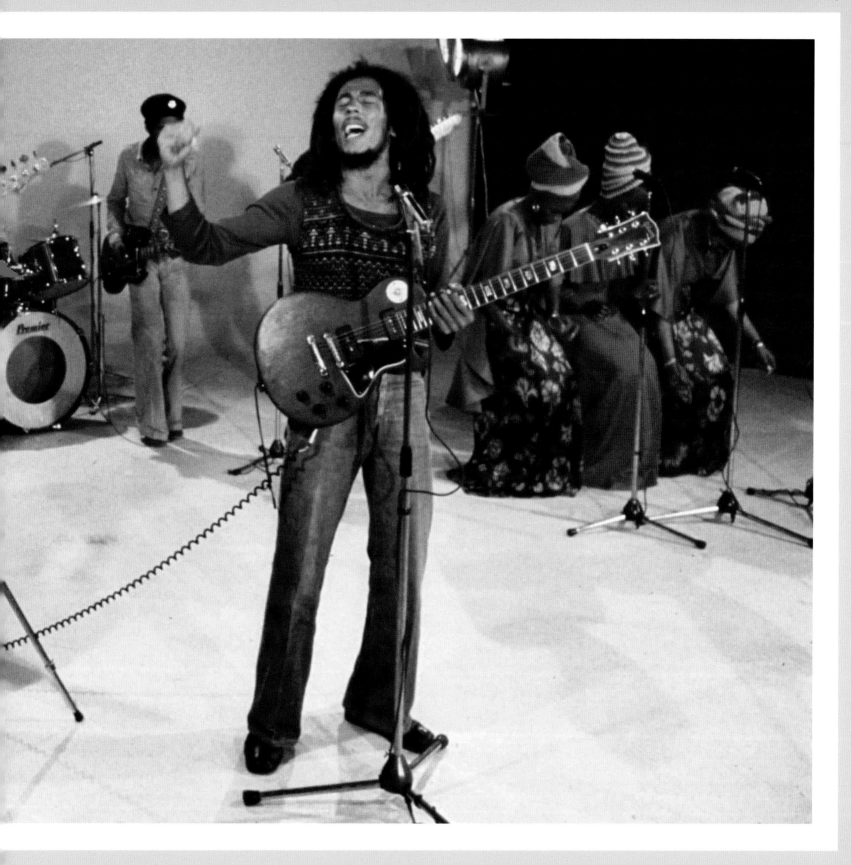

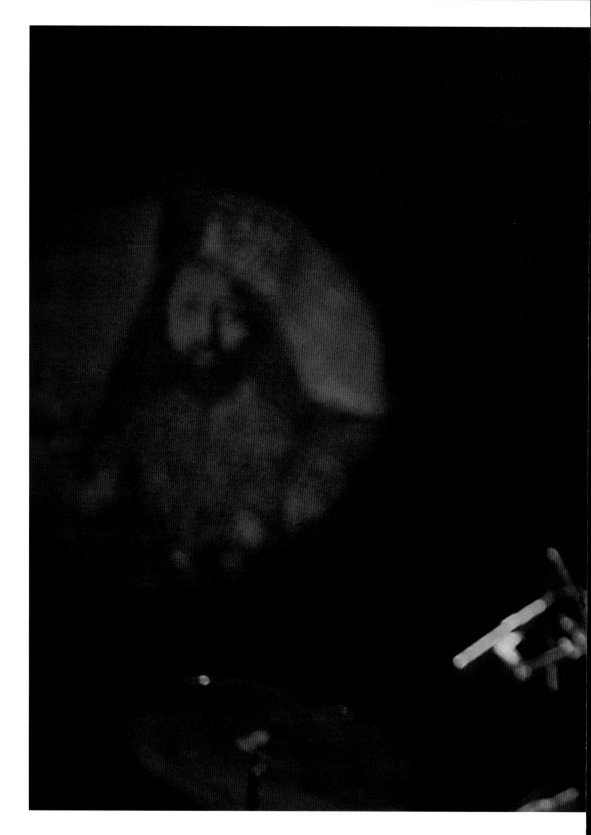

Rainbow high

By any standard the Exodus tour had been a great success yet clouded by the cancellation of the US tour which might well have transformed Bob's popularity in North America. The album sold well and in 1999 would be nominated by *Time* magazine as the greatest rock album of the 20th century.

Right: Probably the high point of the Exodus tour was the run of four nights at the Rainbow Theatre in North London, 1-4 June. The last performance was recorded and released in audio and video formats as *Bob Marley and The Wailers Live at the Rainbow*.

The Rainbow was the only large venue that would host The Wailers after the chaos of Hammersmith Odeon the previous year.

The summer of 1977 was a strange background to Marley's tour: still hanging over him was the threat of assassination and, musically, London was giving it up for punk and in June, Queen Elizabeth's Silver Jubilee celebrations.

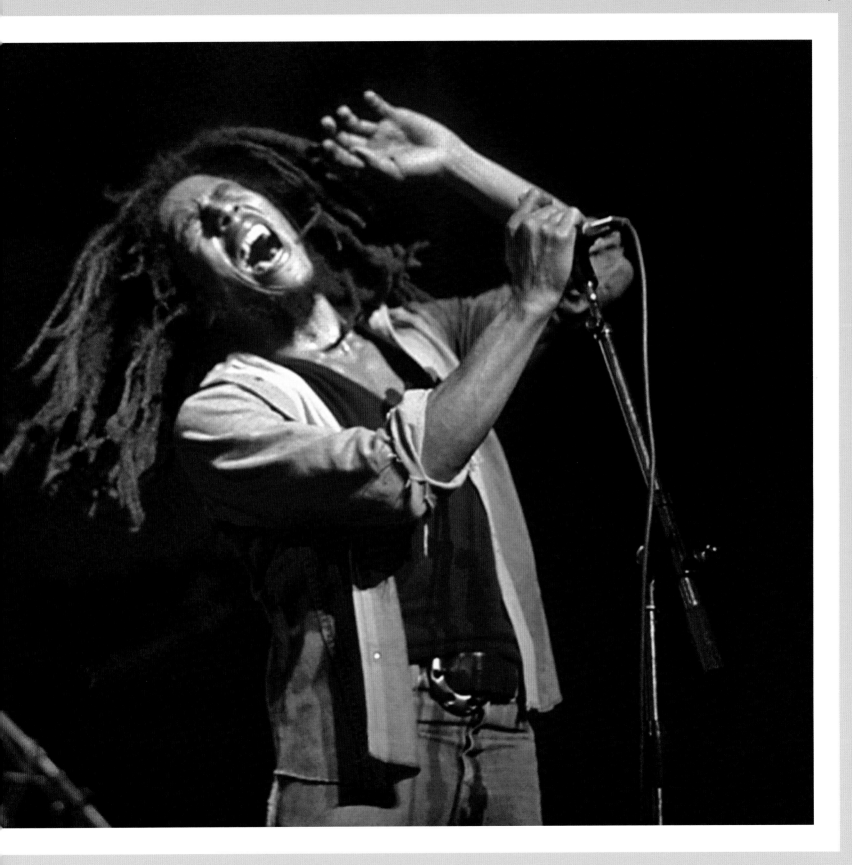

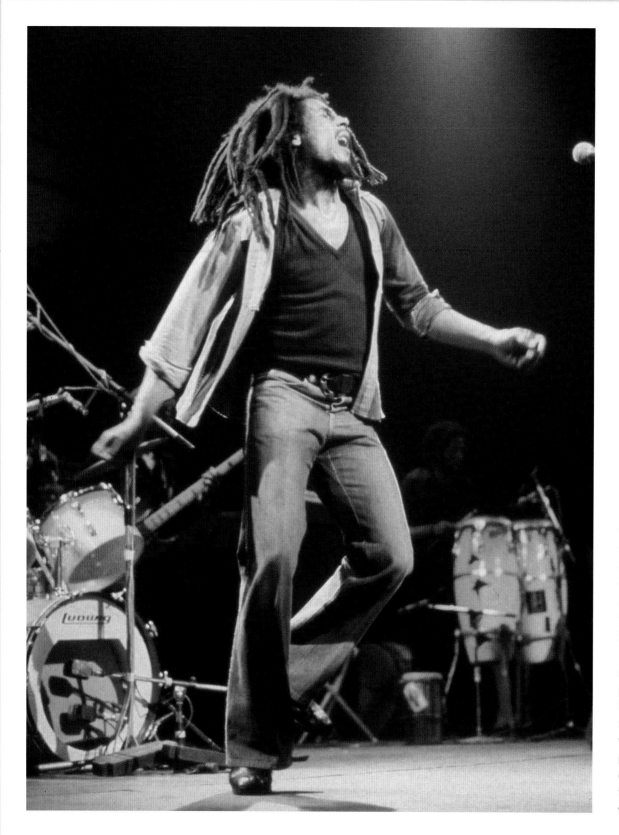

Blanks fired

Left: Bob onstage at the Rainbow Theatre and (opposite) with the I-Threes. Security was tight at the Rainbow – metal detectors were installed in case gunmen made another assassination attempt. Despite this on the second evening a burly black man tried to follow Bob into the venue as he arrived. When challenged he pulled a gun and fired it though it turned out the gun was a starter pistol firing blanks. This was discovered later when the gun was picked up by the metal detectors when the man passed through the ticket barrier on his way into the performance.

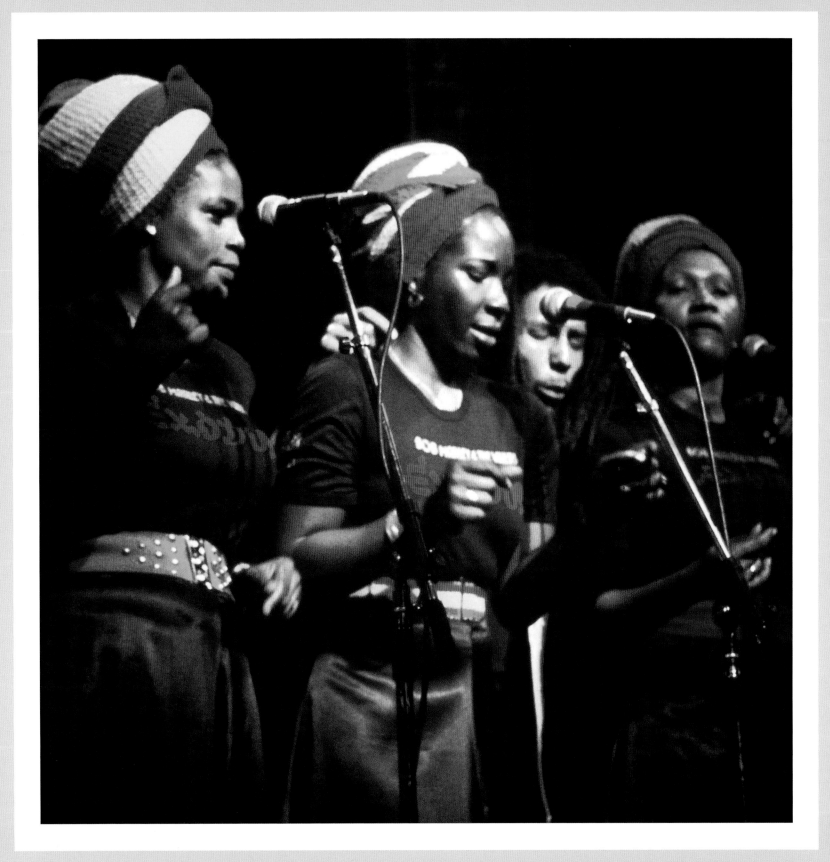

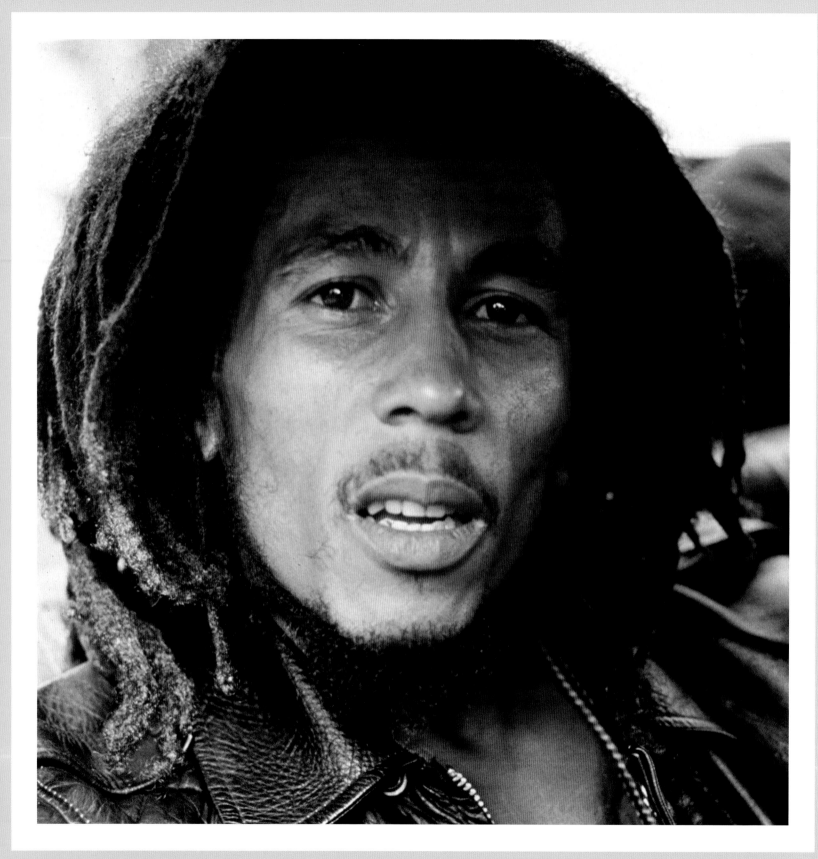

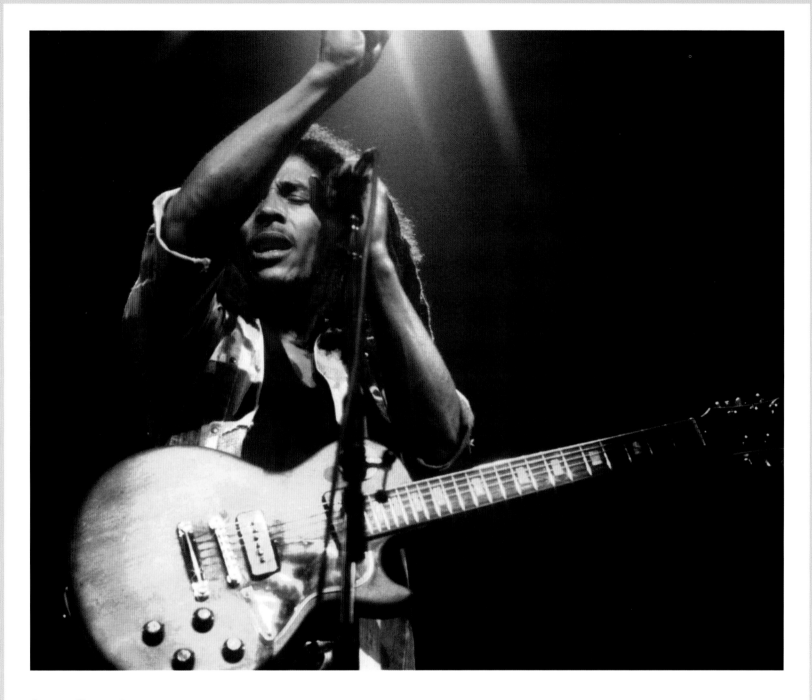

Cancer diagnosis

Opposite: A look of anxiety tinged with suffering. As Bob's toe failed to heal, he consulted a Harley Street doctor and eventually received his diagnosis – the toe had developed acral lentiginous melanoma, a malignant cancer which would prove incurable after Marley declined to have the cancerous tissue fully removed. Partial surgery gave temporary relief but in the meantime two of the London gigs had to be cancelled and the entire US leg was postponed. In August 1977, at the Cedars of Lebanon hospital in Miami, Marley had further surgery on his toe to remove the rest of the cancerous tissue followed by a skin graft to improve the healing process.

Above: Bob bathed in gold on stage at the Rainbow.

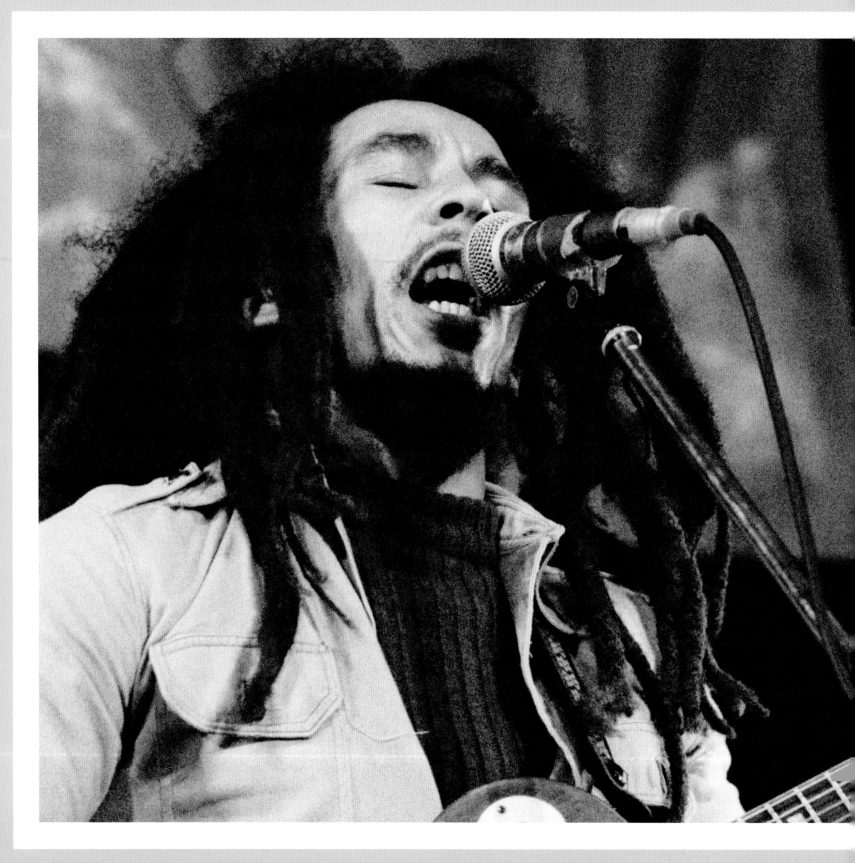

Return from exile

Bob's mother Cedella lost her husband
Edward in 1976 and Bob proposed that
she move south to Miami. In October that
year he found her a large house that would
also provide a base for Bob when in the
USA. Here he spent some five months
recuperating after the operation on his toe
in August 1977.

At the end of February 1978 Bob returned
to Kingston after a two-year absence,
greeted by thousands of fans at the
airport. Some accounts trace Bob's final
decision to return to being approached by
representatives of the PNP and JLP whilst
shooting a video promoting his single "Is
This Love", taken from the *Kaya* album due
for release in March. The video, filmed in
the Keskidee Centre in north London, was
built on Bob's mystique, portraying him as
a kindly Pied Piper and the video featured
children of all races, among them Naomi
Campbell in her early teens.

Left: Performing at Denmark's Roskilde
Festival 1 July 1978 during the Kaya tour.

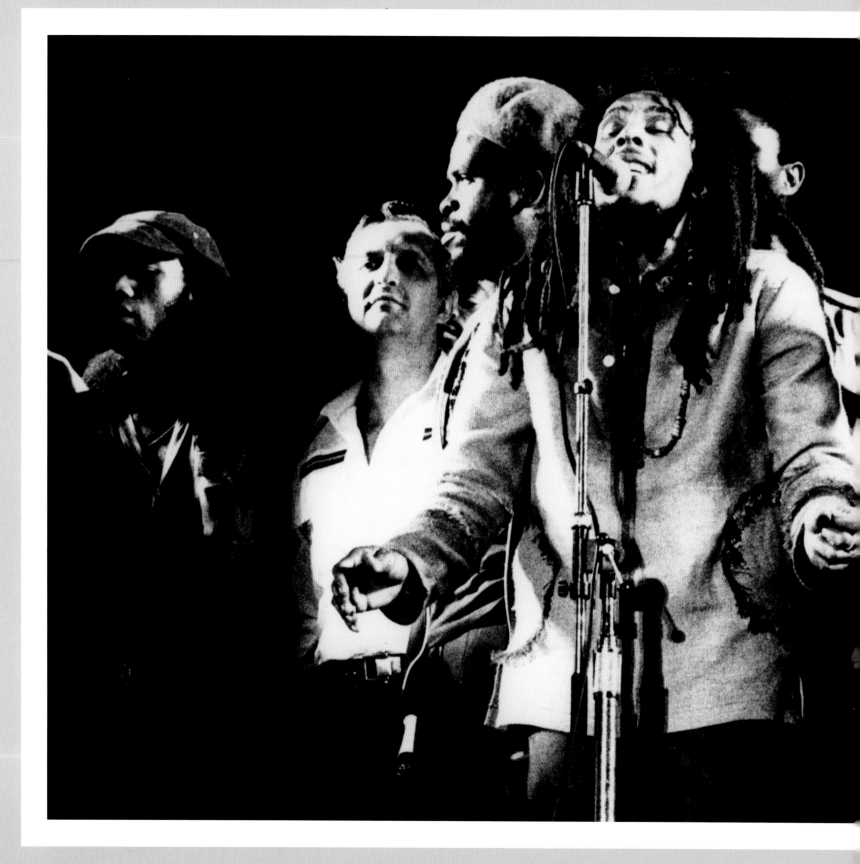

Chapter Three

One Love

Bob returned to Jamaica to perform at a concert that would seal the peace between the violent political factions tearing the country apart. The timing, in April 1978, coincidentally served well as a promotional vehicle for the new *Kaya* album which was released on 23 March. The concert was staged on 22 April, the 12th anniversary of the visit of Haile Selassie to Jamaica; it would carry the title One Love Peace Concert – an eight hour marathon featuring the best of Jamaica's musical talent and culminating with Bob's headline act.

For his set Bob abandoned his guitar to focus on the microphone; The Wailers were enhanced by a horn section and extra drums. Dressed in a red, green and gold burlap jacket with a map of Africa on the back, his performance came over as strained until he moved into "Jamming" which in turn gave way to an extemporized rap in which he called on the rival leaders, governing Prime Minister Michael Manley and his opponent Edward Seaga to come up from their VIP seats onto the stage. As Bob joined the politicians hands high in the air, while each carefully avoided the other's gaze, the band burst into the anthemic "One Love" while the enforcers and bodyguards of the leaders locked arms together on stage. Bob finally wrapped up the show, giving his best performance of the night, with his tribute to Haile Selassie, "Jah Live".

Engineering Jamaica's opposing political leaders to demonstrate their reconciliation in front of a crowd of 30,000 people in the early hours of 23 April is one of the iconic moments in Bob's short career. The One Love Peace Concert opened a new chapter in Bob's life: from being a rising international reggae star he has now become a leader of people – a man who can bring about political change; a peacemaker.

The euphoria of the One Love Peace Concert didn't halt the violence for long. Seeking peace and security Bob bought a secluded estate on a headland of Jamaica called Goldeneye. The house had formerly been owned by James Bond creator Ian Fleming who entertained many celebrities and dignitaries there. Here also Fleming had written the novel *Casino Royale*. However the seclusion of the estate house didn't suit Bob and he eventually sold it to Chris Blackwell.

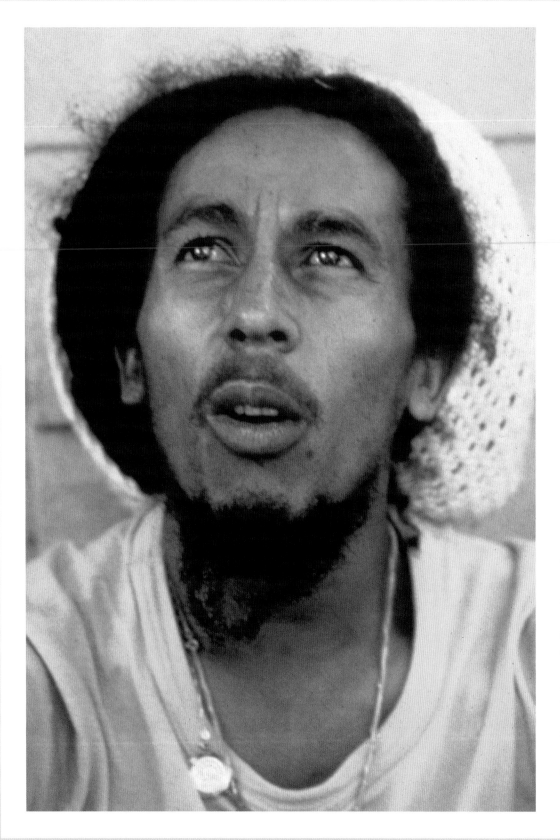

Making peace

Left: Bob gives interviews to the press the day before the One Love Peace Concert. Before the concert, 56 Hope Road became an organizational hub, housing the enforcers of the now peaceful opposing parties, attracting journalists and the attentions of the local police. The day before the concert Bob took time to talk to the press and politely asked inquisitive police to leave the premises.

Opposite: At the One Love Peace Concert Bob takes the stage well after midnight, performing to a crowd of 30,000.

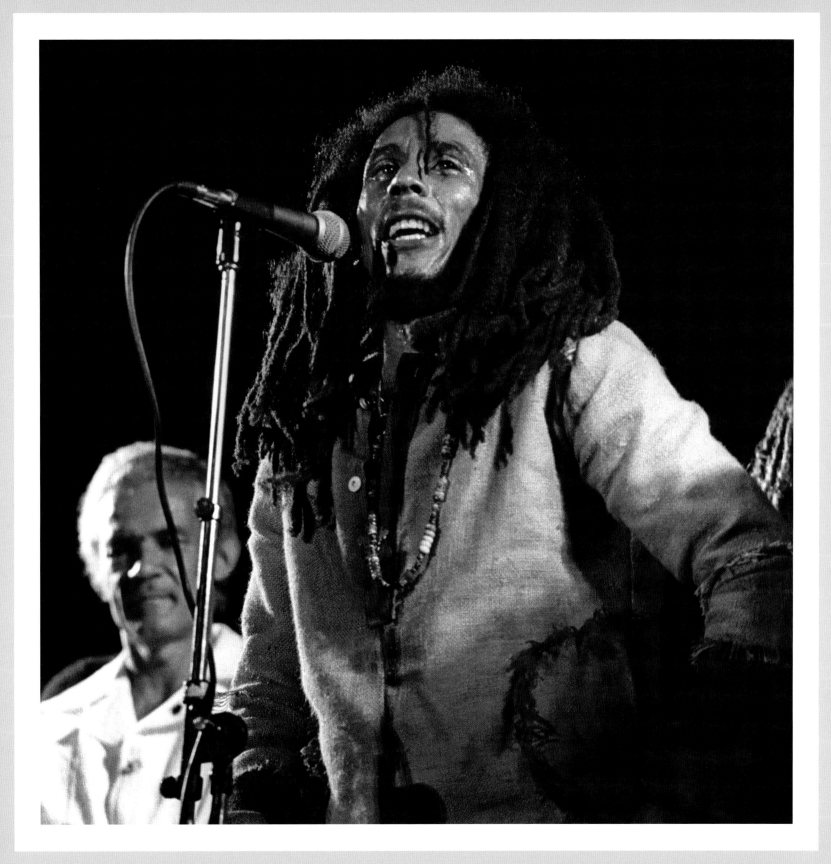

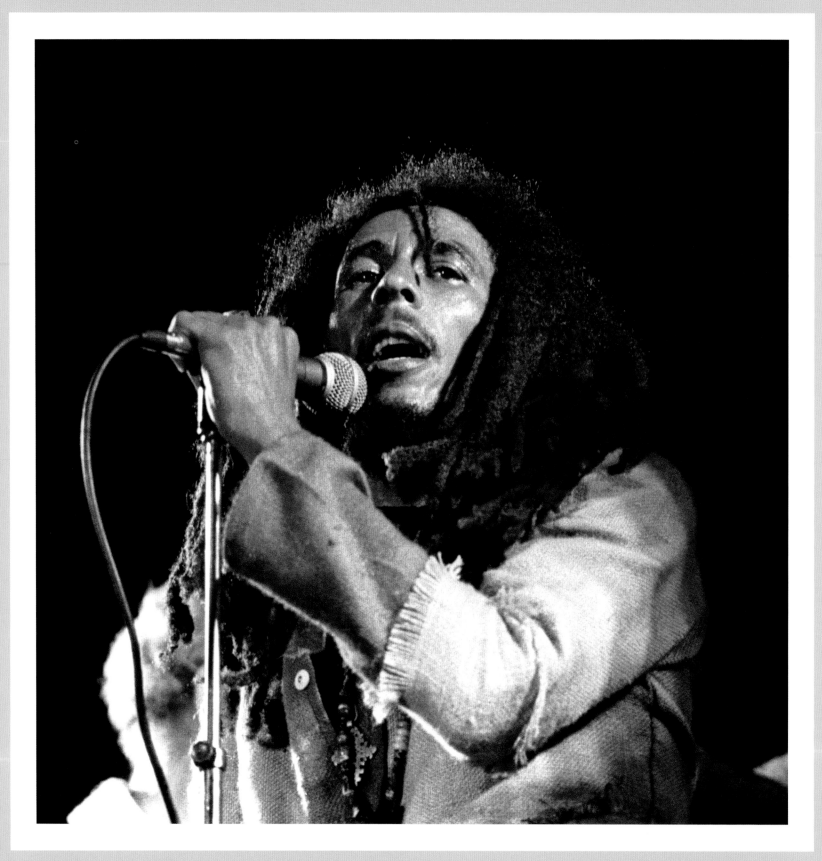

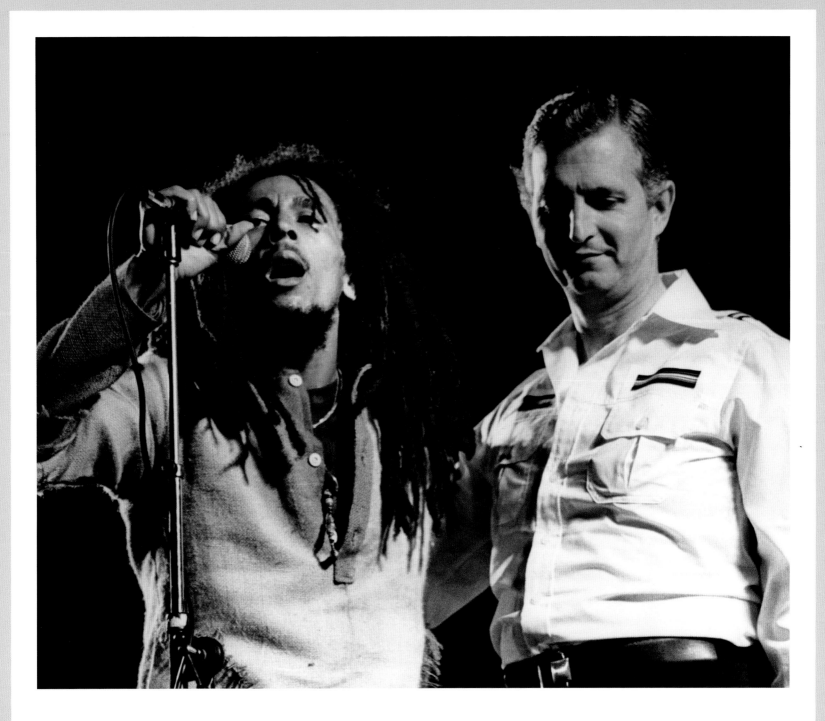

Joining hands

Opposite and above: Bob on stage during the One Love concert; Edward Seaga, leader of the opposition party (above) wears a sheepish expression shortly before joining hands with Michael Manley.

Among the other performers at the concert was Pete Tosh who, during his set, lit up an enormous spliff and then broke into his hit song "Legalise It". Tosh's aggressive stance on ganja caused him much grief at the hands (and feet) of the police but it didn't put off Mick Jagger who was in the audience. Tosh was signed to the Rolling Stones record label and went on tour with them the same year.

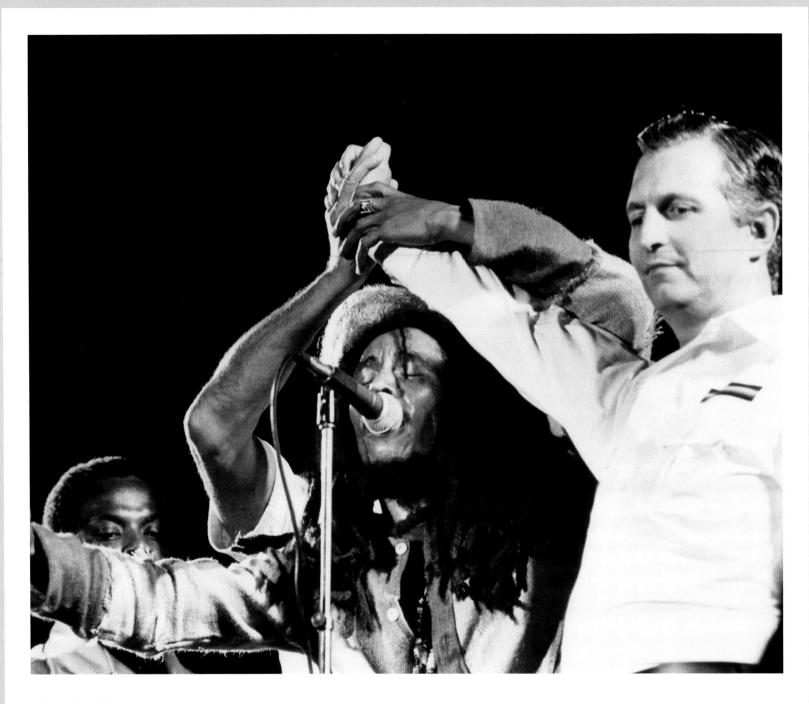

Joining hands

Above: Bob, transfixed by the moment, sings One Love as Edward Seaga (in full view) locks hands with Prime Minister Michael Manley. It's the defining moment of the One Love Peace Concert and a turning point in Marley's career.

Opposite: Bob's performance earned him international attention; during the Kaya tour later in the year he received the UN Peace Medal of the Third World at a ceremony in New York's Waldorf-Astoria on 15 June. The UN Youth Ambassador, Mohammadu Johnny Seka of Senegal owned up to feeling that he was the one being honoured as he presented the medal, repeating words that delighted Bob, "We love you in Africa".

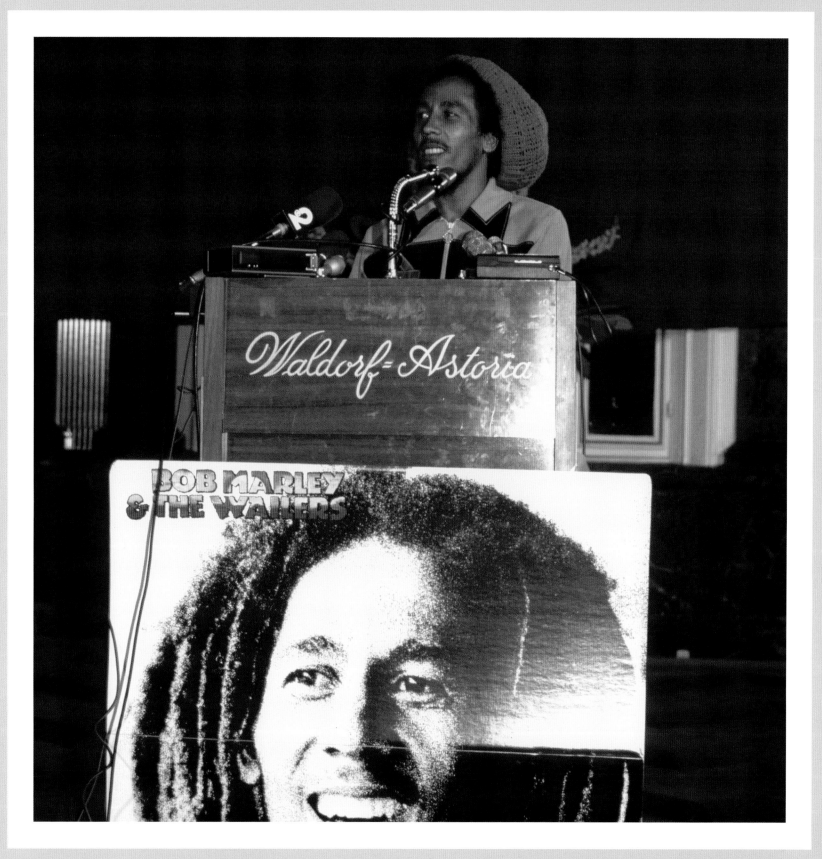

Kaya tour

The Kaya tour set out from Ann Arbor, Michigan, on 18 May. It was due to start earlier, from Miami, but early dates had to be postponed as a result of guitarist Junior Marvin's problems in getting a visa owing to a history of cocaine use. This delay further compounded the disappointment of the cancelled Exodus tour. The Wailers were developing a reputation for unreliability with their US tour promoter. The first and final legs of the Kaya tour were in North America with European dates in between. In the first leg, Bob and The Wailers played to sell-out audiences in Toronto's Maple Leaf Gardens and Madison Square Garden in New York City.

Right: Bob performs at Denmark's Roskilde Festival on 1 July, during the European leg of the Kaya tour.

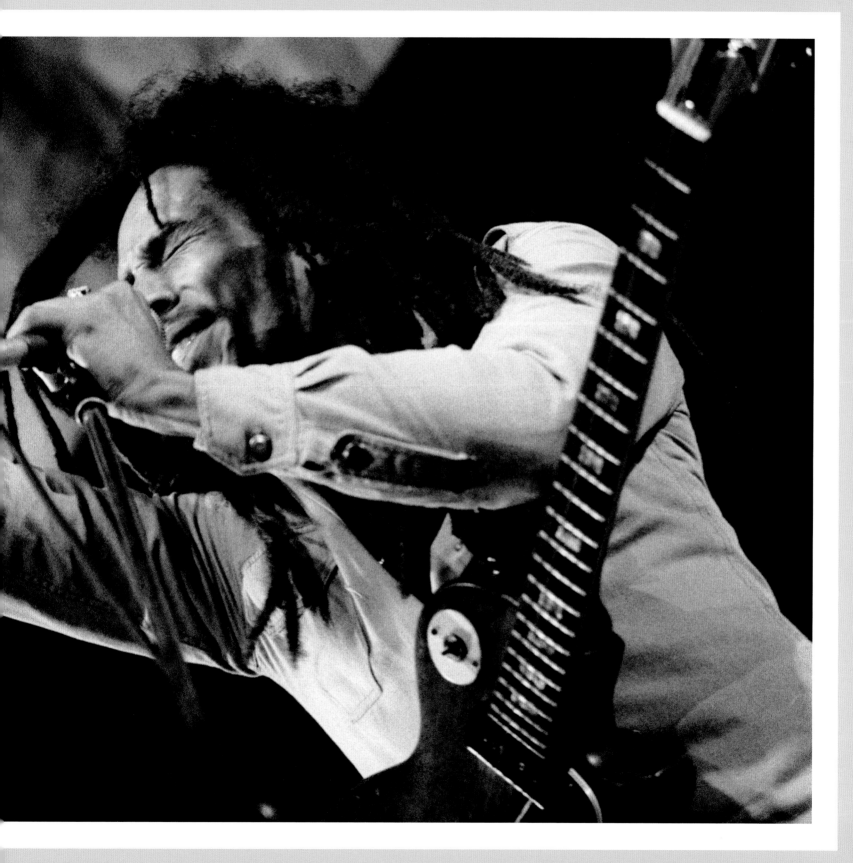

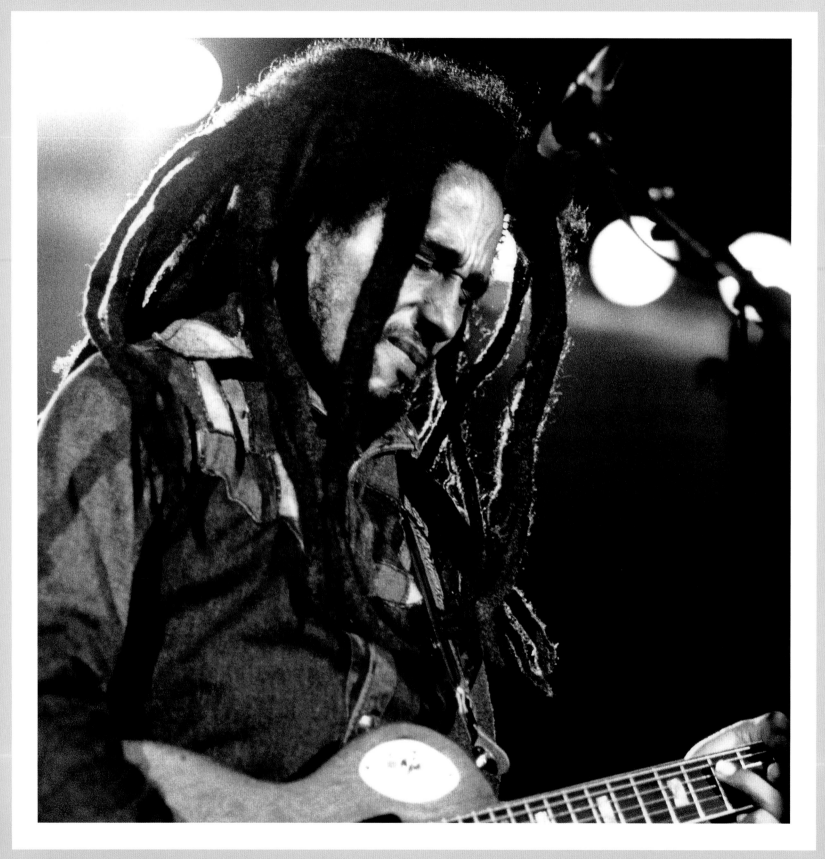

Rocking The Garden

On 17 June Bob and The Wailers played to a sold-out house in Madison Square Garden. Guitarist Al Anderson had returned to join Junior Marvin in the line-up, making two strong lead guitarists; Wire Lindo had also returned to play organ alongside Tyrone Downie on keyboards plus the dependable anchor rhythm and bass of the Barretts and percussionist Alvin Seeco Patterson. The enormous sound they created roused audiences to fever pitch, dancing, applauding and singing along.

Moving on to the European leg, the band arrived in the UK to play a single gig at a major rock venue, New Bingley Hall near Stafford on 22 June. Hungry for news stories now that Bob was a stadium-filling superstar, a coachload of media people headed out from London, only to be delayed on the journey, arriving well into The Wailers set. The next edition of the *New Musical Express* shouted "Babylon by Bus" in its headline story on Marley. Neville Garrick liked the sound of this and Blackwell put out the double live album of the same name on Island Records in November.

Opposite: Bob squeezes something extra from his guitar on stage at the Ijshal Glanerbrook, Geleen, Limburg, on the second of two Netherlands dates, 8 July 1978.

Right: Bob plays the Greek Theater, University of California, Berkeley, on 20 July.

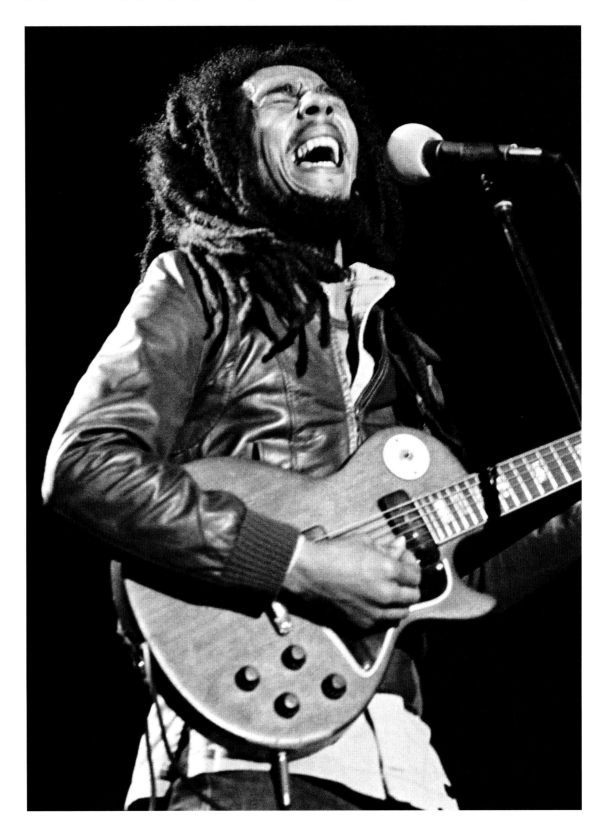

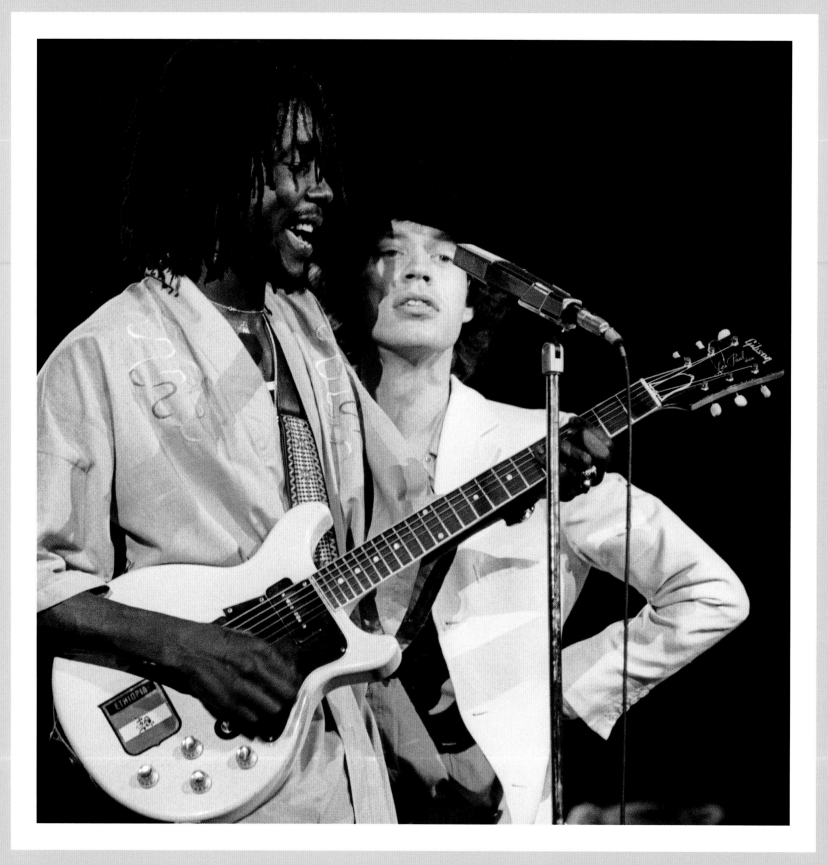

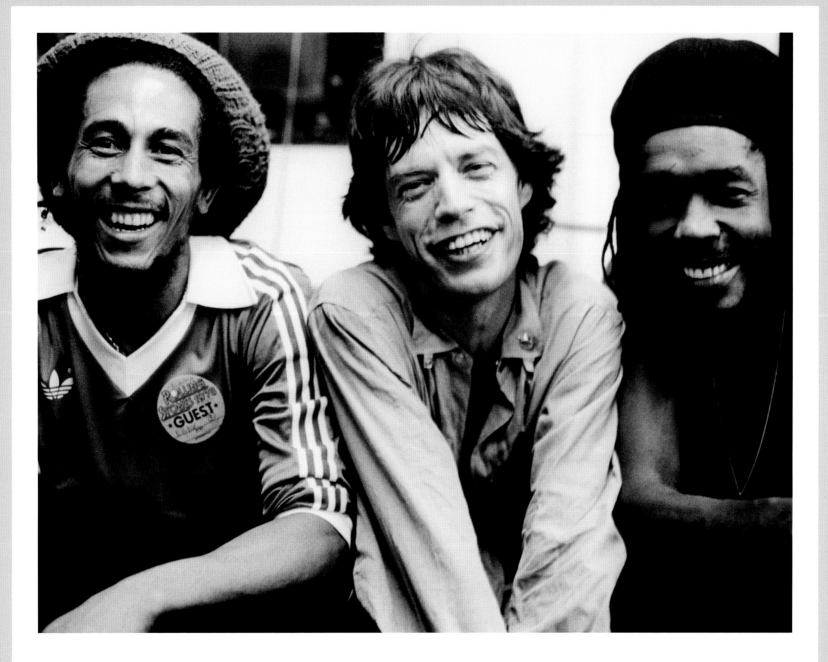

Famous friends

Above: The Stones and The Wailers were both in New York City for gigs in mid June 1978. Mick Jagger and Jerry Hall attended The Wailers' Madison Square Garden show and Bob, shown here backstage with Mick and Tosh, turned up at the Rolling Stones' concert at the Palladium on 19 June before flying to London for the next stage of the Kaya tour.

Opposite: Opening for the Stones on their 1978 tour, Tosh was sometimes joined onstage by Mick Jagger for their duet "Don't Look Back".

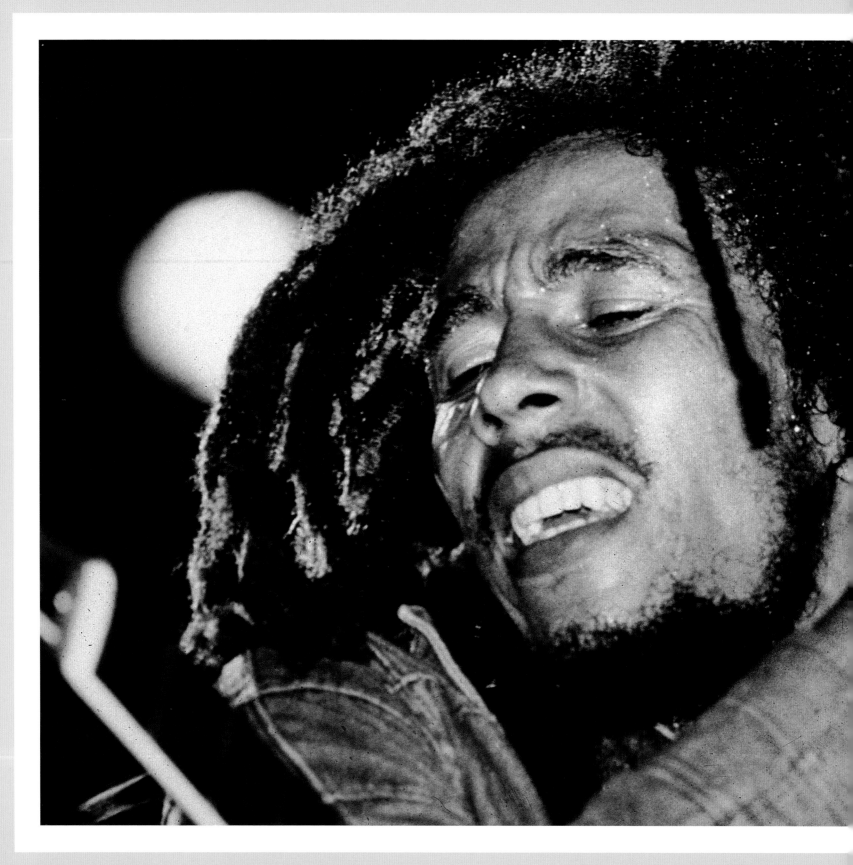

Summer festivals

Departing the UK for Paris, the band played three nights at the Pavillion de Paris from 25 June then moved on to Scandinavia to play Roskilde Festival in Denmark followed by two more major festivals, Horten in Norway and Ahoy in Rotterdam, The Netherlands. Calling in at the UK on the way back to the final leg of the tour in North America, Bob and The Wailers performed on BBC's *Top of the Pops* on 13 July.

The very next day the band played the Queen Elizabeth Theatre in Vancouver, Canada, their first gig of the third leg. There followed nine dates along the West Coast to packed houses and outdoor arenas. On 21 July The Wailers performed at the Starlight Bowl in Burbank, California. Pete Tosh, touring with the Rolling Stones, turned up at the gig and appeared on stage with Bob. That same day, news came through to Bob that Cindy Breakspeare had given birth to his latest child, son Damian Marley, bringing the extended family of children acknowledged by Bob to 11.

According to some accounts this is the occasion Rita chose to confirm to Bob that their daughter Stephanie had indeed not been fathered by Bob but by her lover Ital. If Rita was raining on Bob's parade, it could be said he had caused her some frustrations by funding a lifestyle for his lover Cindy that Rita dearly desired for herself; this included buying Cindy a house in a smart area of Kingston and reportedly setting her up in a craft business with an investment of around $100,000.

Left: The Kaya tour continues along West Coast USA.

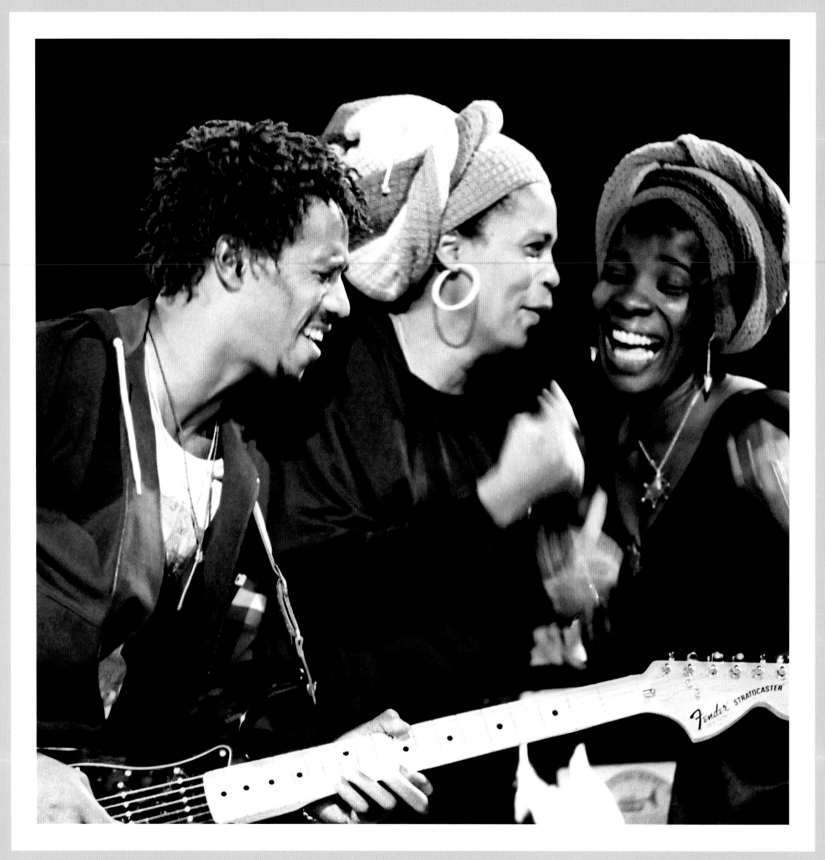

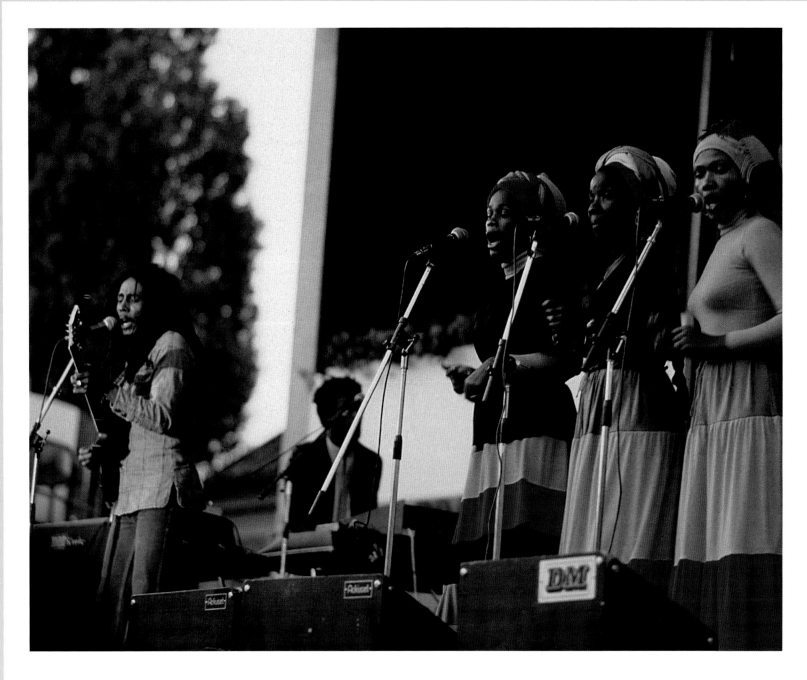

Kaya tour wraps up

Above: A number of the West Coast shows took place in outdoor arenas such as the Santa Barbara Bowl and the State Amphitheater, San Diego University. The West Coast dates ended at the Roxy Theater on 25 July; from there Bob and The Wailers picked up their six postponed gigs from the beginning of the tour, starting with Austin, Texas and ending up at Miami's Jai Alai Fronton on 5 August. The reggae sound provided ideal outdoor summer music and the crowds responded with joyous enthusiasm.

Opposite: Junior Marvin at an exciting moment with the I-Threes on stage at the Greek Theater, Berkeley.

Visit to Ethiopia

Right: Bob in a contemplative moment. From Miami, Bob and the band returned to Jamaica. A few days later Bob flew to Ethiopia to visit Skill Cole who had taken residence there to avoid the unrest in Jamaica. During the short visit of just 4 days, Bob wrote "Zimbabwe", a song celebrating the troubled country's struggle to throw off the rule of apartheid.

The double album *Babylon by Bus* was released on 10 November to mixed critical reaction. The success of the *Live!* album convinced Island that another would be welcomed and with a focus on the Paris shows, the double album was recorded during the Kaya tour. While the extended performances given to many songs worked well with a live audience, *Babylon by Bus* is regarded by many as lacking the energy and passion on which Bob had built his reputation as a live performer.

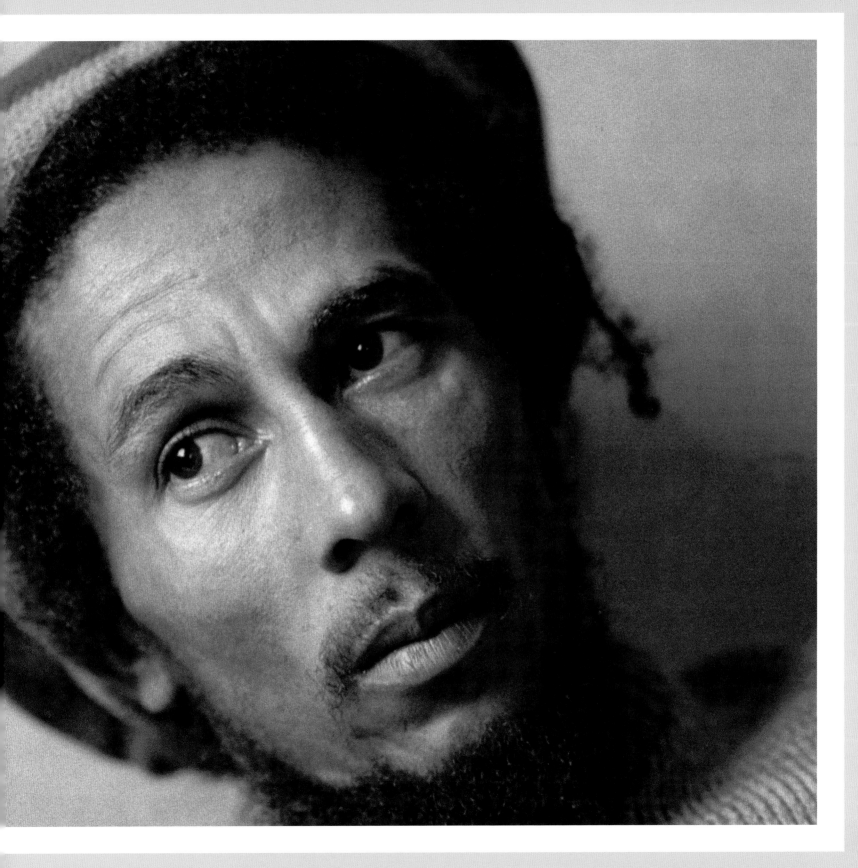

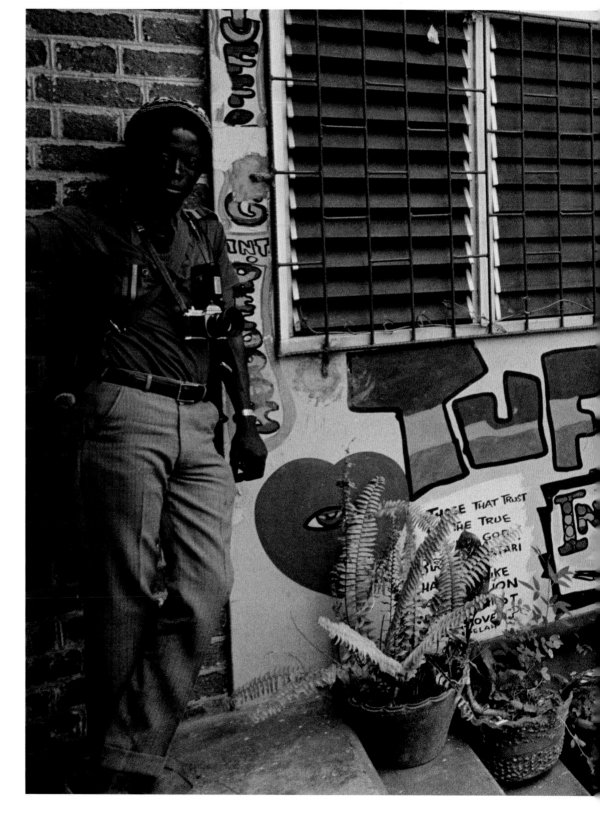

Back to the studio

Right: Tuff Gong studios photographed in 1980. The building is part of 56 Hope Road, Bob's home, office and studio in one.

With *Kaya* effectively the second-best collection of songs from the sessions that gave Bob his breakthrough album hit *Exodus*, and with *Babylon by Bus* comprising little in the way of new material, Bob was overdue in serving something up to wow his album audience. He returned to the studio with Scratch Perry, recording four songs at Black Ark studios which were then mixed at Tuff Gong. Concentrated work on the next album *Survival* began in February 1979. The material had a focus on the African struggle – particularly opposition to apartheid – as shown in the songs "Zimbabwe", "Africa Unite", "Wake Up and Live" and the title track, "Survival".

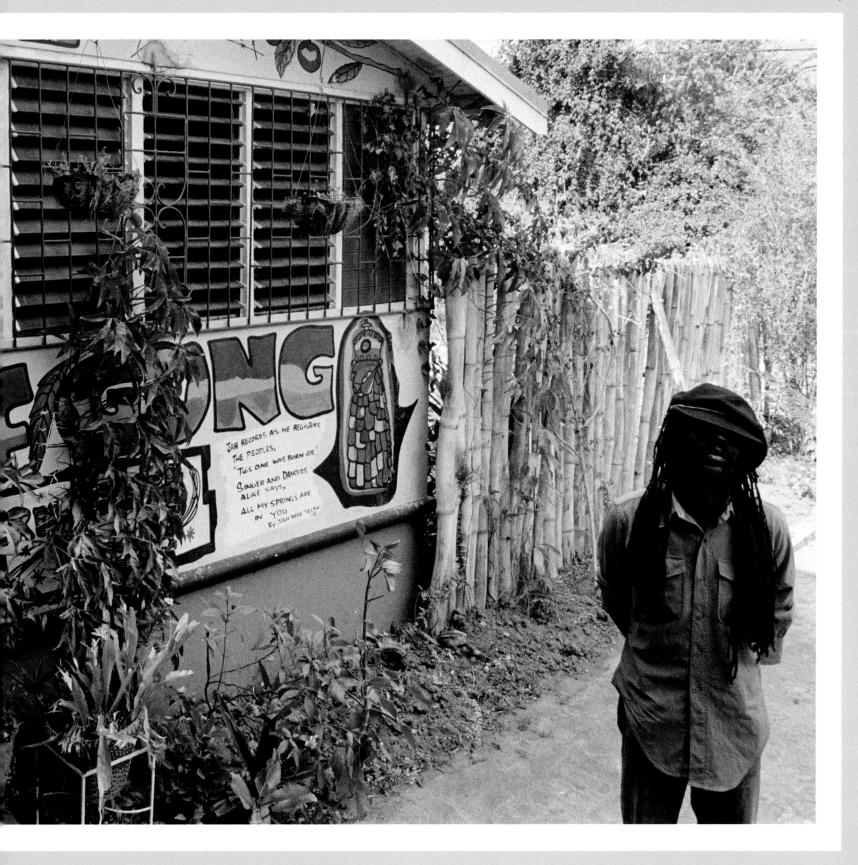

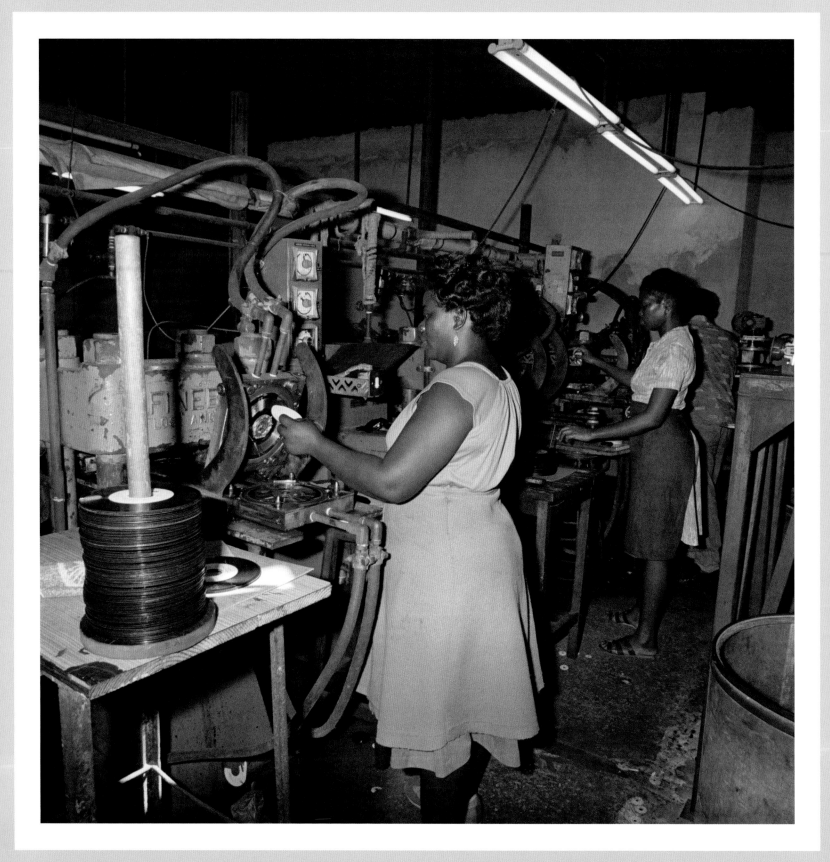

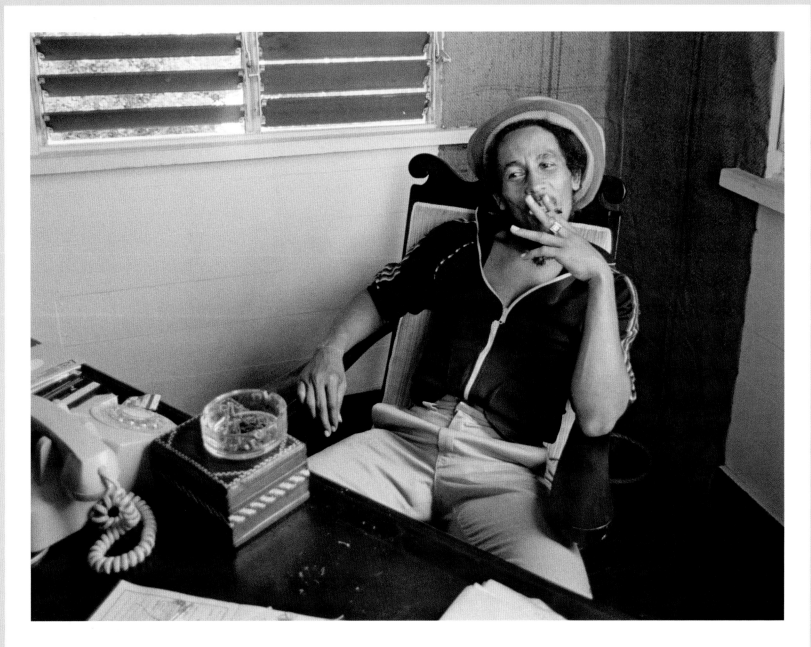

Survival

Above: Bob photographed in his Tuff Gong office. Hardly a typical entrepreneur, the only way Bob could achieve his musical independence in his home country was to own production. The studio likewise gave him artistic independence and *Survival* would be his first totally home grown album.

The Babylon by Bus tour launched in Japan on 5 April 1979 and although it was due to start in West Africa, the two shows planned for Ivory Coast were cancelled. The Japan section of the tour – 6 dates, and Bob's first visit to the country – was highly successful, feeding a groundswell of enthusiasm that continued long after as an enduring fanbase. A single show in Auckland, New Zealand, gained a warm response – especially from the Maoris who dubbed him "Redeemer" in their own language. After eight dates in Australia, the tour wound up on 6 May with two gigs in Hawaii. Bob returned to the Tuff Gong studio to wrap up *Survival*.

Opposite: Tuff Gong invested in its own pressing plant, photographed at work here in 1980.

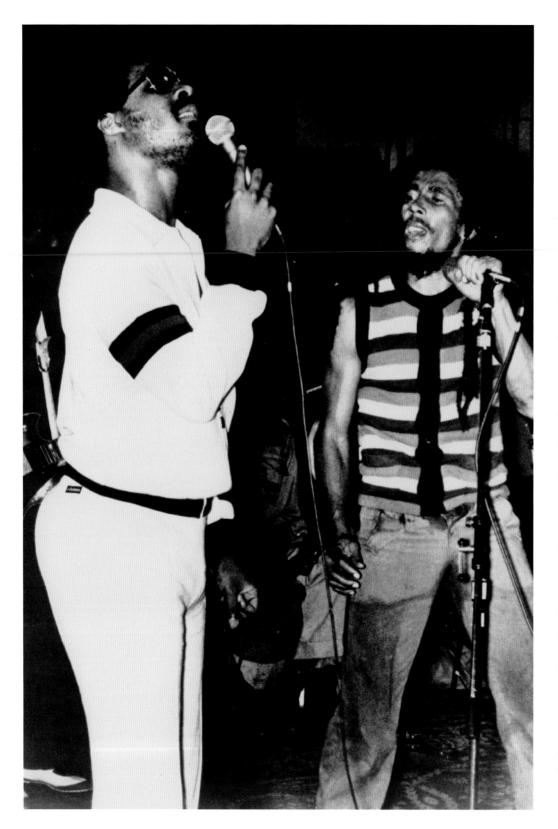

1979 Year of the Child

Opposite: Bob participated in the special year assigned by the UN, playing a number of high profile benefits.

On 7 July Bob and The Wailers headlined Reggae Sunsplash II in Montego Bay's Jarrett Park – giving his first public performance in his home country since the One Love Peace concert in April 1978.

Exactly two weeks later the band was top of the bill at the Amandla Festival of Unity in Boston, playing a benefit for Relief and Humanitarian Aid in Southern Africa. The venue was the Harvard Stadium in Cambridge, Massachusetts, and the artists line-up included Patti LaBelle and other black music celebrities.

On 24 September Marley and The Wailers also played a benefit for Rastafarian children at the National Heroes Stadium in Kingston. Bob's commitment to his themes of Africa and Rastafarianism was now at its peak, reflected in his musical performances and his memorable speeches on stage.

Left: On 7 November Marley is reunited with Stevie Wonder on stage in Philadelphia when they perform "Get Up, Stand Up" and "Exodus" together during a benefit concert for the Black Music Association.

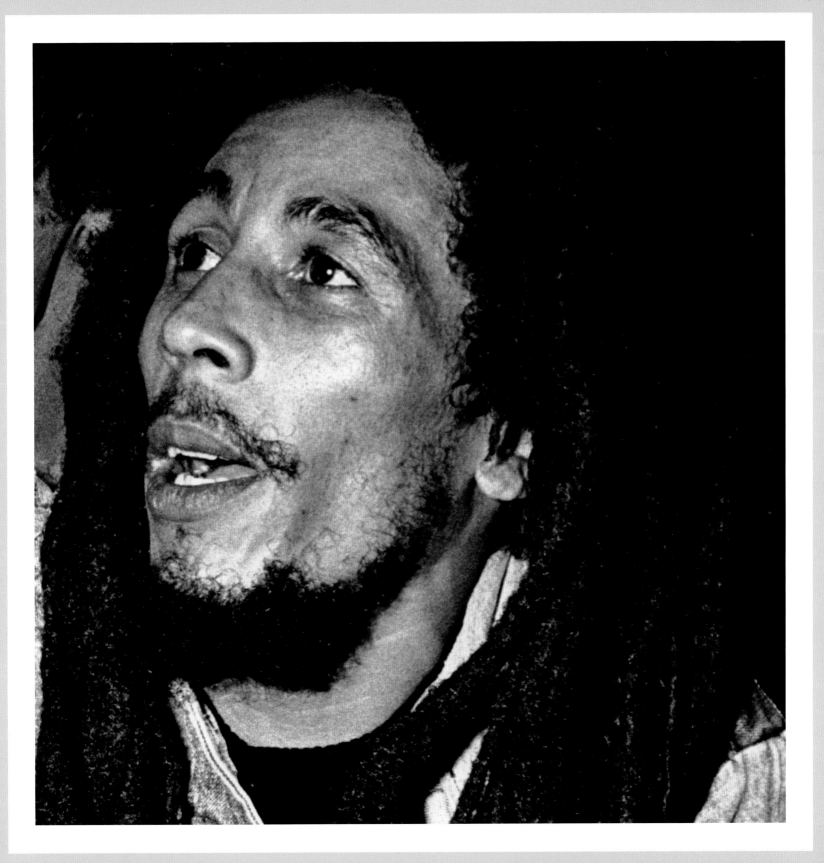

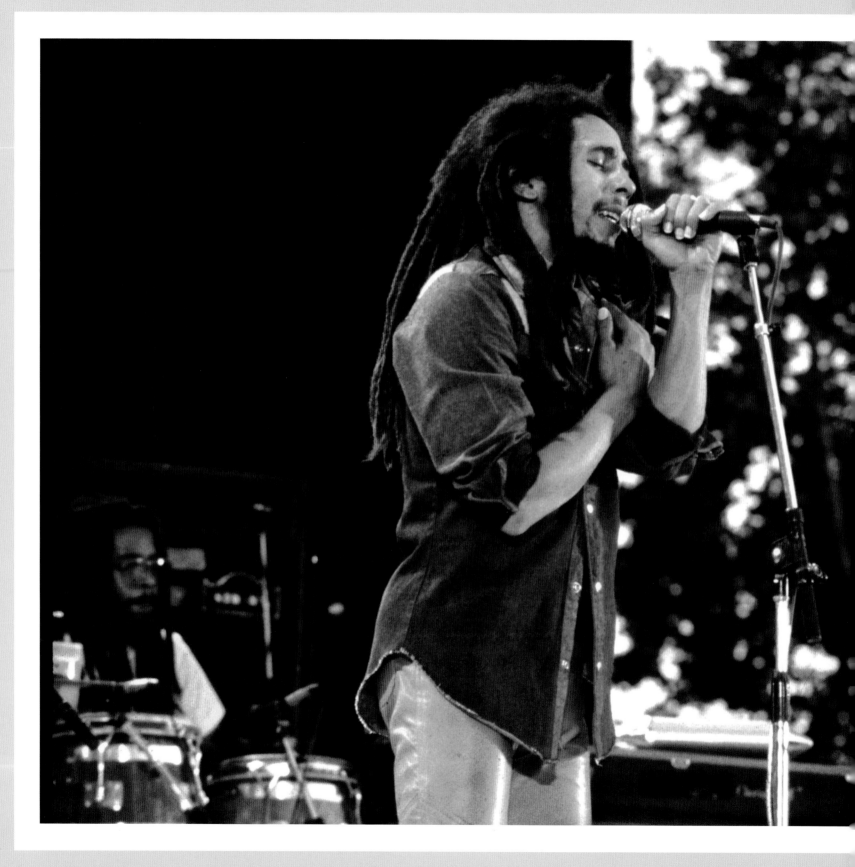

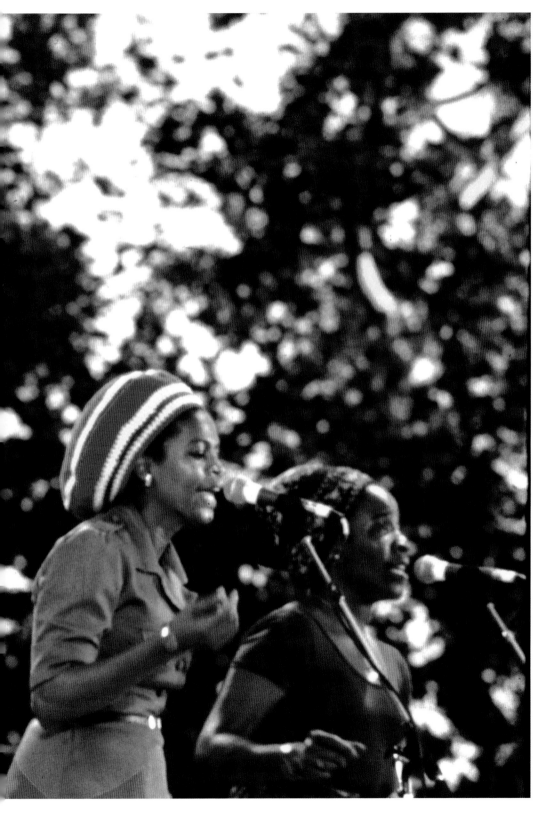

Touring again

Left: The Wailers play Santa Barbara Bowl on 25 November 1979 during the Survival tour. The *Survival* album was released on 2 October – a few weeks before the tour started out at Harvard followed by 4 dates at Harlem's legendary Apollo Theatre, commencing on 25 October. In seven weeks Bob and The Wailers performed 45 shows, on several occasions playing two shows on a single date. Although the tour was restricted mainly to the USA, it was hard work for a man who, although he didn't acknowledge it, was on the edge of a medical condition that would kill him.

As well as the *Survival* recording line-up that included Glen da Costa and Dave Madden, Devon Evans was added to the percussion section giving further support to Carly and Seeco. However, on occasions Marcia Griffiths was missing from the line-up, reducing the I-Threes to two. Nonetheless, the male musicians also contributed backing vocals and nothing was lost to the quality of sound.

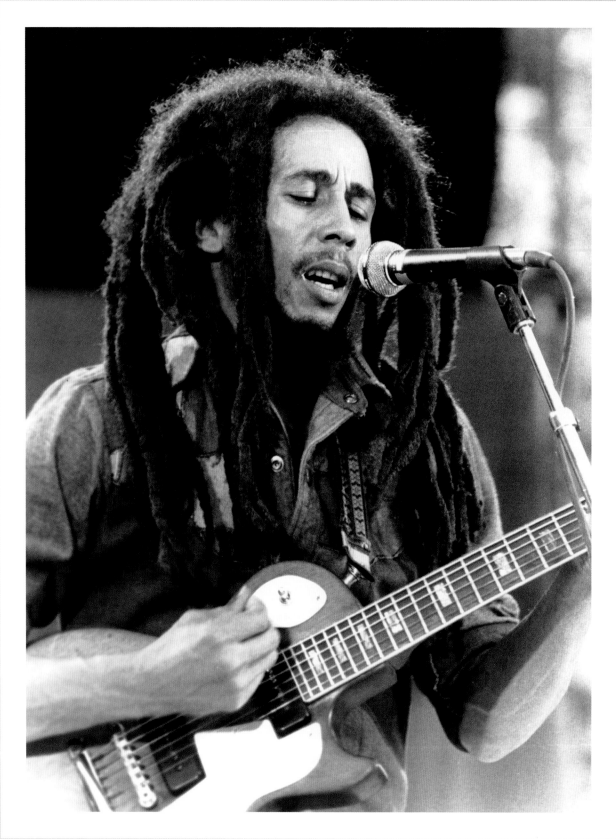

Santa Barbara Bowl

Left and opposite: Bob Marley and The Wailers' third and last performance at the Santa Barbara Bowl, California, was recorded by Bill Graham and later released on VHS and DVD as *Bob Marley – The Legend Live*. The performance five days later in Oakland, featuring Ronnie Wood of the Rolling Stones in the encore, was also recorded on videotape but has never been publicly released.

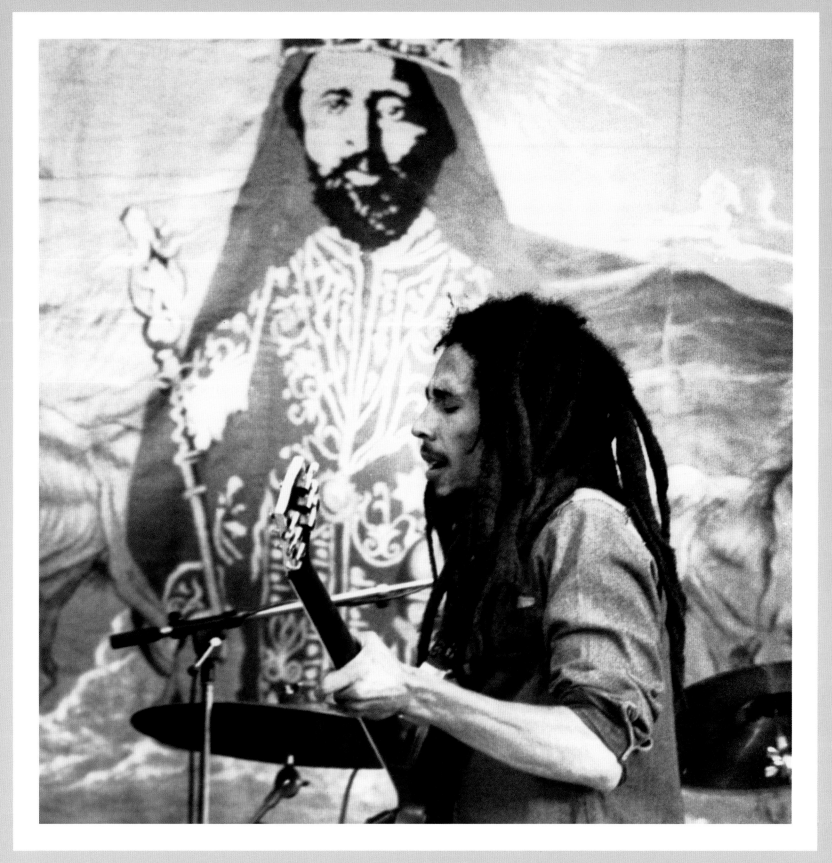

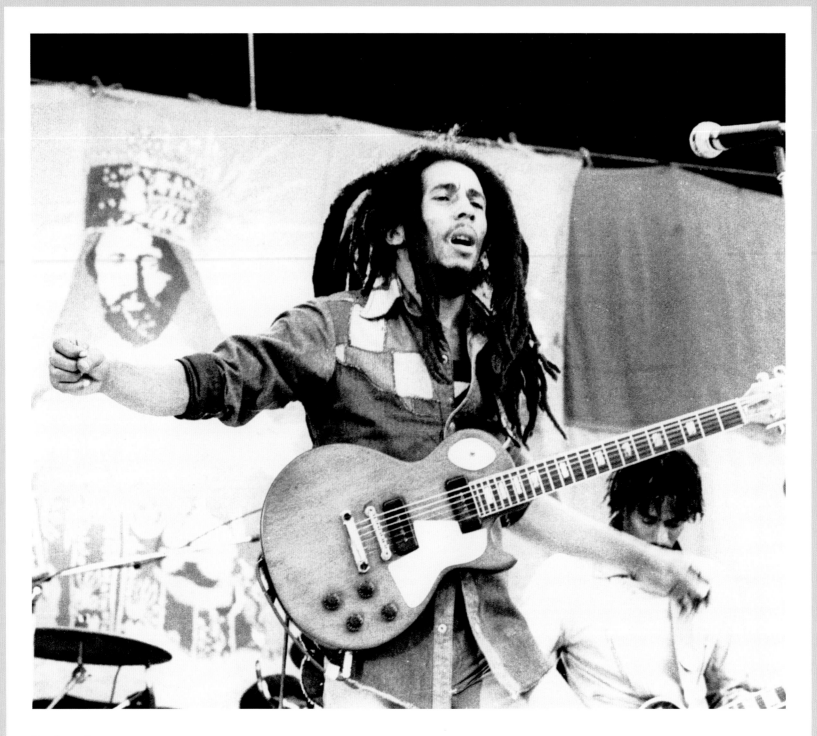

Peak performance

Above and opposite: Bob and Junior Marvin on stage at Santa Barbara Bowl. The Santa Barbara Bowl show was a model of professional polish: the quality of musicianship superb – to studio standard – with the band performing seamlessly through the set list of 20 songs, which started out with the gently paced "Positive Vibration" and ended with the rousing "Get Up, Stand Up".

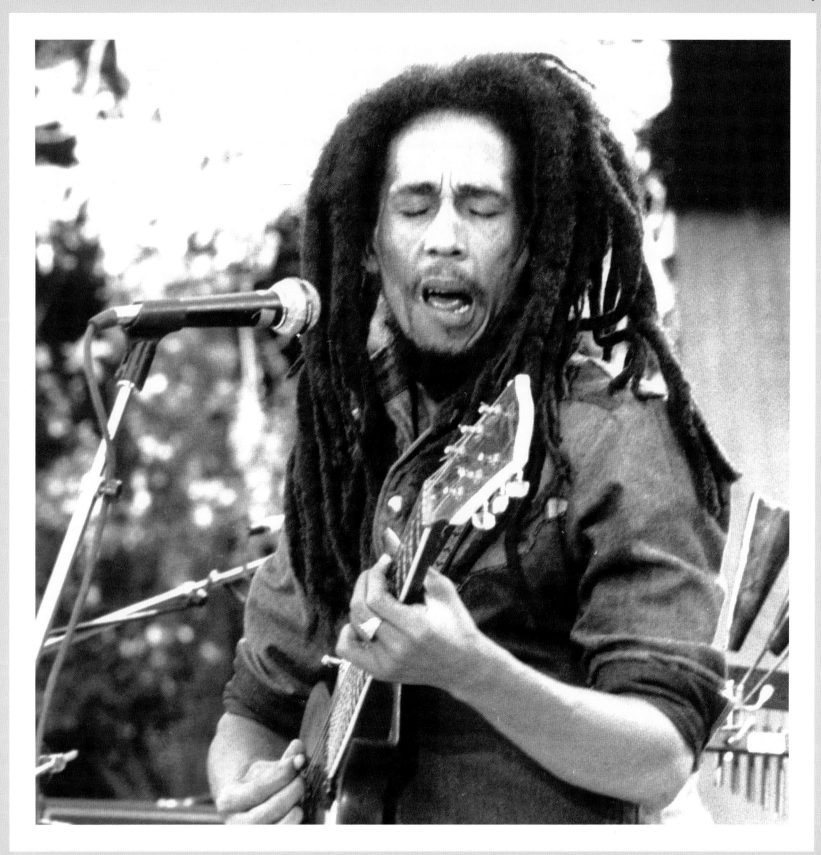

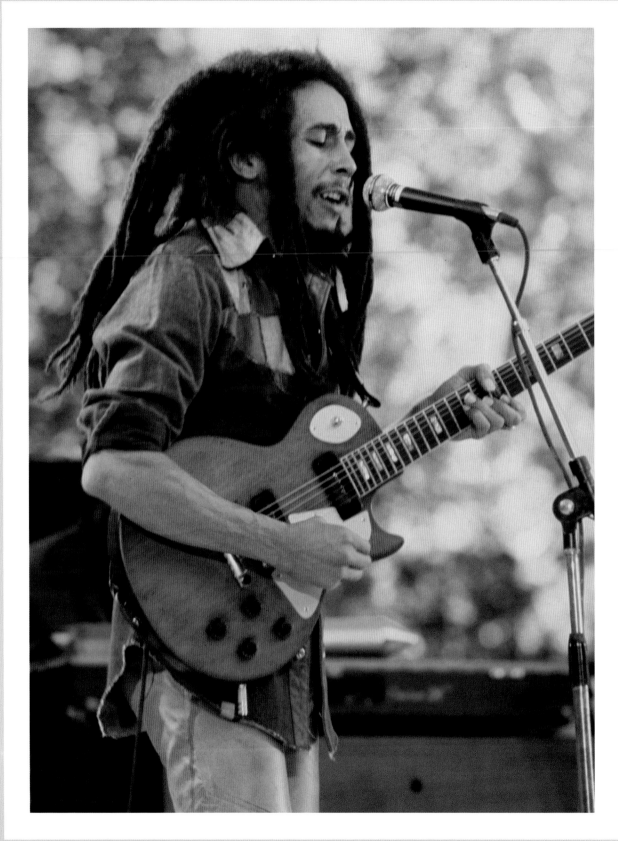

Horn section

The Survival tour was unique in that The Wailers line-up, already quite large, was further beefed up by a brass section with David Madden on trumpet and Glen da Costa on saxophone. The two musicians had a longstanding relationship in the studio with Bob, playing on album recordings, but this was their first outing on tour with him. No other Wailers' tours featured a horn section.

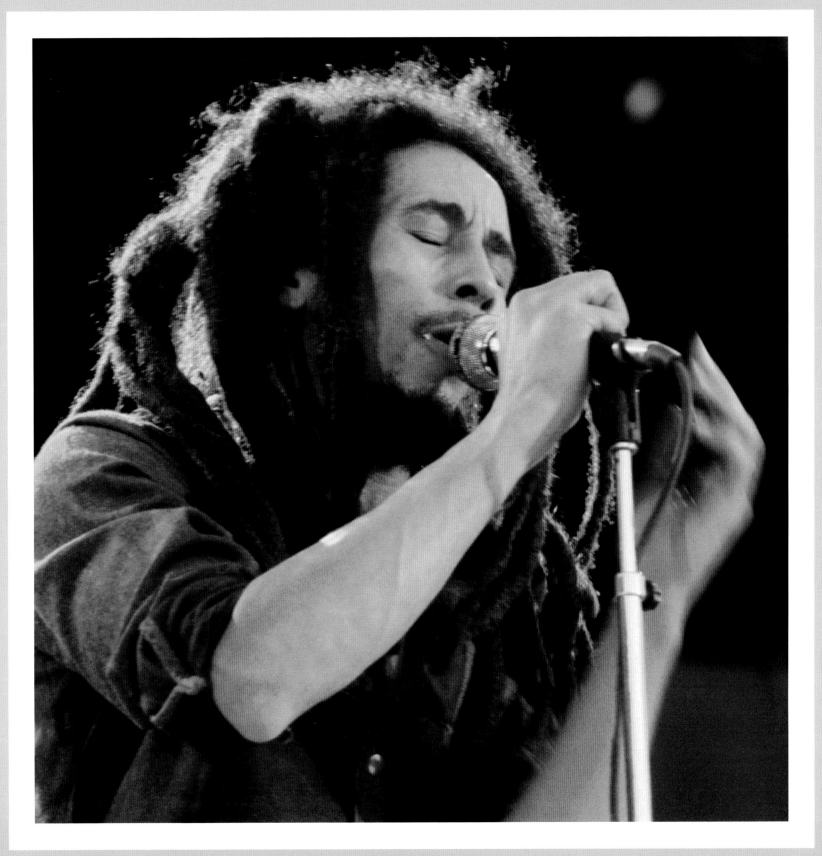

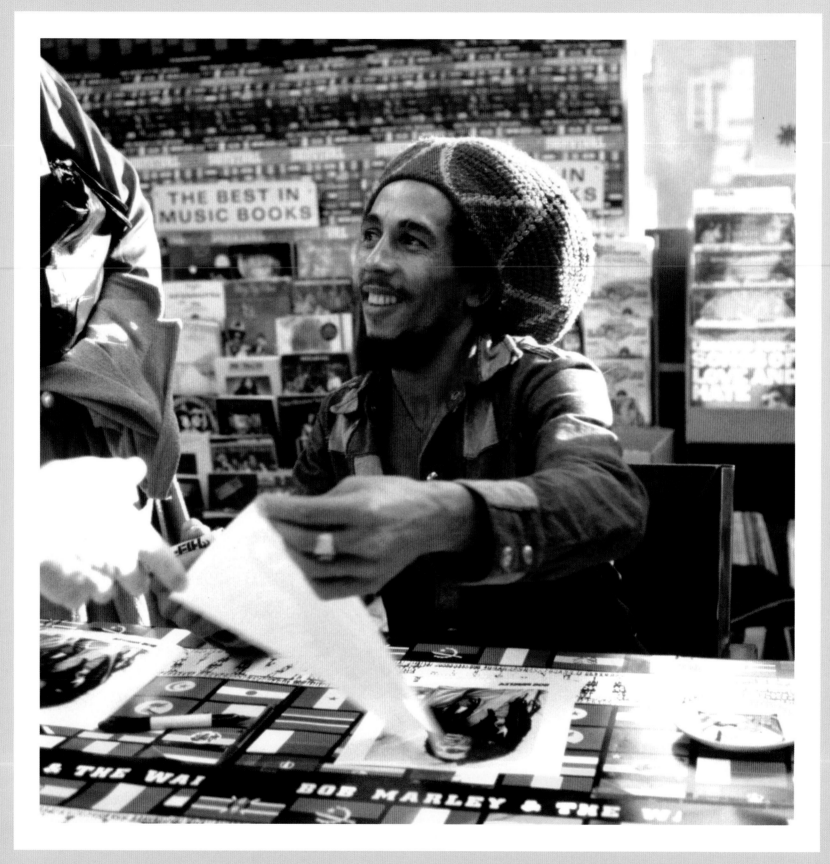

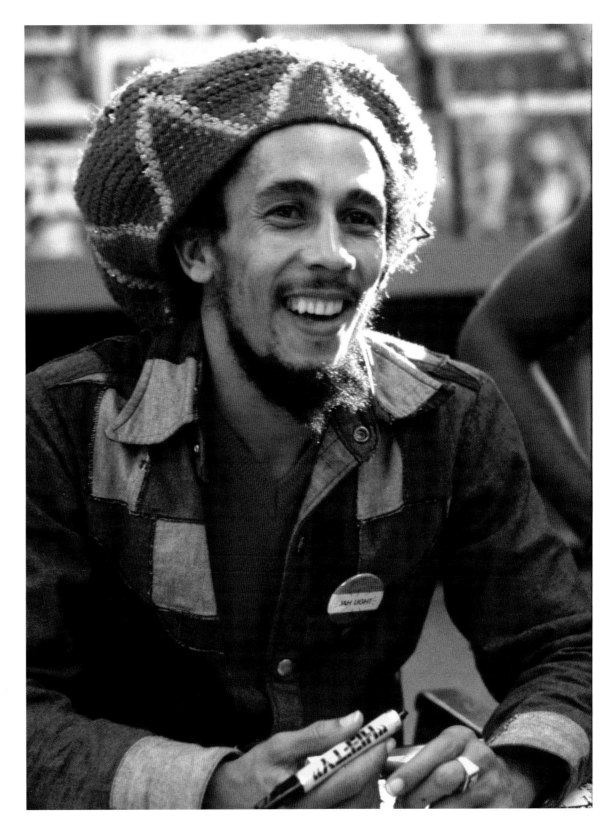

Tower signing

Opposite and right: Bob signs copies of his *Survival* album in Hollywood's Tower Records store during the Survival tour. The cover art of the album, designed (as many of the previous LPs had been), by Neville Garrick, showed 48 flags on the front, 47 of them being African countries.

The cover perfectly represented the message of the songs on the album which are of a rallying, almost political, nature and include "Zimbabwe" and "Africa Unite". The 48th flag, Papua New Guinea's, represented the native peoples of the Pacific, in acknowledgement of the Maoris that had greeted Bob with the soubriquet "Redeemer".

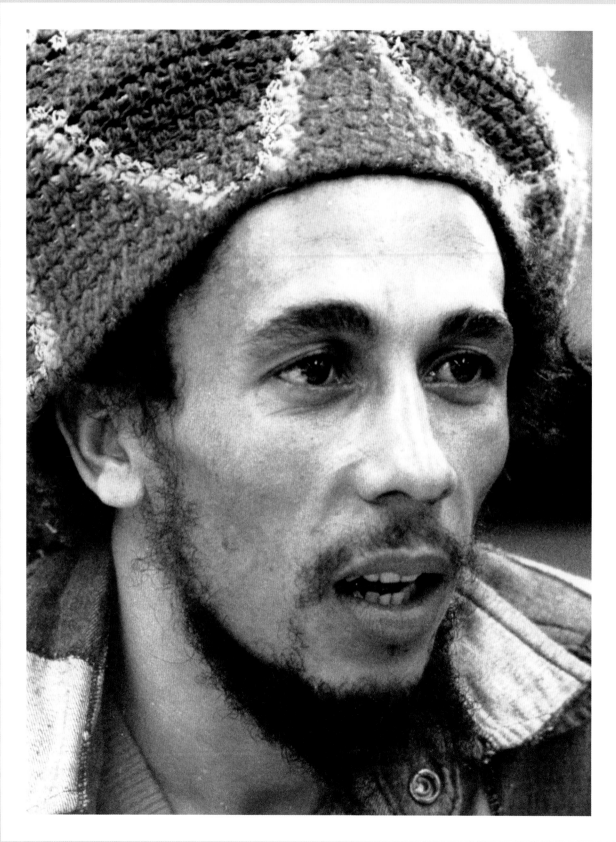

Towering spirit

Left and opposite: Bob pictured in Tower Records, Hollywood. At this time Bob is in the heartland of music in Southern California; it's also, according to the beliefs of Rastifarians, the Babylon of Babylons – the home of privileged white authority and its controlling capital,

These pictures almost pedestrian in their normality are unusual in the contemporary music scene. Although an inveterate cannabis user, an international superstar and a man with a wide ranging taste for the ladies, Bob's lifestyle was not the feckless disaster of some of his celebrated peers. He dressed in the same clothes he used for his stage shows, often most comfortable in a track suit. Even without meeting the man these pictures stir an extraordinary reaction, implying an unworldly spirit for whom, though money is not unimportant, it would probably be the last thing on his mind.

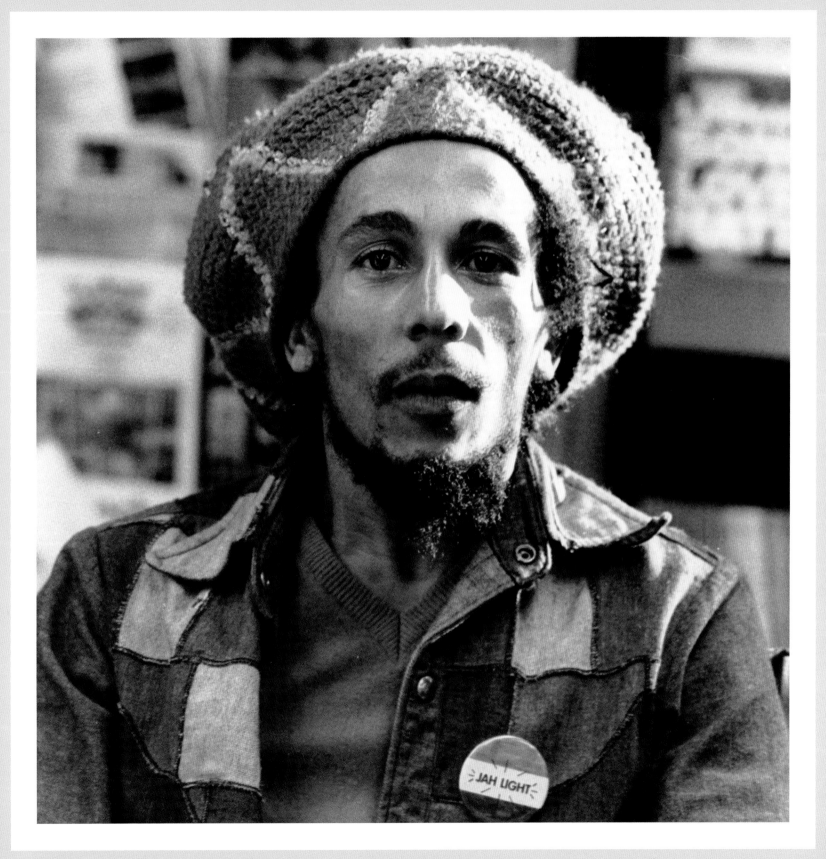

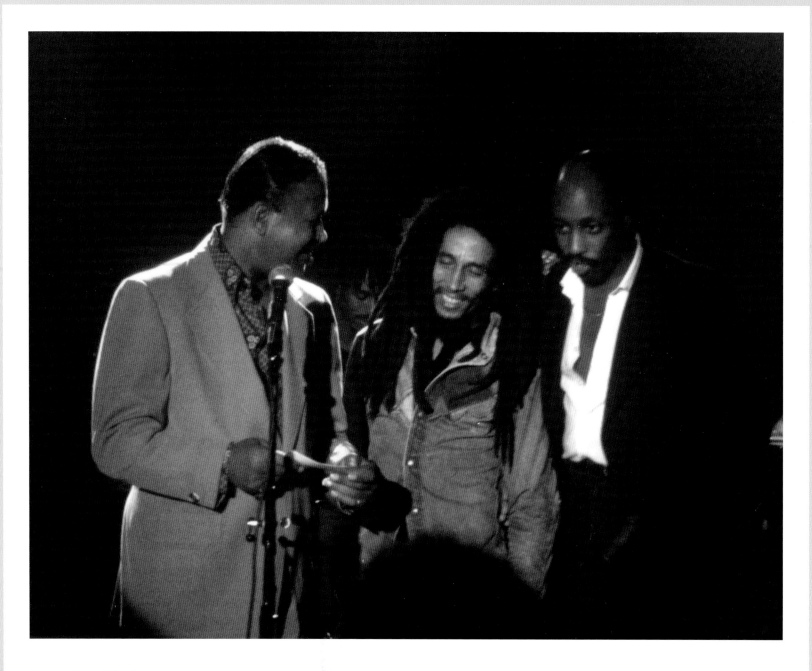

Sugar Ray at the Roxy

Above: On 27 November Bob returns to the familiar Roxy Theater in Los Angeles' Sunset Strip, this time to perform a benefit concert for the Sugar Ray Robinson Youth Foundation. Muhammad Ali named Sugar Ray as his hero but the young Robinson had a difficult upbringing with involvement in street crime in his earlier years. The Foundation, established in 1969, aimed to provide support to young blacks to divert them into sport and other pastimes that would give positive social results. Sugar Ray Robinson shows Bob the cheque for the proceeds of the benefit concert.

Opposite: Bob routinely played benefits but there are more of them during the International Year of the Child and they are mainly for children's charities.

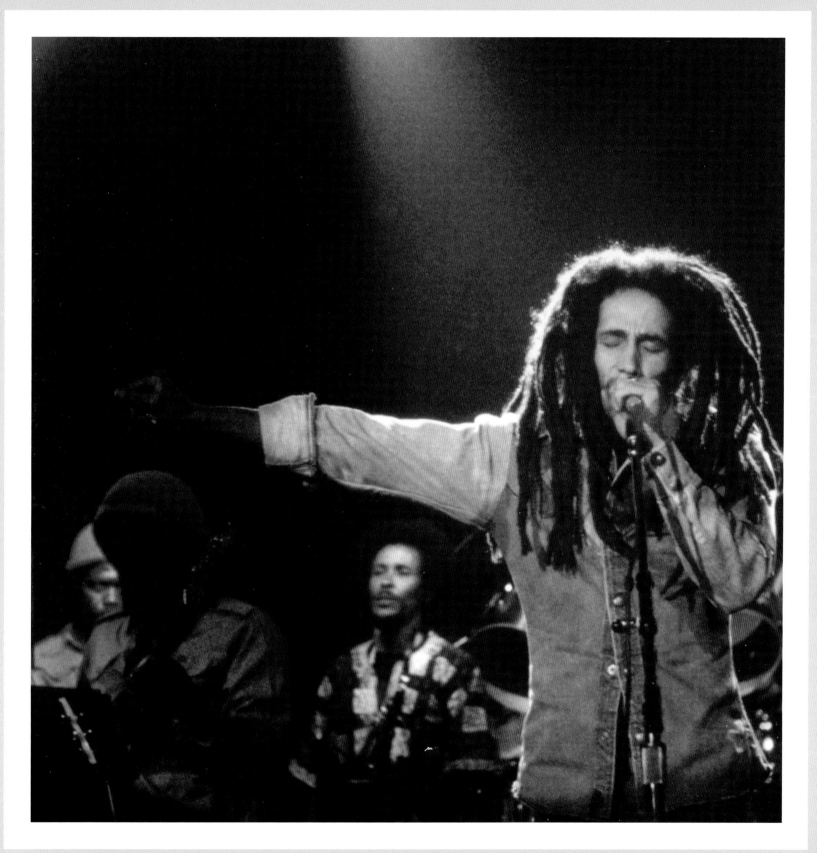

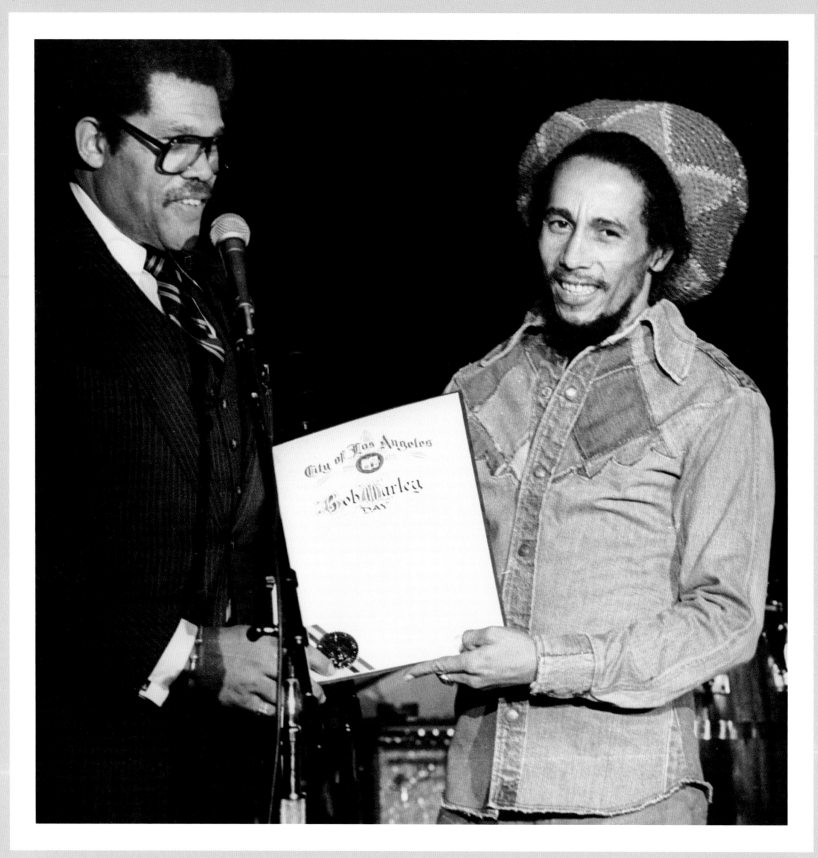

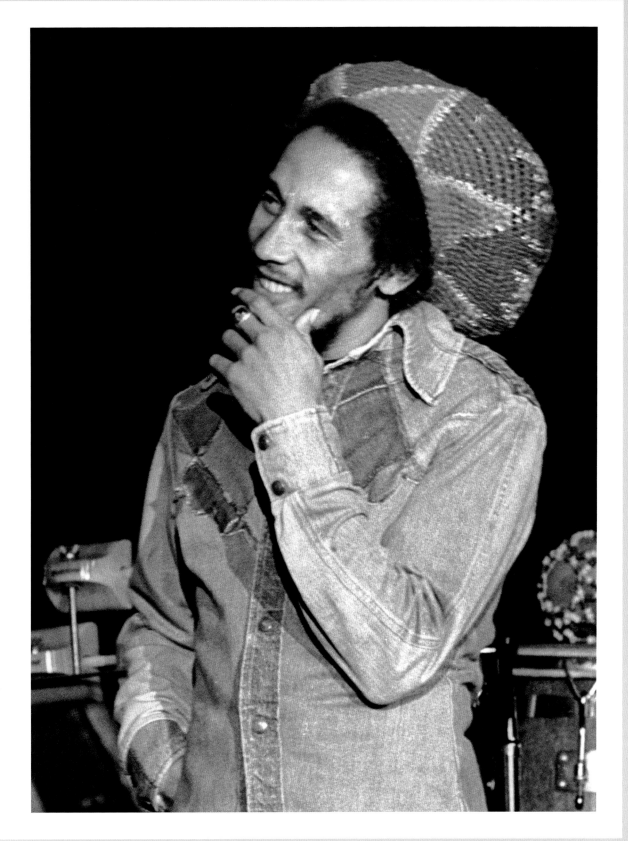

Bob Marley Day in LA

Opposite and right: Looks of amusement and slight embarrassment pass over Bob Marley's features as, during the Sugar Ray benefit, he is presented with a certificate by the City of Los Angeles that announces Bob Marley Day. The City of Angels was ahead of the rest of the world and Bob Marley Day would take place under many guises, including Bob Marley Ragga Muffin Day, until the 1990s when Marley enthusiasts around the world officially honoured their dead hero on his birthday.

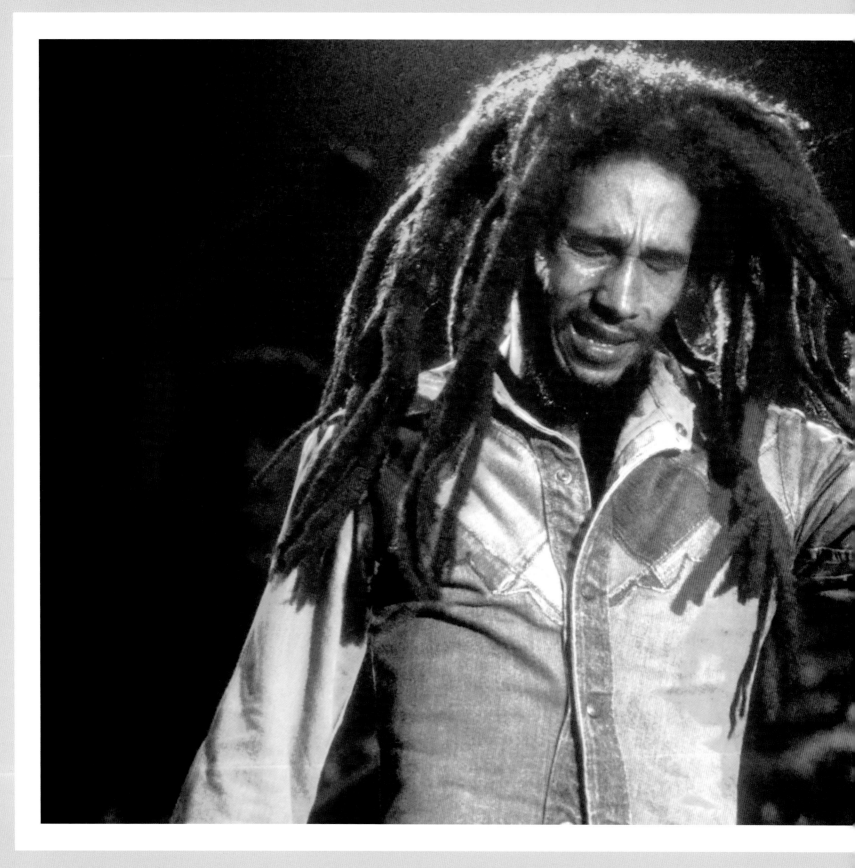

Time passing

Left: No one, least of all Bob himself, could have comprehended that this man in his prime, at the peak of his musical prowess and his outspokenness, was performing at these classic rock venues for the last time.

Many intimations or prophecies of Bob's early death are recalled by his close entourage. One of these was from Bob himself saying he would die at the age of 36. Others recount times in the studio when Bob would say he didn't have much time left – an intuition no doubt reinforced by the assassination attempt in 1976.

Survival was the first in a planned album trilogy of which only one more would see fruition during Marley's lifetime – the sequel, *Uprising*.

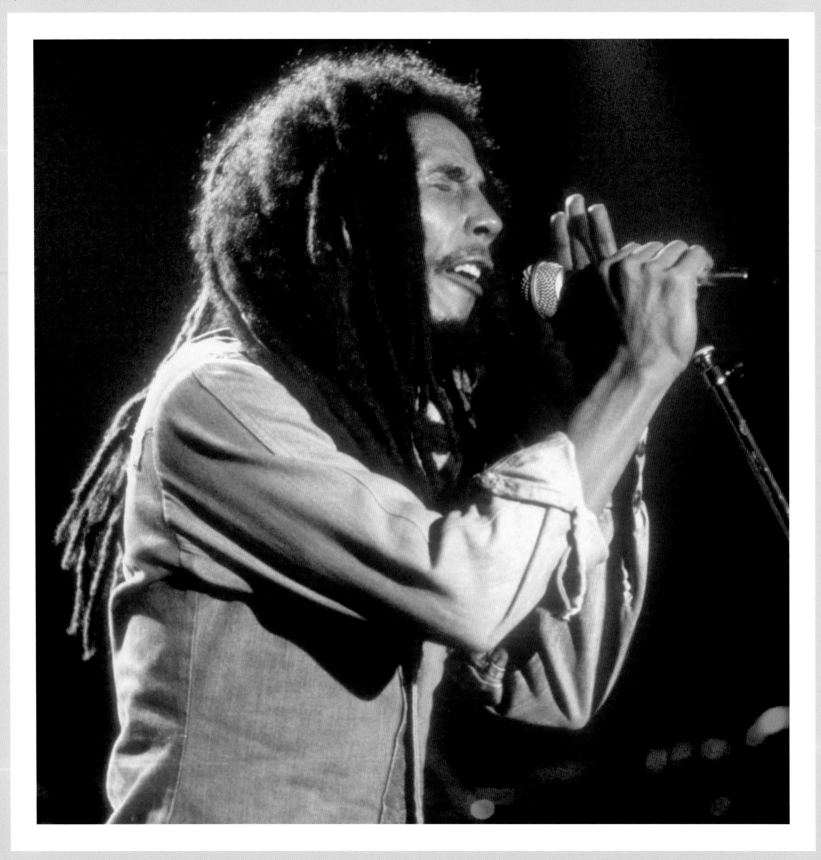

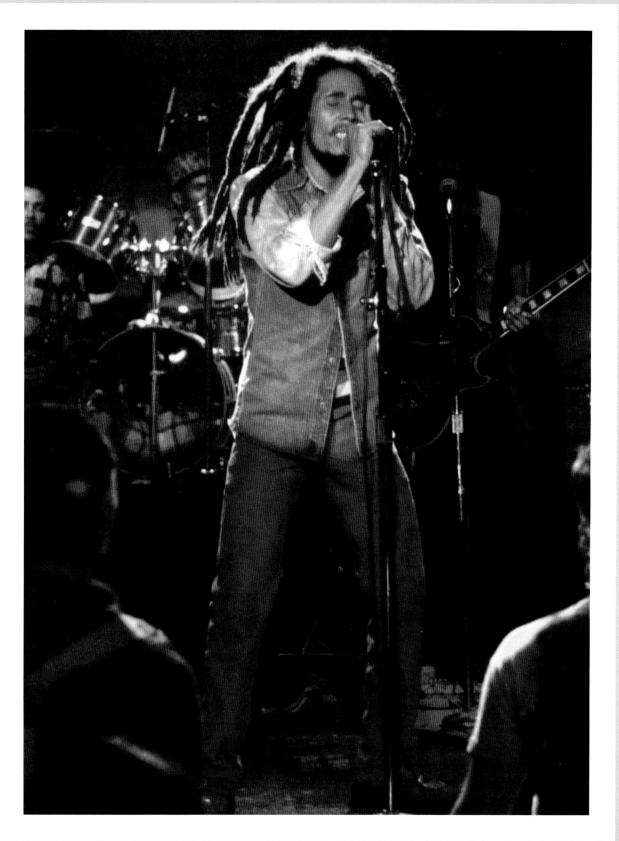

Southern USA

Opposite and right: Performing at the Roxy. In the photograph, right, Junior Marvin plays guitar while singing vocals; Carly can be seen on drums and there is also a rare glimpse of Glen da Costa on saxophone almost out of shot.

After the Roxy, Bob and the band moved on to play other dates in southern California before moving through Kansas and Texas and making a brief excursion to Trinidad and Tobago before taking in other southern states cities such as New Orleans and ending at the Brothers Music Hall in Birmingham, Alabama.

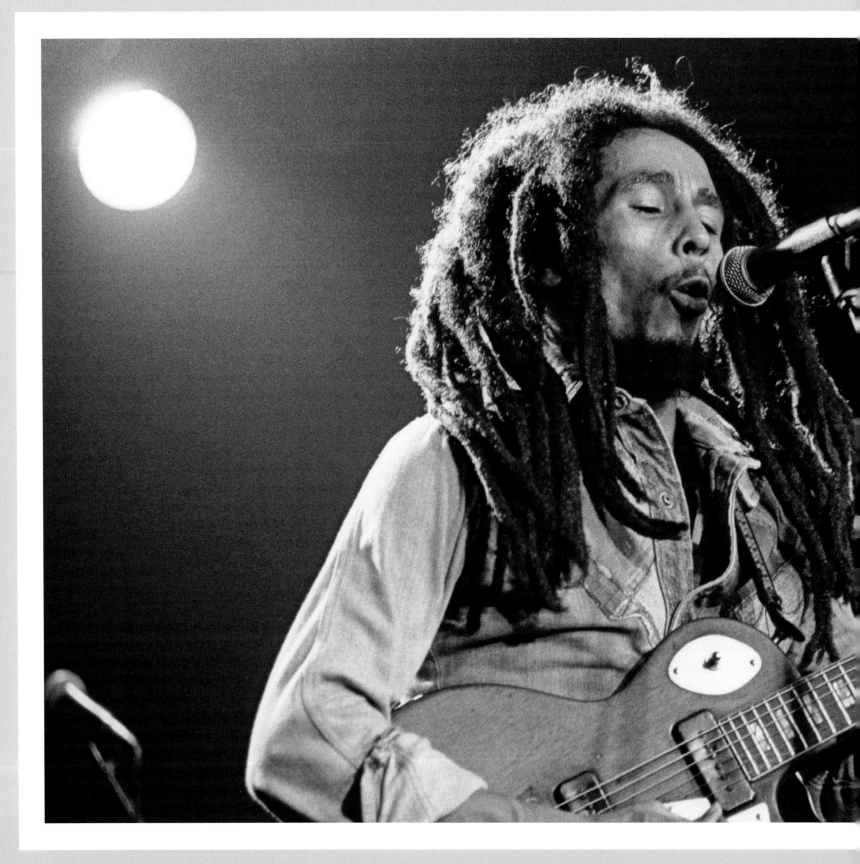

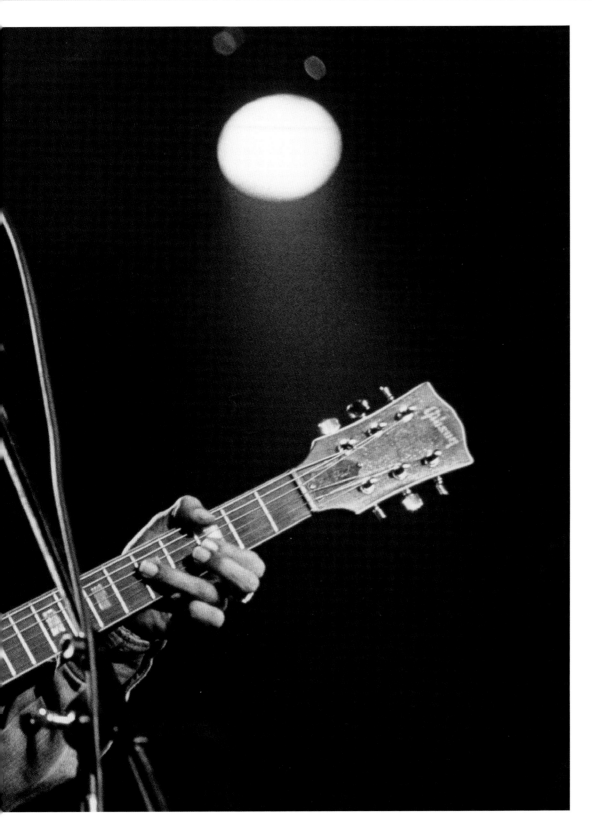

Tour ends in Nassau

The gruelling Survival tour ended in Nassau in the Bahamas on 15 December with a benefit concert for Bahamian Children. Afterwards Bob flew into Miami to spend time with his mother and get some much needed rest.

Left: Bob on stage during the Sugar Ray Foundation Benefit.

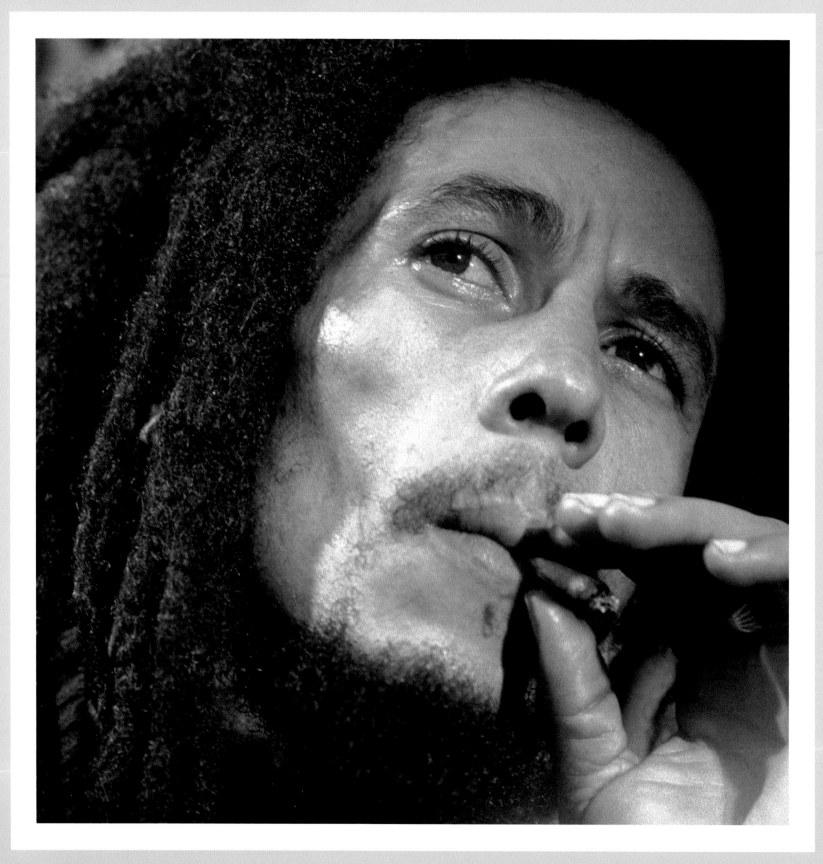

Visiting Africa

Early in January 1980 Bob and the band flew to Gabon in West Africa where they had been invited to play at birthday celebrations for President Bongo. Bob had been so pleased by the prospect of playing in Africa for the first time that he told his manager Don Taylor that he would do the gig for free. The Gabon visit was a disappointment in other ways – the two performances given by the band were to privately invited audiences and Bob's dreams of playing to a wider African audience failed to materialize on this trip.

Opposite and right: A photo session during a press interview in Atlanta while playing the Fox Theater on 11 December 1979 provides a moving image of the artist at this time – his features displaying a quiet sense of purpose and an inner peace. In reality, as the year drew to a close, turbulent times lay ahead in the short time remaining to the reggae star.

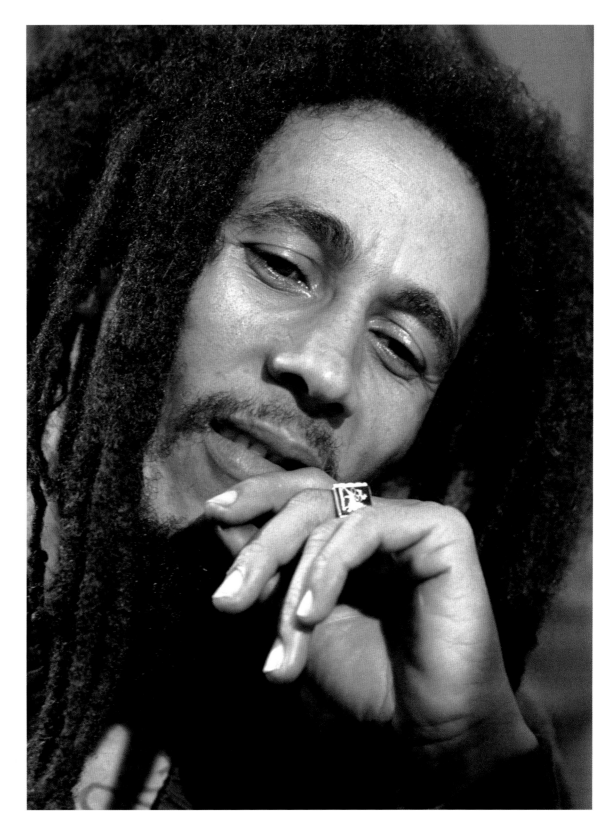

Parting company with Don Taylor

Right: Bob visits the Tuff Gong pressing plant in early 1980 where locally produced copies of *Survival* are packed into sleeves for distribution around Jamaica.

Returning to Jamaica from Gabon, Bob resumed work on his next album, *Uprising*. Taking a break in February he flew to Miami to spend time with his mother while also attending to business. There Danny Sims called by to discuss returning to his previous role as Bob's manager. Soon after, Bob also settled his affairs with Don Taylor who was persuaded to resign all his responsibilities and connections with Bob.

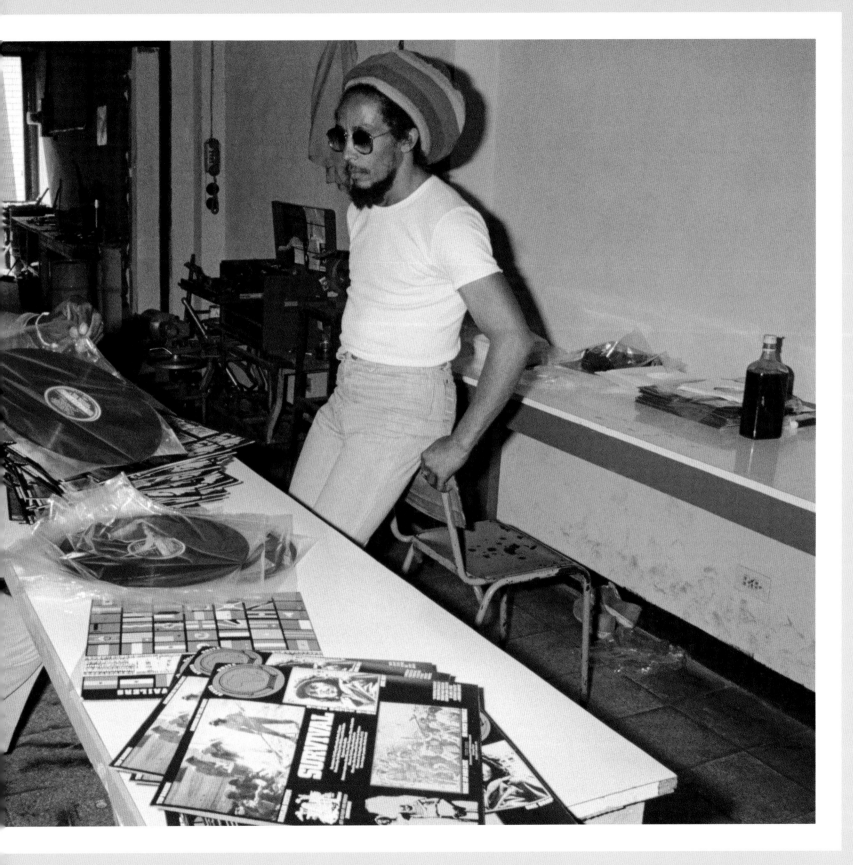

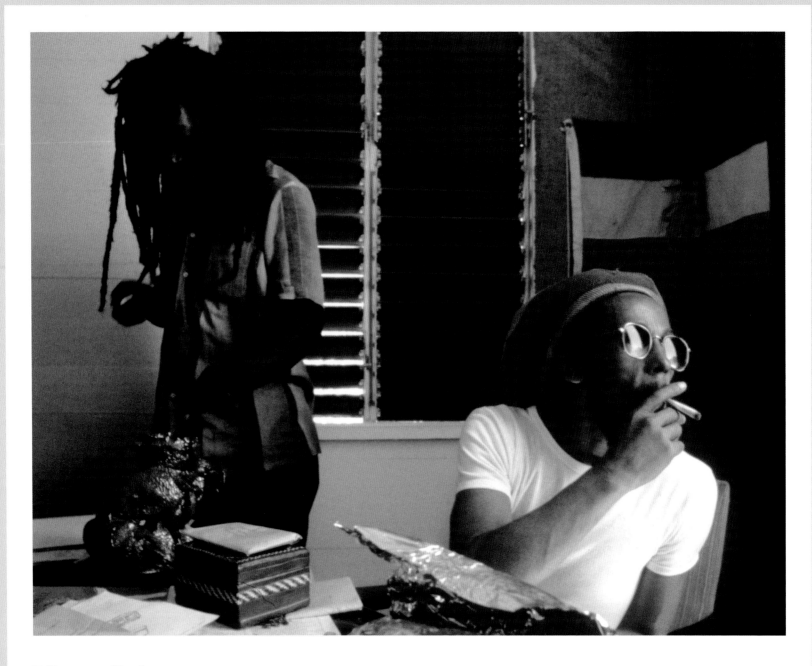

Taking care of business

In 1980 Bob had arrived at a pinnacle of achievement, now one of his era's greatest music stars and Jamaica's most famous son ever. Bob's albums have a guaranteed world audience and his performances are now drawing record-breaking crowds. His Tuff Gong record label and recording studio enabled his creative independence and an unrivalled position in his home market. By all accounts Bob continued to be fanatical about the detail of the band's rehearsal and performance. He also regularly insisted on seeing evidence of his earnings. As a millionaire businessman, however he was not on top of his affairs. Bob's informal arrangements with his band colleagues meant that he split his earnings with them on a roughly 50/50 basis but without any written contracts. This would cause many problems for core members of the band like Junior and the Barrett brothers after Bob's death, especially since he was to die intestate.

Above and opposite: Bob photographed at Hope Road in March 1980.

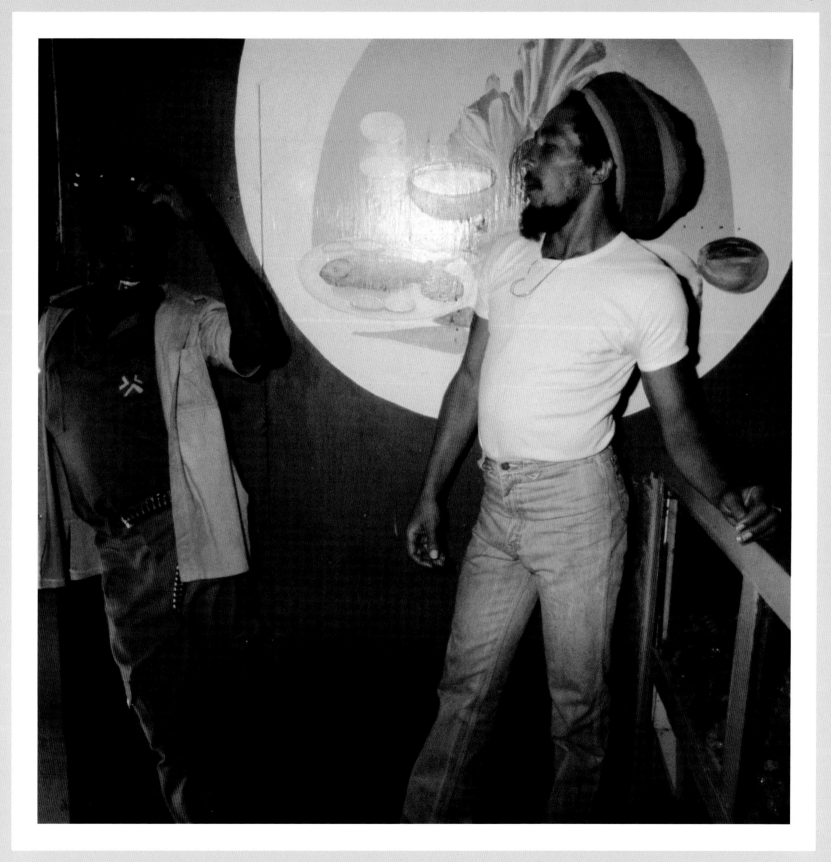

Breaking into South America

In March 1980 Chris Blackwell took Bob to Brazil on a five-day promotion trip in support of a local record label, Ariola Records, which had recently signed a distribution deal with Island. Blackwell was personally active in taking Bob into new markets and would attend gigs in support of what was probably his favourite artist. The intention in Brazil was to publicize a planned South American leg of the Uprising tour to take place immediately after the US dates in the autumn.

In the chartered plane flying to Rio, Chris and Bob were joined by Jacob Miller, lead singer of Jamaican band Inner Circle, and Junior Marvin, who together with Bob were on a creative roll in their musical writing. Despite Bob's mood of excitement from the Rio experience, his performance on the soccer pitch while playing with celebrity Brazilian footballers was below par, heralding the ill health which was soon to blight him.

Opposite: Bob on stage at London's Crystal Palace Bowl in 1980.

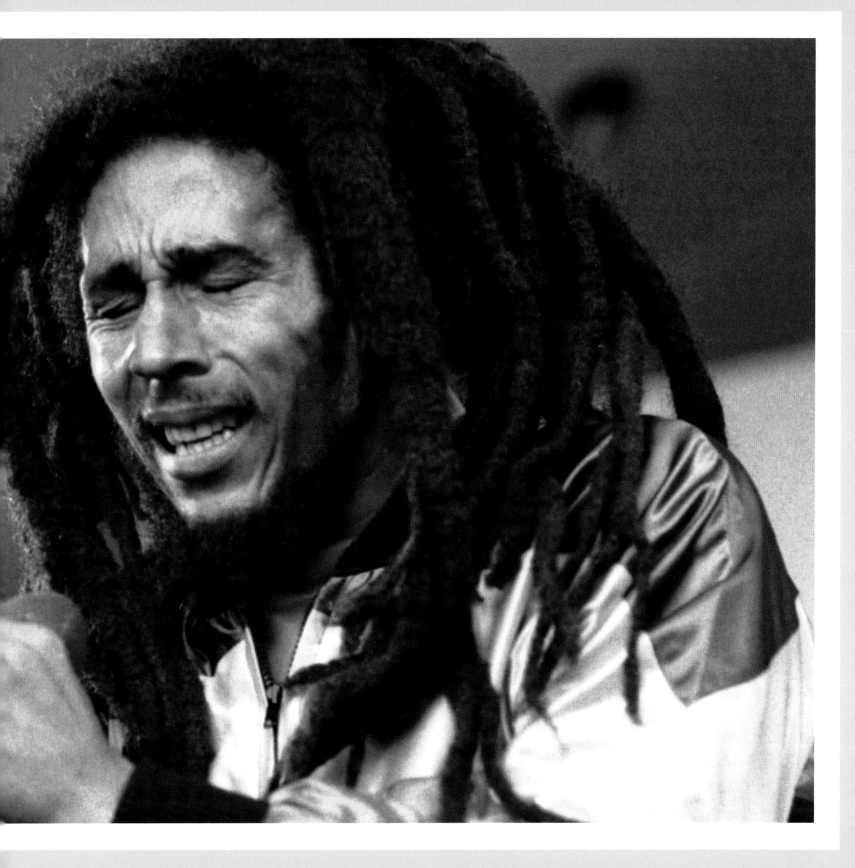

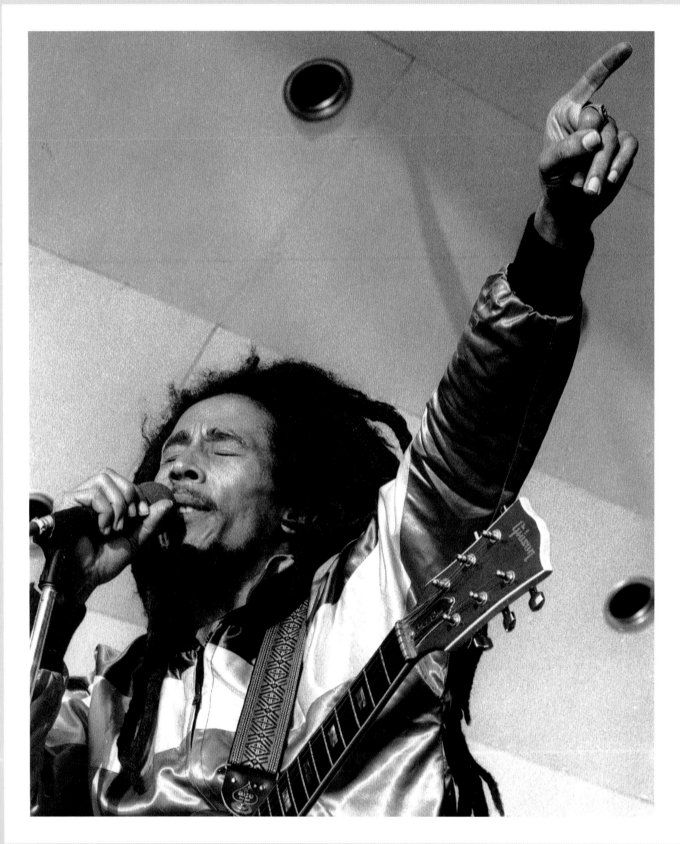

Uprising tour setback

Opposite and left: Scenes from the Uprising tour summer 1980 . Two days after their return to Jamaica Jacob Miller, just 27 years old, was killed in a car crash on Hope Road. This put paid to the plans for Miller and his band to support Bob Marley and the Wailers in the planned tour later in the year.

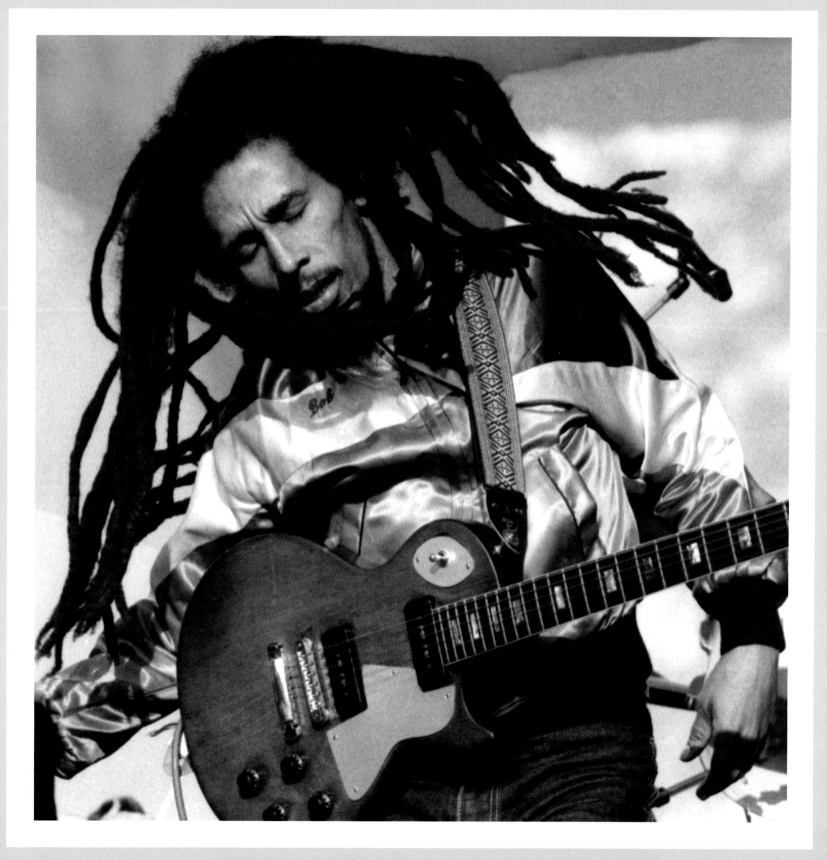

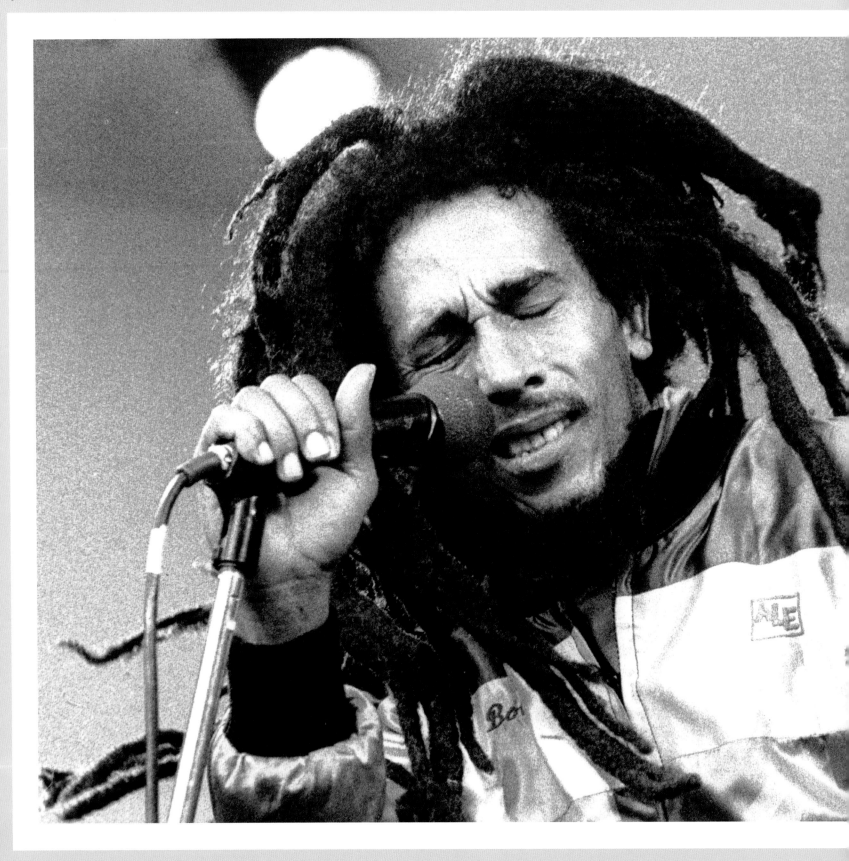

Independence Day

After a long struggle to free itself from an apartheid colonial regime, Zimbabwe planned to celebrate its hard-won independence with a number of different ceremonies. The official independence day was 18 April 1980 and many dignitaries from other nations attended, including Prince Charles, representing the Queen of England. Zimbabwe's struggle had captured Bob Marley's imagination, inspiring him to write the song "Zimbabwe" back in 1978. When, only four days before independence day, he was invited to headline the celebration concert on 17 April he accepted with alacrity, willing to fund the The Wailers' travel expenses himself. Unfortunately the concert turned into a fiasco when a riot broke out, as people of the ZAPU party, rivals of the now ruling ZANU party and who had been denied entrance, overran the stadium venue. The authorities suppressed the riot with tear gas while Bob was performing on stage, and he was led off for medical attention, returning later to finish the set. The next day another free concert was put on for the crowds that failed to get into the formal concert. An estimated 120,000 people were in attendance.

Left: Bob wears an expression of suffering – a prerequisite of the Rastafarian experience and soon to become a permanent state of reality for the star.

Sold-out stadia for the Uprising tour

Despite the approaching illness, Bob's stage performances during the summer of 1980 are full of energy.

Returning to London from Zimbabwe via France the band hooked up with members of the Gabonese ruling family in Paris, spending the night partying. Next day on a photoshoot in London's Royal Garden Hotel, photographer Adrian Boot noted the shattered appearance of Bob and Junior Marvin. The Wailers posed in the lift to provide a photo for the *Uprising* album cover art. For many the resulting picture of Bob, looking pale and ill, is a clear intimation of his approaching death.

On 10 June, when *Uprising* was released, Bob and The Wailers were already well into the European leg of the promotional tour that was to hoist the new album high into the UK charts. The European tour, setting out from Zurich's Hallenstadion on 30 May turned into a succession of sell-out stadium venues, with Bob breaking attendance records – even out-pulling the Pope when the band played the San Siro in Milan shortly after a papal visit there.

Right: Bob connects with the sell-out audience at Crystal Palace Bowl, south London, in June.

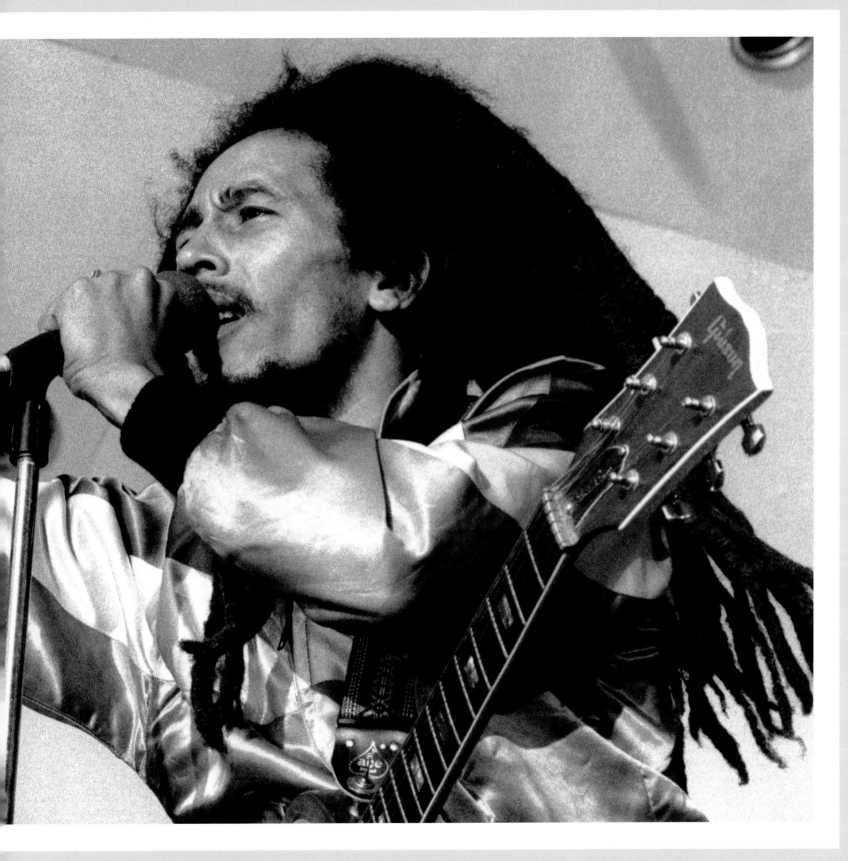

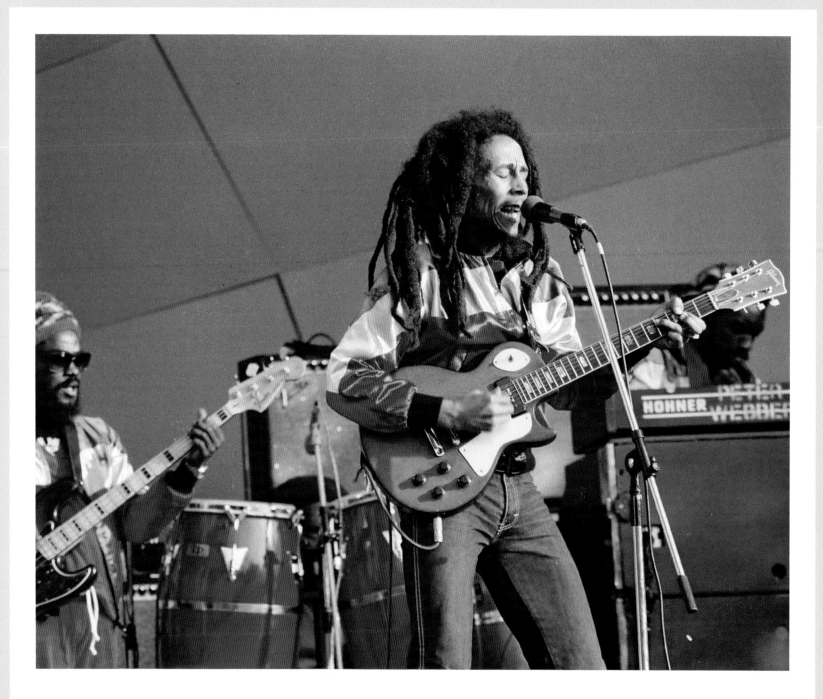

High in the water

Above: Bob in action on the Crystal Palace Bowl stage, having flown into London after their Cologne gig on 6 June to headline the 'Summer of 80 Garden Party' on 7 June.

Fans flock from all over the country to Crystal Palace in south London. The fine weather combined with readily-available cannabis leads to an air of euphoria in the crowd and the atmosphere is dominated by the pervading smoke of countless joints. At one time a giant spliff passes through the audience with a drag available to all who so desire. The small lake intended as a barrier between stage and audience steadily fills with people up to their waists in water. Many have difficulty later in recalling the events of the day but the feel-good factor ran very high.

Redemption Song

Right: Of all the concerts during the Uprising tour, there seems to be the least information about the setlist for the Crystal Palace Bowl; this is perhaps further confirmation of the level of recreational cannabis being smoked on the day. Typically the main set during the tour would end with "Exodus" to be followed by a lengthy encore set starting with "Redemption Song" and usually closing with "Get Up, Stand Up".

"Redemption Song", a downbeat, plaintive acoustic solo, was a late addition to the *Uprising* album; Chris Blackwell on hearing the completed mixes for the album told Bob he thought it needed something more. Without fuss or delay Bob then returned with this classic, which of all the Marley songs is most closely and poignantly associated with him.

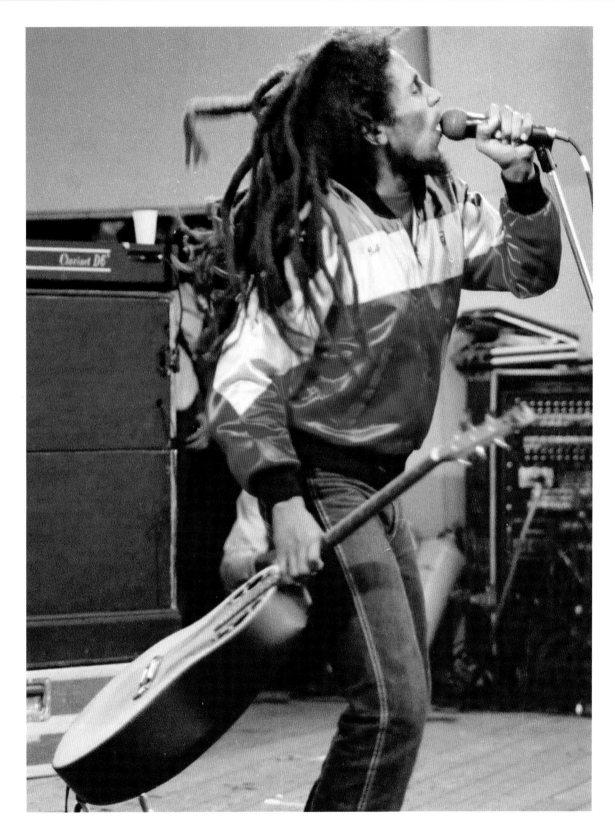

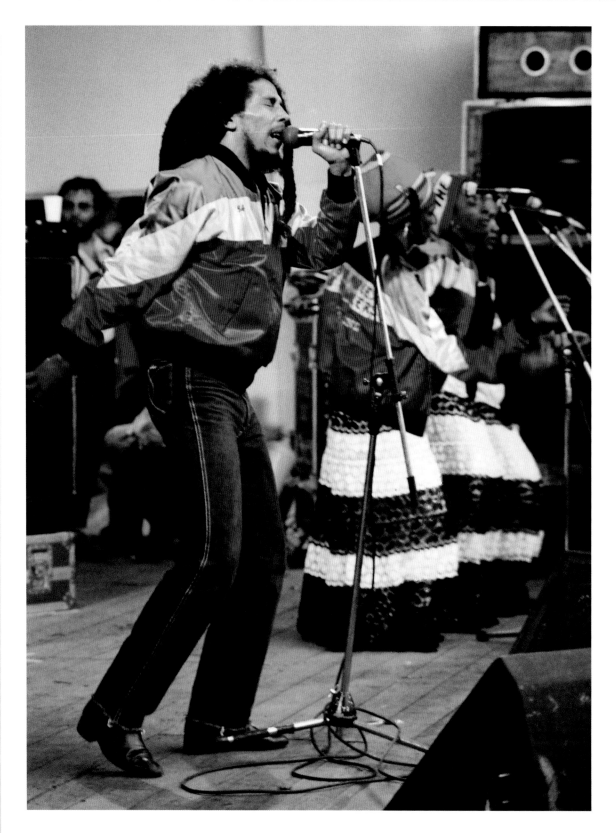

Colours of Ethiopia

Left and opposite; The line-up for the Uprising tour is virtually the same as the Survival tour but no horn section and no extra percussion.

The bright tour jackets shout the colours of the Ethiopian flag emphasizing the militant message unfolding through the successive *Survival* and *Uprising* albums. Behind the band hung an enormous banner of the *Uprising* album artwork proclaiming both Africa's struggle and a more global call to change the world.

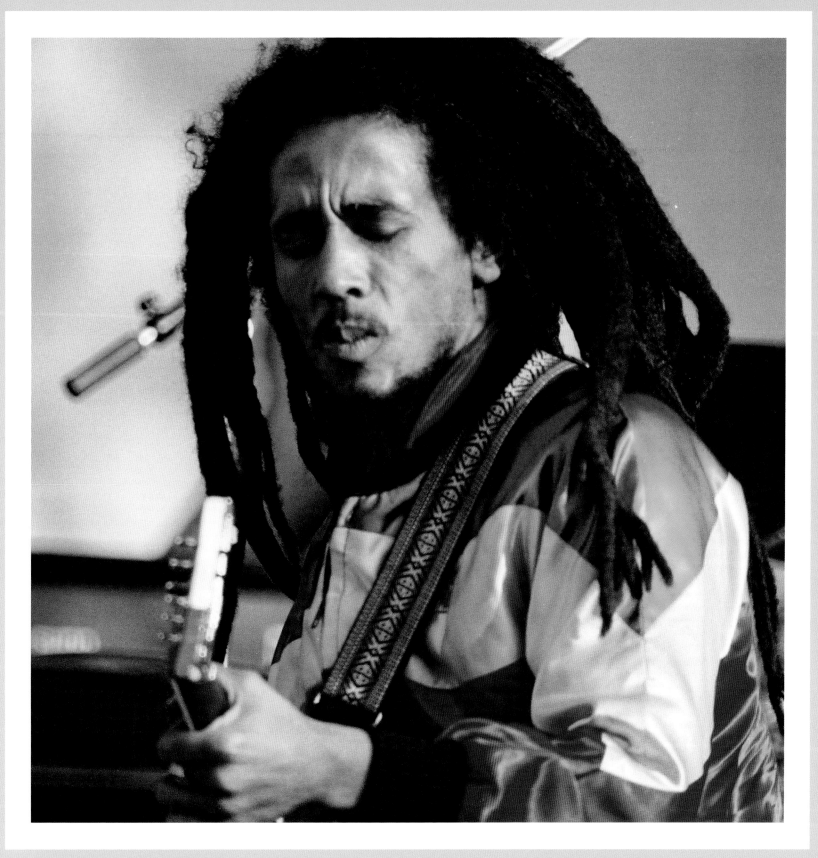

Vindication

Chris Blackwell was among the thousands at the Crystal Palace Bowl for the concert. After persevering in nurturing Bob Marley and The Wailers to bring them to their current heights of popularity he must have felt fully vindicated in the faith he put into his fellow countryman and the money invested in the band.

As the gig ended and the crowd melted away, Blackwell set out for his next appointment – to see a rising new band in a south London club. They are called U2. He will sign them to the Island label.

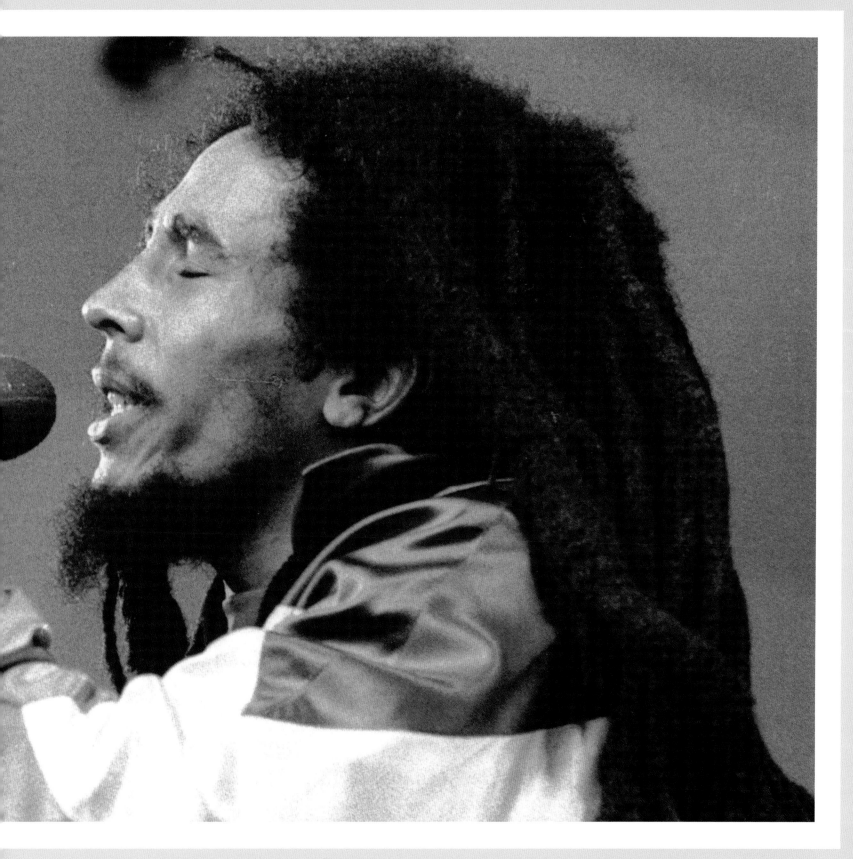

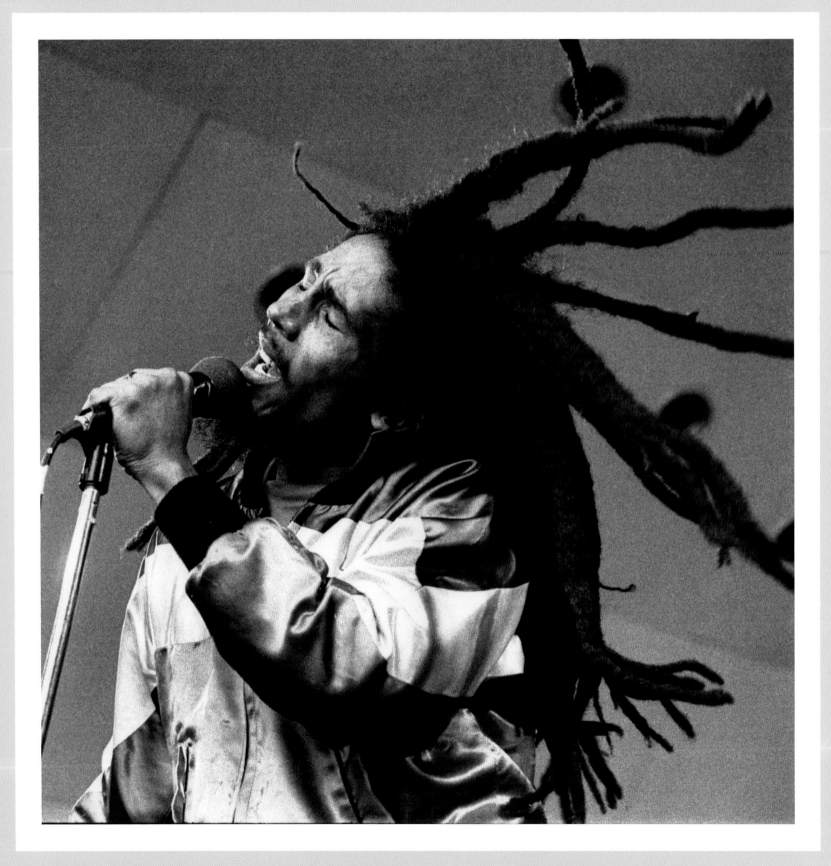

Dash to the airport

Opposite: The Summer of 80 Garden Party draws to a close.

Right: Leaving in a hurry from Crystal Palace Bob still finds time to greet a fan. Security was less strict at that time but in any case The Wailers would socialize with their followers – during the concert Bob and the band had been talking to members of the audience and sharing joints through the chain link fence of the artists' enclosure.

Since a curfew applied to live outdoor performance at Crystal Palace the concert ended before darkness fell. The tour organizer arranged for Bob and the band to fly out to the next stage of the Uprising tour in Germany on an evening flight the same day. Short of time, Bob left the stage and immediately leapt into a car to be taken to the airport. However, the transport due to take them from Munich airport to their hotel failed to arrive and they were forced to spend the night marooned in the airport.

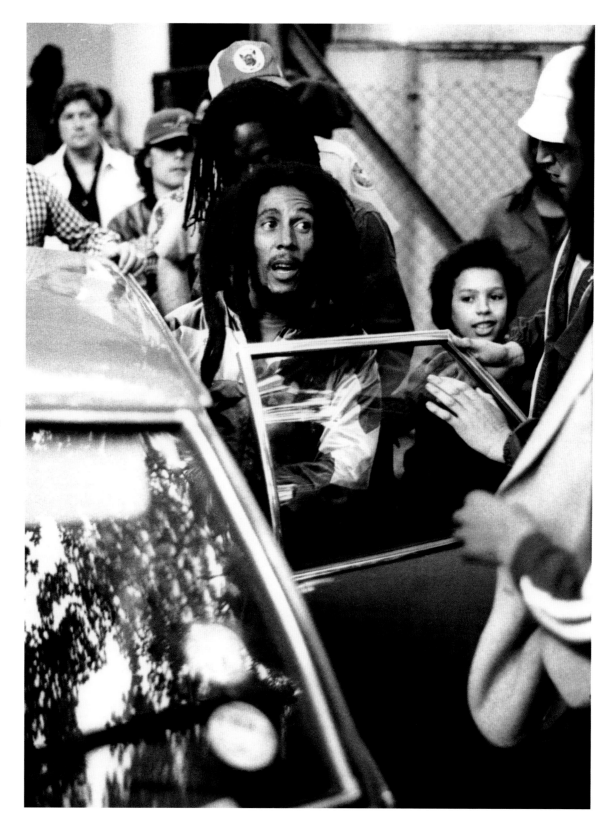

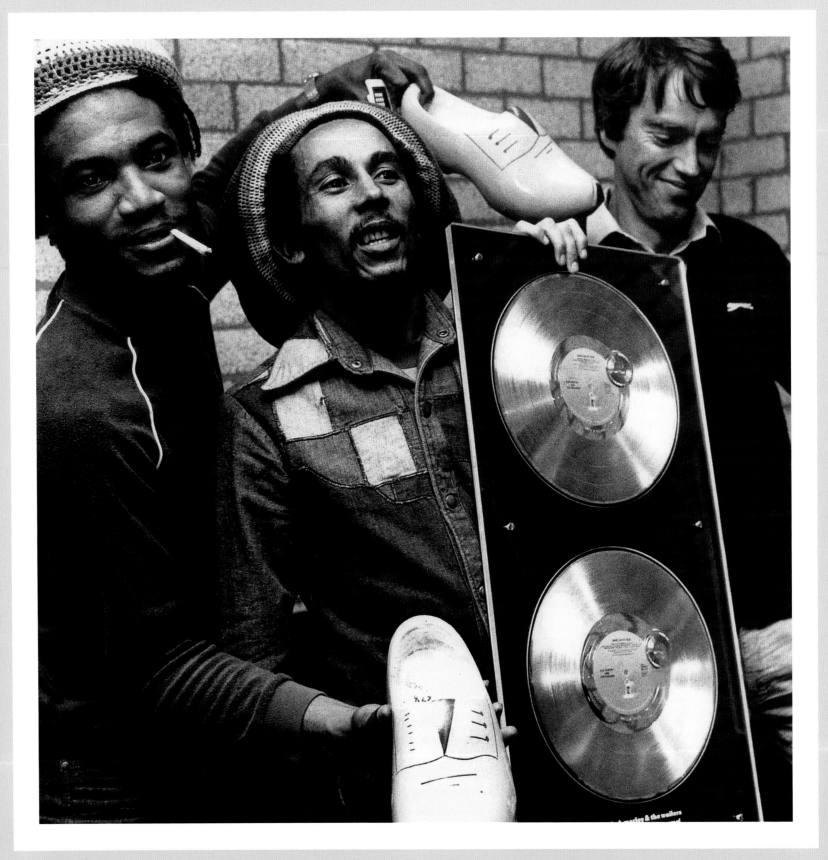

Benelux celebration

Touring on through Germany, Scandinavia, France and Belgium, the band returned to Netherlands music festival Ahoy at Rotterdam on 23 June.

Opposite: Bob in the backstage dressing room at Ahoy with Anton Witkamp of Warner Music (right) from whom he receives commemorative discs for sales exceeding 100,000 copies of *Babylon by Bus* in Benelux. This is accompanied by another certified sales disc for *Live!* – also having sold 100,000 copies in Benelux. Wire Lindo is in support on clogs.

Right: Bob's euphoria seems quickly to transfer to the traditional Dutch clogs which were part of the local record company's presentation. The traditional round Dutch cheese seems to be receiving very little attention!

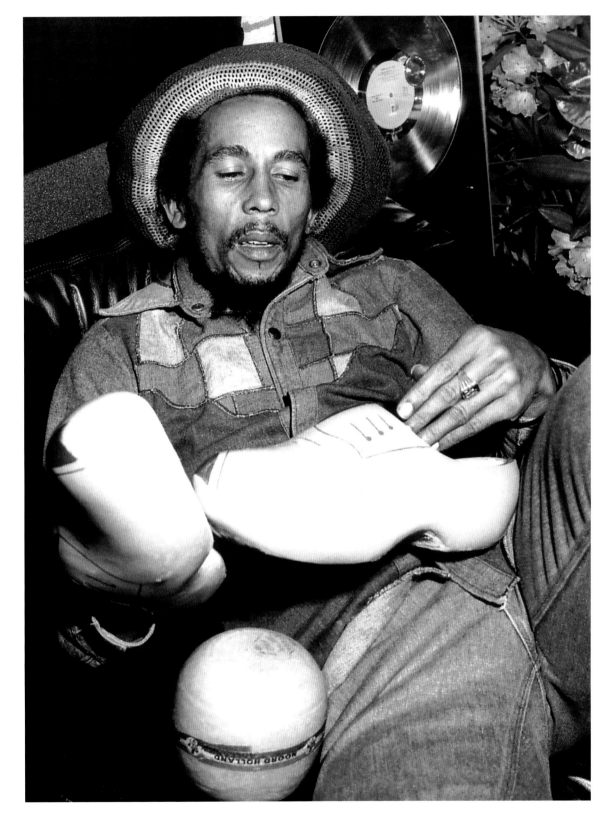

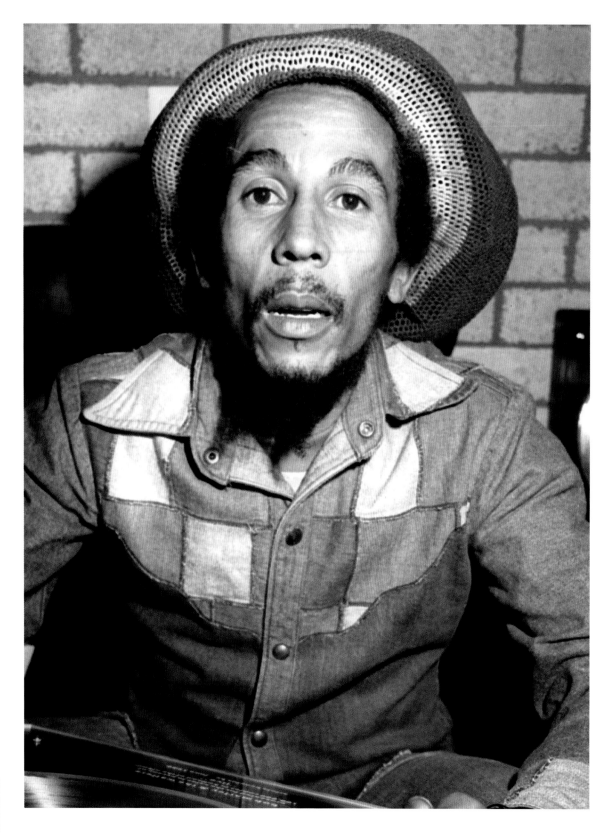

At home in Holland

Left and opposite: Bob and the Wailers are at the height of their popularity in The Netherlands with its liberal laws on cannabis, which could be smoked legally in the country and bought easily in the hundreds of coffee shops, which to this day carry posters of Bob Marley and display the colours of the Ethiopian flag.

However, Bob's popularity had now also reached cult proportions across France and Italy. Not only his music but the causes he espoused had become hot news in the media and as the band scoured the newstands during the Uprising tour, they found themselves the subject of cover stories in every tour venue. They were now one of the most newsworthy bands in the world.

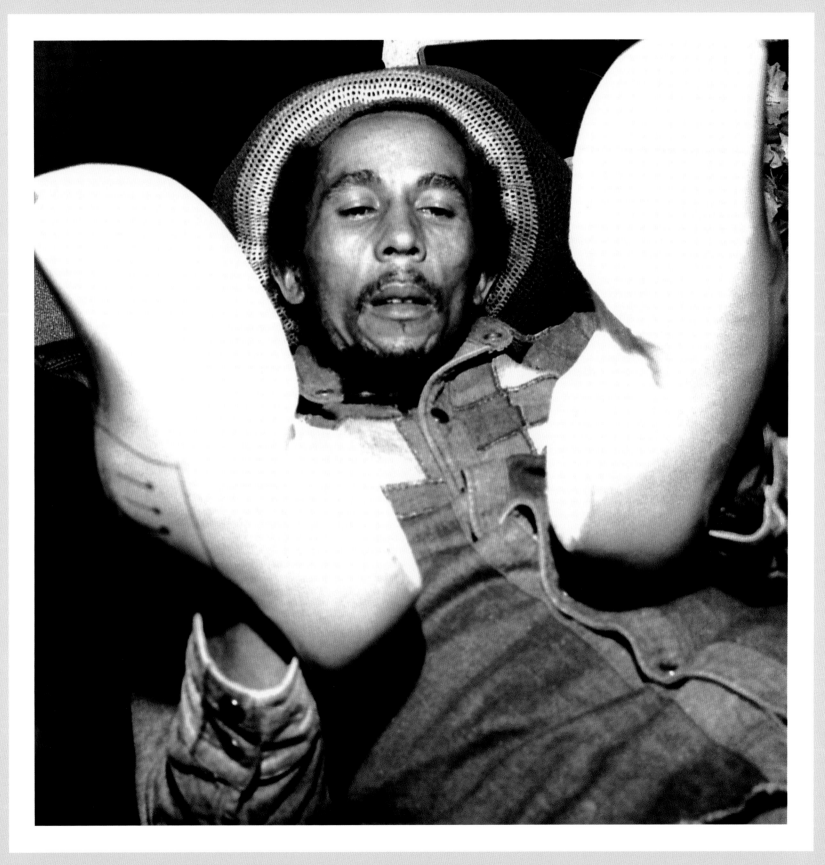

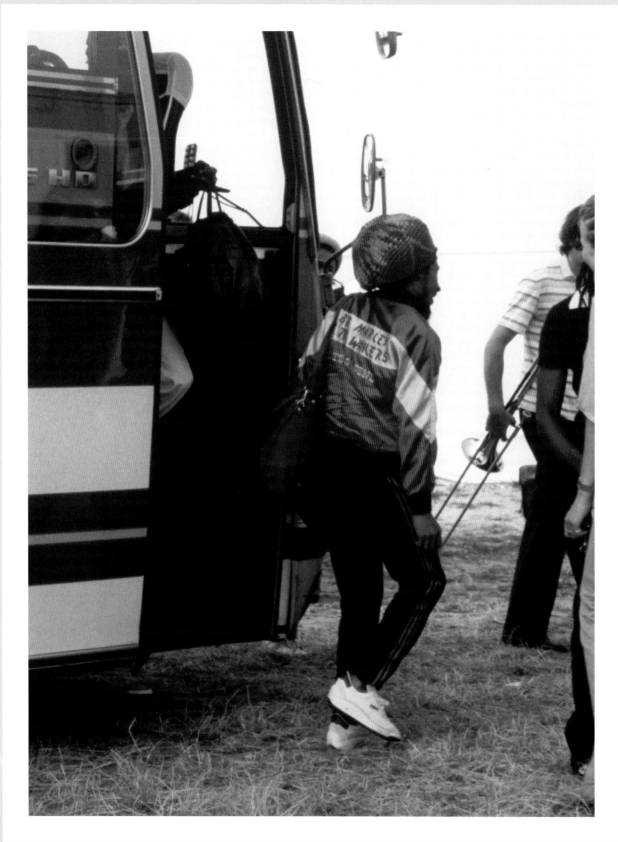

Paris Le Bourget

After dates in Spain, The Wailers played Palais de la Beaujoire in Nantes, France; they made the journey from there to Paris in a small turbo prop aircraft rocked by violent summer storms. The Le Bourget concert was a huge success and the gig concluded with Bob and the band receiving a 20-strong motorcycle escort, sirens sounding, which accompanied the bus back to their city centre lodgings. An aftershow boat trip on the Seine was laid on for Bob and the band with a stunning and expensive light show that was more or less ignored in favour of some good weed and the screening of a recently made feature film. Drama ensued when Tyrone Downie took exception to a stranger's disrespectful behaviour towards Chris Blackwell's girlfriend, actress Nathalie Delon.

Left: Bob steps out of the band's bus at Le Bourget just outside Paris on 3 July. This was the ninth and final gig in France during the Uprising tour. It would be Bob's last ever performance on Europe's continental mainland. There is some irony in that the final injury to Bob's toe that led to the incurable cancer took place in Paris during the Exodus tour in 1977.

Opposite: Rita poses for photographer Jean-Louis Atlan at the legendary Parc des Princes stadium in Paris during The Wailers visit in July 1980.

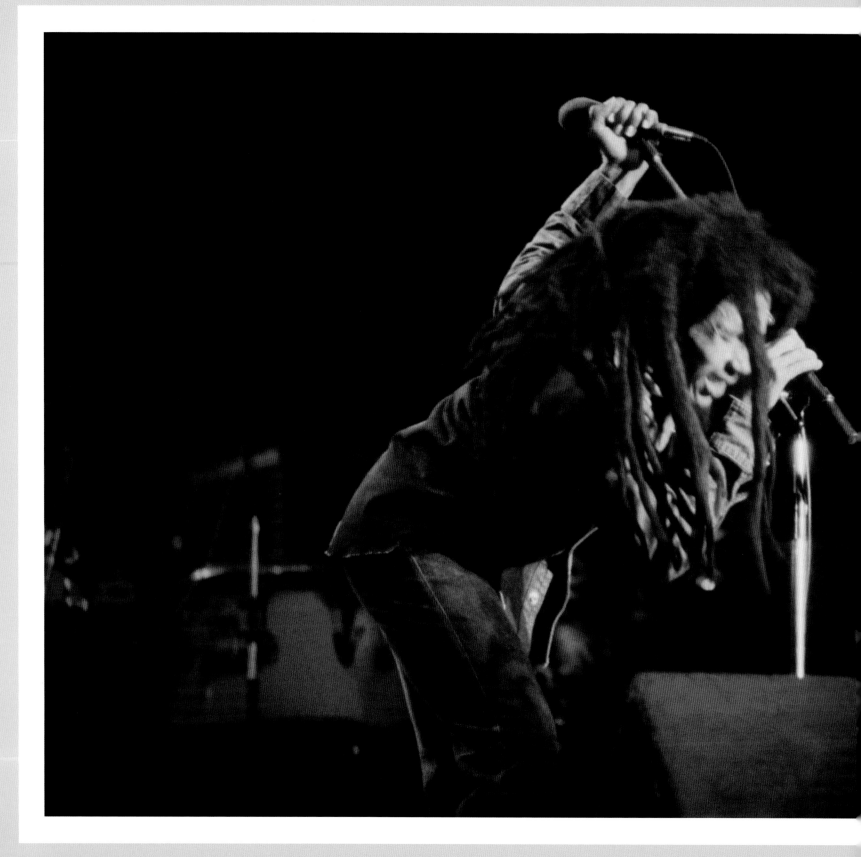

Sporting talk

After returning to the UK for a few more gigs in early July, Bob gave over the daylight hours to football – organizing a five-a-side tournament in a sports centre in Fulham; many of the teams being made up from the media. This was his way of talking to them at this point – formal interviews ceased! The last gig of the last tour was again New Bingley Hall, Stafford on 13 July. The original intention had been that Bob should return to Jamaica after the European leg of the tour, before embarking on the North American dates scheduled for mid-September; however, his island home was still ravaged by violent political unrest and instead he flew to Miami to rest up under his mother's watchful eye.

Left: Bob live on stage with the I-Threes at Le Bourget on 3 July.

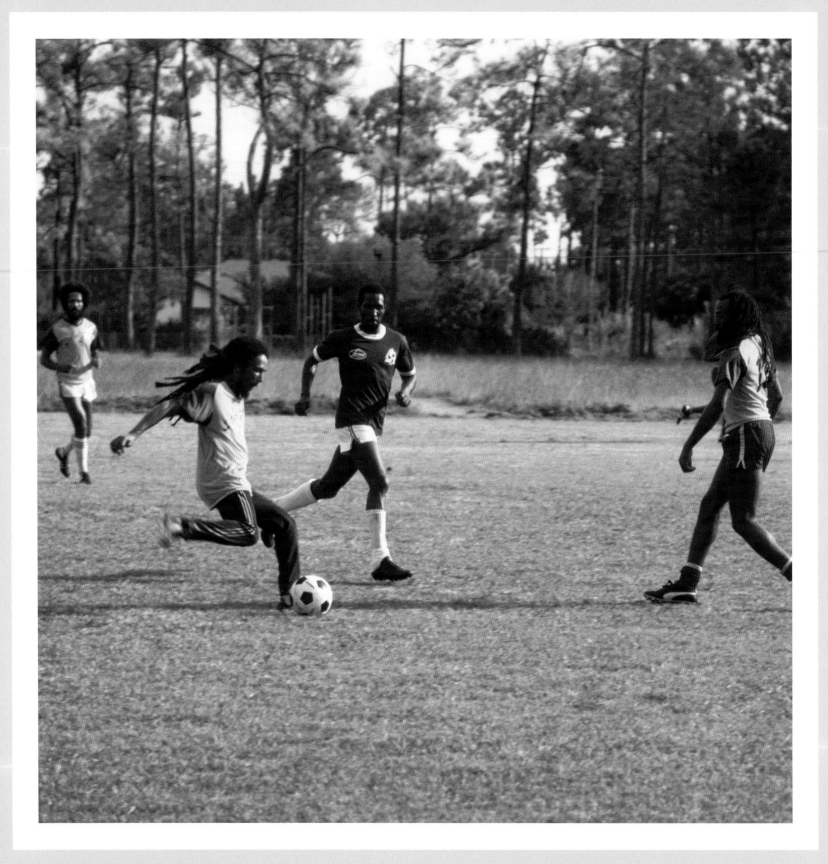

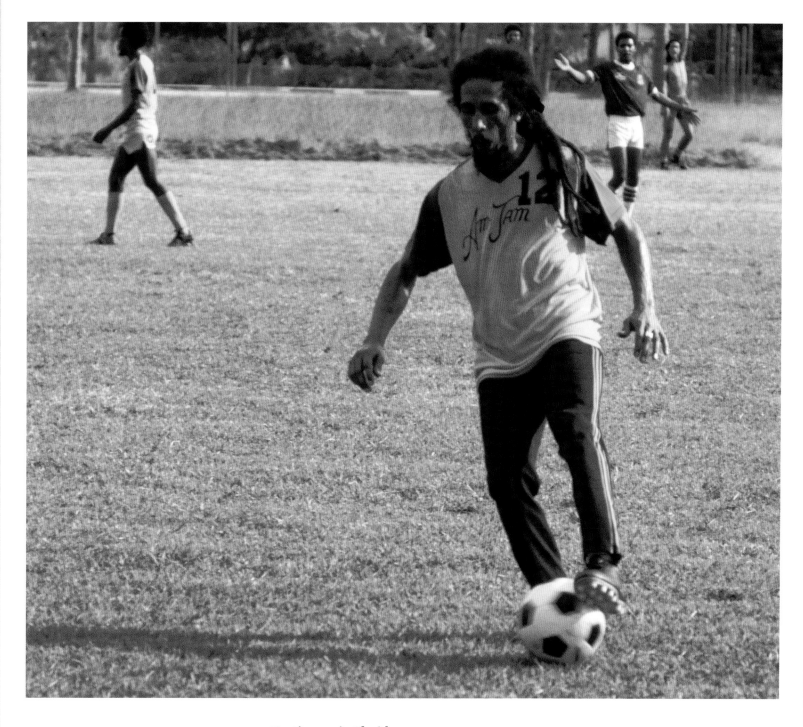

Resting up in Florida

Opposite and above: Resting up in Miami during August and early September awaiting the US leg of the Uprising tour, Bob continues the focus he displayed in London earlier in the summer, giving up as many of the daylight hours as possible to football. Bob plays in the Am-Jam Team (America and Jamaica) against Haiti in Miami in late summer, 1980.

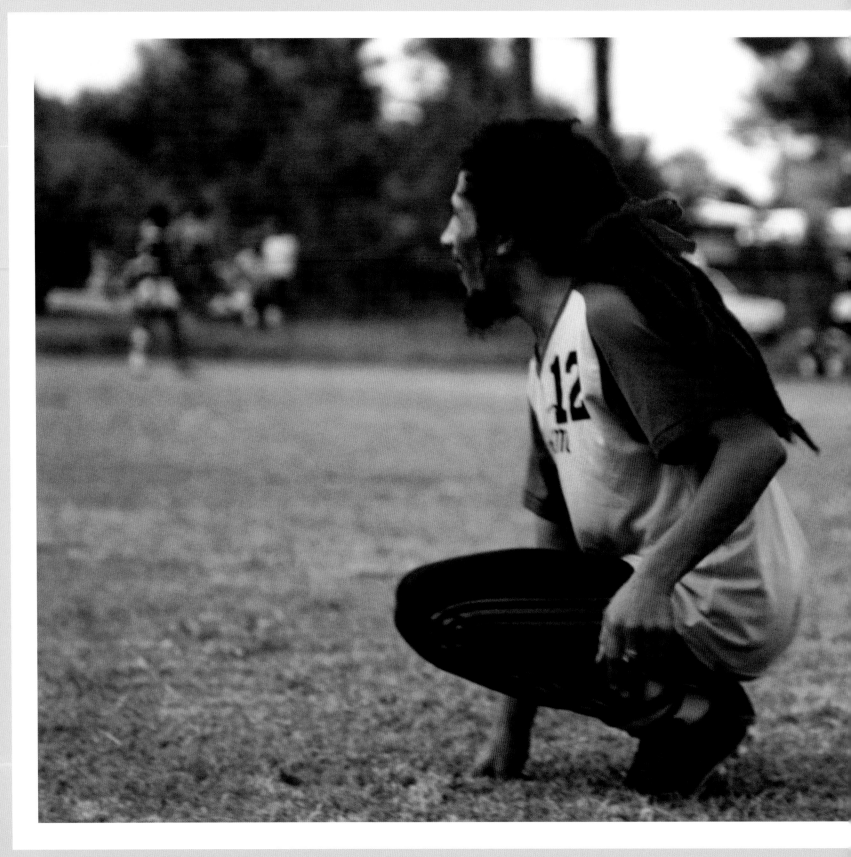

Uprising USA tour

The US tour started out from Boston on 16 September 1980; three days and two shows later, there were two sell-out nights at Madison Square Garden on 19 and 20 September where Bob Marley and The Wailers opened for The Commodores. Clearly in denial of his increasing weakness, Bob hosted an entourage of people in the rooms he was renting in the Essex House Hotel, Central Park South. There was much coming and going and drugs being taken. Outwardly Bob was increasingly looking tired but he was determined to carry on as normal.

Left: In Florida there are signs that Bob doesn't have his normal stamina on the soccer pitch.

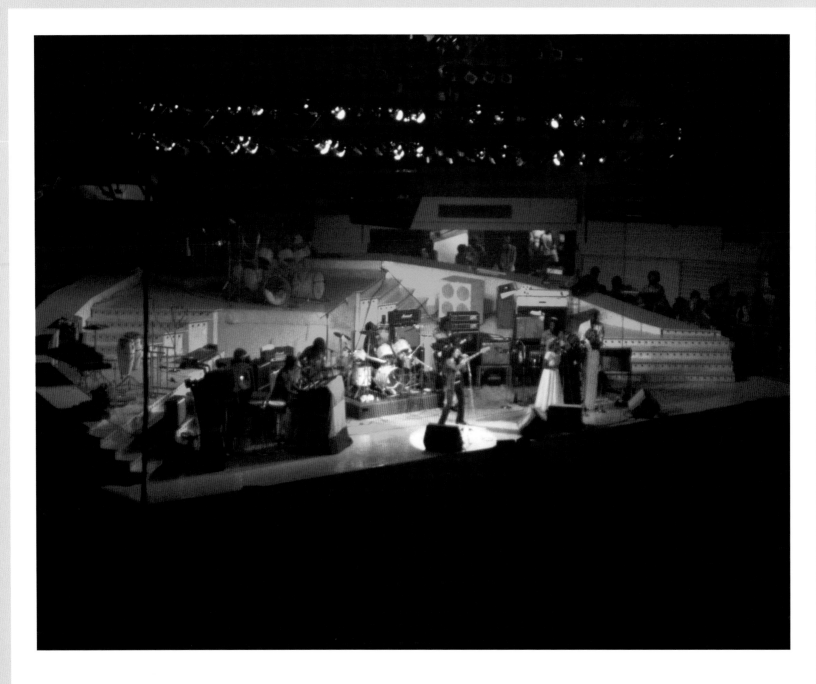

Separate hotels

In a rather curious arrangement, although Bob was staying uptown at the Essex House, the I-Threes and other members of the band were staying at the Gramercy Park Hotel, some distance downtown. No doubt partly because Bob was entertaining Pascaline Bongo, daughter of the Gabonese president, in his suite – a situation shortly to be made even more difficult as Cindy Breakspeare flew in from Jamaica.

Above: Bob and The Wailers perform on stage at New York City's Madison Square Garden. Bob's energy seems inexhaustible and the shows are a storming success.

Opposite: Bob photographed backstage at Madison Square Garden pulls deeply on a joint, growing oblivious to the increasingly chaotic entourage surrounding him.

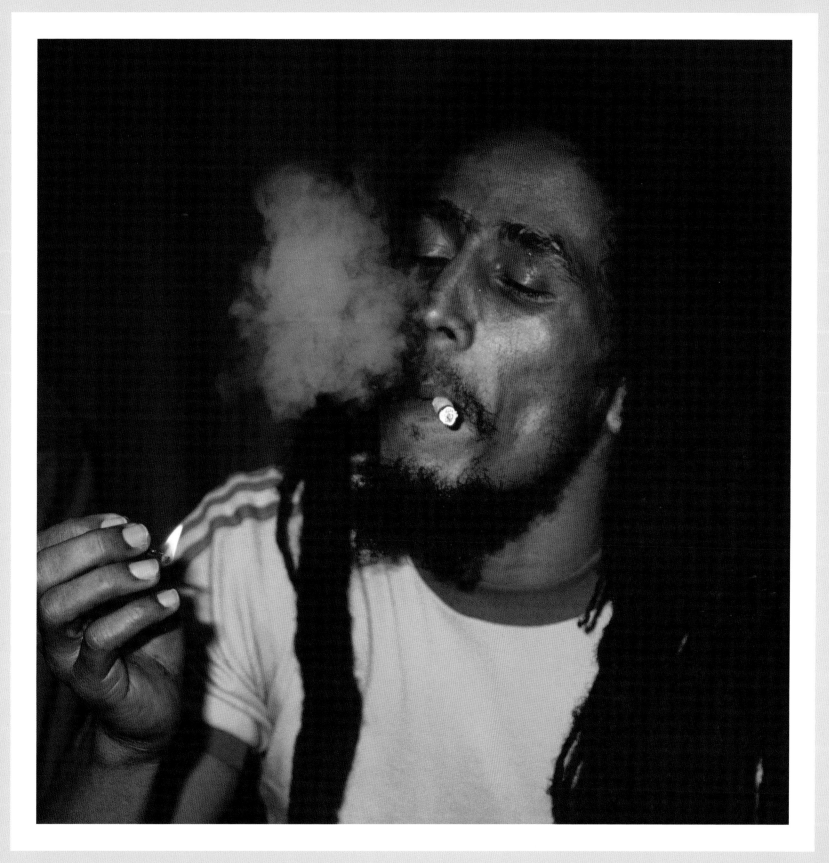

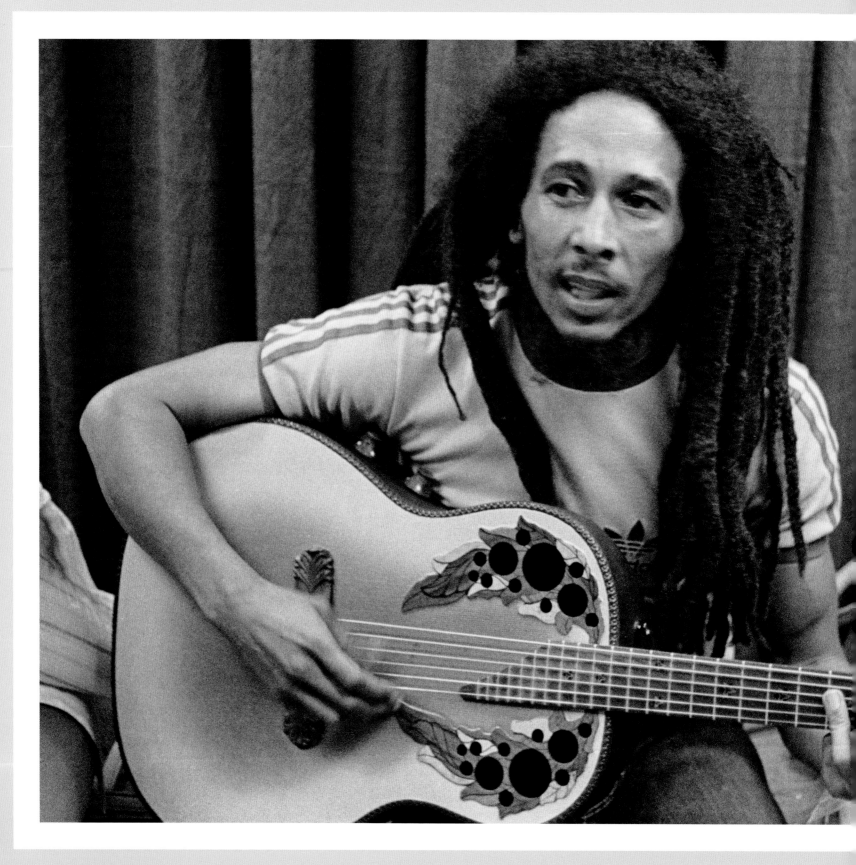

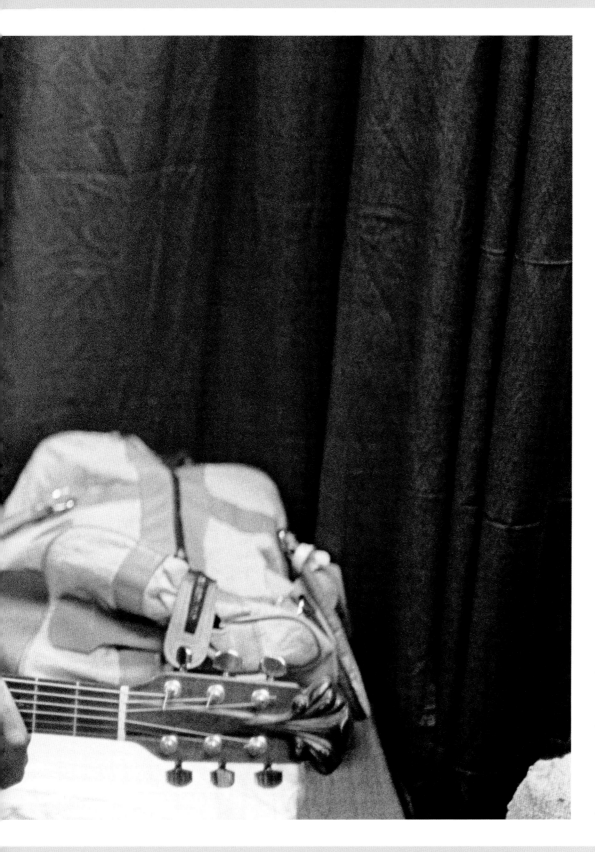

Coming down from the high

Left: Bob picks the strings of his beautifully carved Ovation acoustic guitar backstage at the Garden. The Madison Square Garden concerts were a huge success with the band on top form, however the demands of the gigs and perhaps Bob's nightand day commitments were taking a serious toll on him. On Sunday 21st he woke completely exhausted and decided to try running off his lethargy in Central Park. He was joined by Skill Cole and Danny Sims. Complaining of terrible pain in his neck Bob collapsed. Visiting a neurologist soon after, he was diagnosed with a malignant brain tumour. He was told his condition was terminal and that it would make little difference whether he continued with the tour or not because he will die anyway. On Monday Marley knocked on the door of Chris Blackwell's Essex House apartment to tell him the terrible news in person.

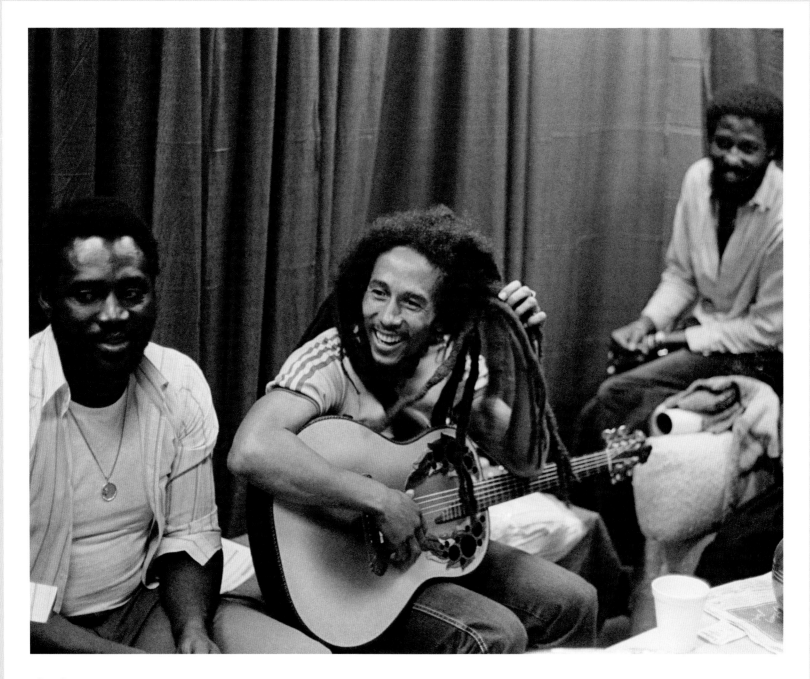

The show goes on

Above and opposite: Backstage at Madison Square Garden the atmosphere seems light. However, band members not staying at the Essex House and other longstanding friends are concerned at the entourage that has assembled around Bob in his hotel. There are a lot of drugs and other people living off Bob while he, seemingly oblivious, smokes and plays his guitar.

While Bob remained in New York, the rest of the band had already departed from Gramercy for their next gig in Pittsburgh on Tuesday night. Rita only found out about Bob's collapse while on the bus and the next day when Bob caught up with the rest of the band in their hotel she said the tour should be cancelled on the spot. The Pittsburgh show went ahead but a press release broke the news that the rest of the tour was cancelled, citing Bob's exhaustion.

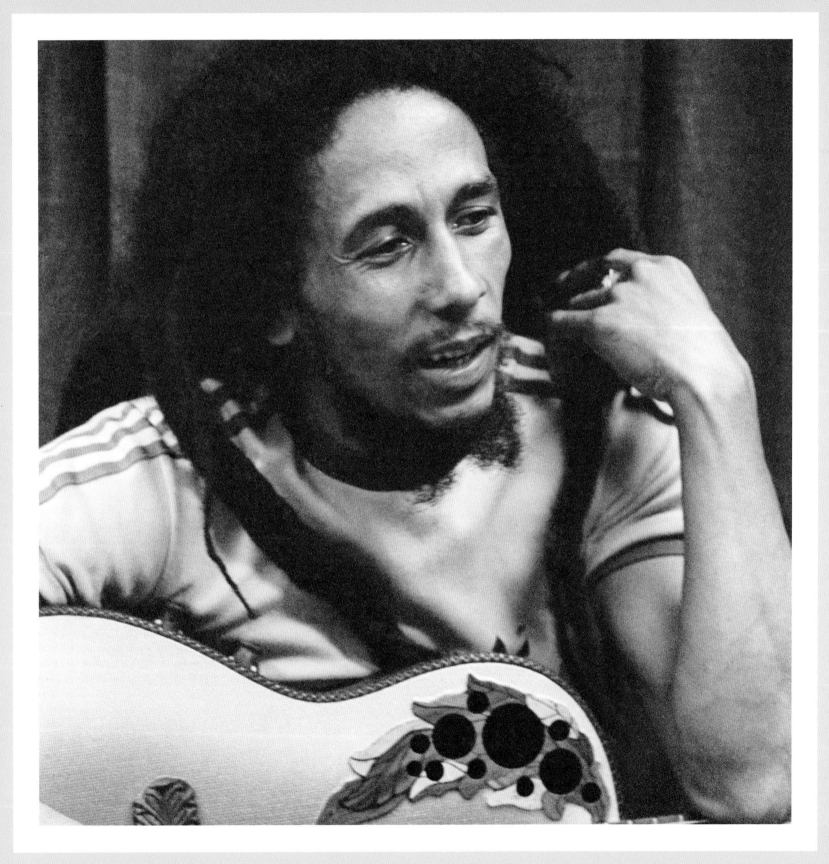

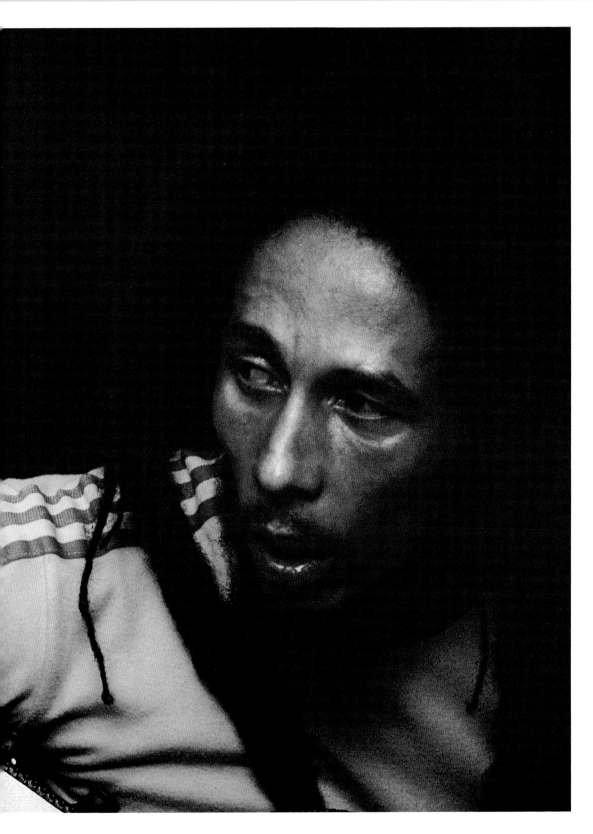

Treatment begins

Left: Bob backstage at the Garden. This dark picture seems to sum up the dire events that will soon unfold.

A strict media blackout descended on reporting his illness and Bob checked into a specialist clinic in Manhattan to receive radiation treatment on the cancer which had now spread through his body. Also spreading were rumours about his illness so Bob checked out of the clinic and underwent outpatient treatment for some weeks before deciding to fly down to Miami where he received further therapy at the Cedars of Lebanon Hospital. Travelling from there to Mexico he paid a brief visit to the cancer clinic that had treated Steve McQueen, then returned to New York. None of the treatments appeared to be working.

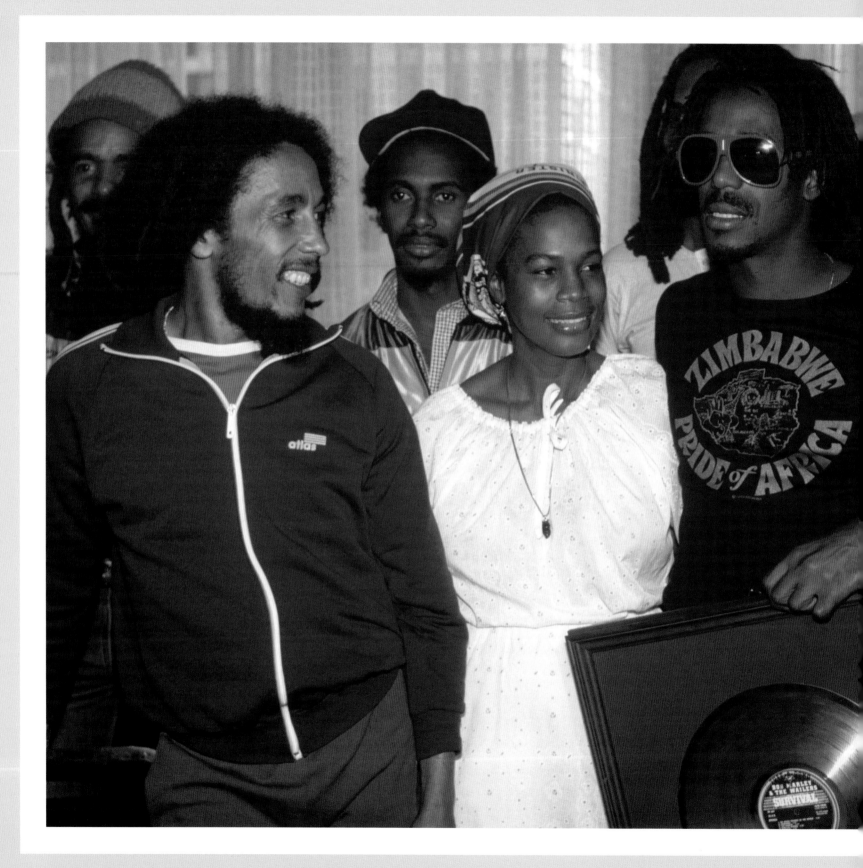

Chapter Four

Legend

1980 was a year of triumph – a complete endorsement of Bob's musical and spiritual aspirations; he had achieved a worldwide following – from a wannabee musician hawking his own records from a bicycle in Jamaica he had risen to be a superstar with his records now eagerly awaited in stores by million of fans around the world. More than this, Bob's music was a compelling and effective vehicle for his convictions about personal freedom, political liberation and man's spiritual destiny. At his last performance ever, in Pittsburgh 23 September 1980, the set opened with "Natural Mystic" from the *Exodus* album. Bob introduced it thus: "Yeah! Greetings in the name of His Imperial Majesty, Emperor Haile Selassie, Jah Rastafari, who liveth and reigneth I'n'I itinually ever fearful, ever sure. They say experience teacheth wisdom, but there's a Natural Mystic blowing through the air!" Perhaps knowing this could be his last ever performance, Bob went on to give his all to the ensuing 90-minute show.

Bob Marley would have never become a legend if he was not such a great artist but the Bob Marley legend was born more from his conviction and his own sense of purpose which took him to great heights while he lived and inspired others to continue with his message after he died. As the year of 1980 drew to a close it was increasingly clear to his friends, family and associates that Bob had little time left.

Left: *Survival* went Gold in 1980; a smiling Bob, Judy Mowatt and Junior Marvin are photographed at the ceremony.

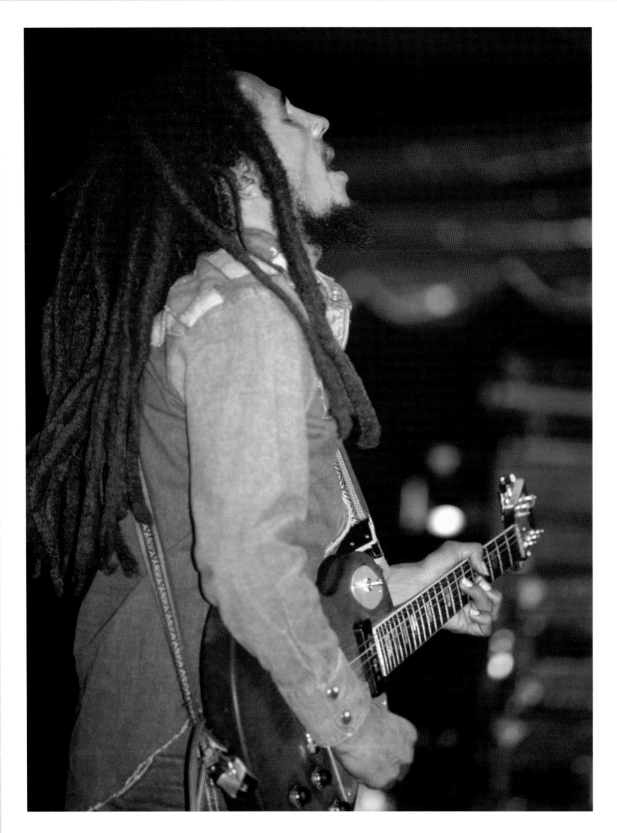

Radical treatment

Left: Bob's unmistakable profile captured on stage in 1980.

Opposite: Signs of strain show on Bob's features as he strums his custom inlaid Ovation during the Uprising tour.
A Jamaican doctor, Carl Fraser, respected by the Rasta community suggested Bob try the controversial Bavarian clinic run by Dr Josef Issels whose unusual methods were generally dismissed by the medical establishment.

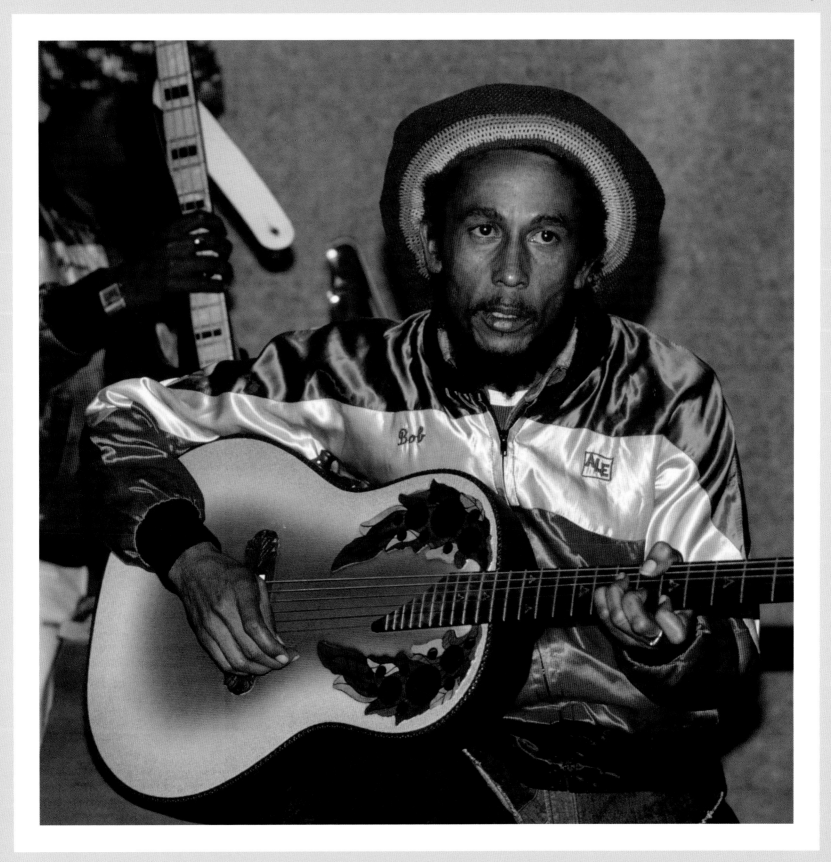

Terminal decline

Right: Bob is almost unrecognizable as the aggressive disease progresses. His mother Cedella is by his side in the final stages of his illness.

By the year end, Bob had flown to Bavaria with an entourage that included his mother Cedella, Rita, his family lawyer Diane Jobson, Skill Cole and Dr Fraser. The treatment at the clinic gave Bob back some hope as well as some physical improvement.

In February he celebrated his 36th birthday in the Ringberg Clinic; his bandmates Junior Marvin, Seeco Patterson and Tyrone Downie flew in to be with him. Together they watched football on TV, no doubt recapturing some of their own football memories when together in The Wailers.

In April Bob was awarded Jamaica's Order of Merit – the country's highest civilian honour. The award was announced on the auspicious date of 22 April and accepted on Bob's behalf by his son Ziggy. As the spring wore on, there was no further improvement and, showing all the signs of terminal decline, Bob flew back to Miami where, in the Cedars of Lebanon Hospital, he passed away on 11 May 1981.

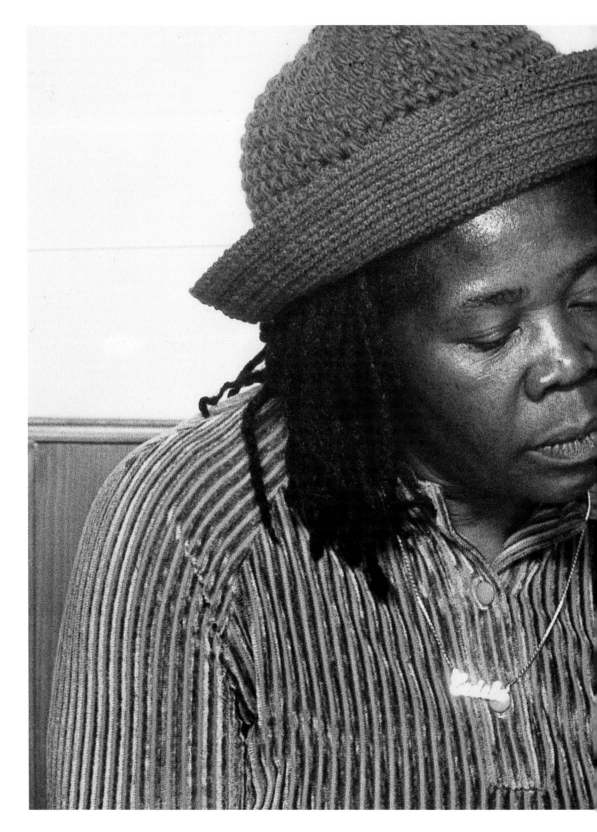

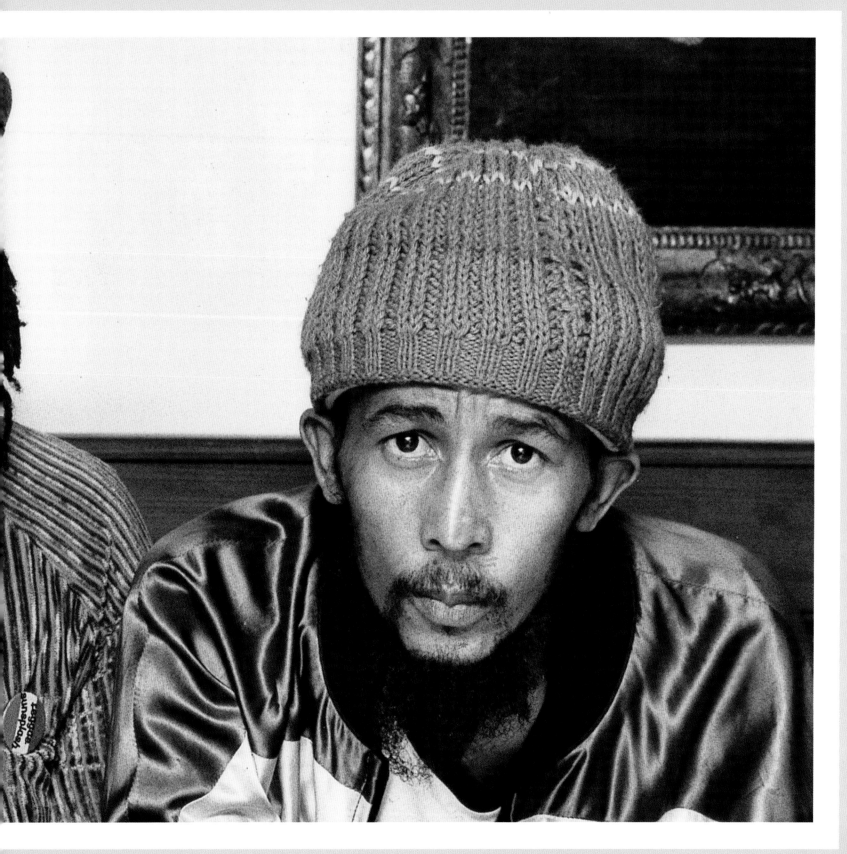

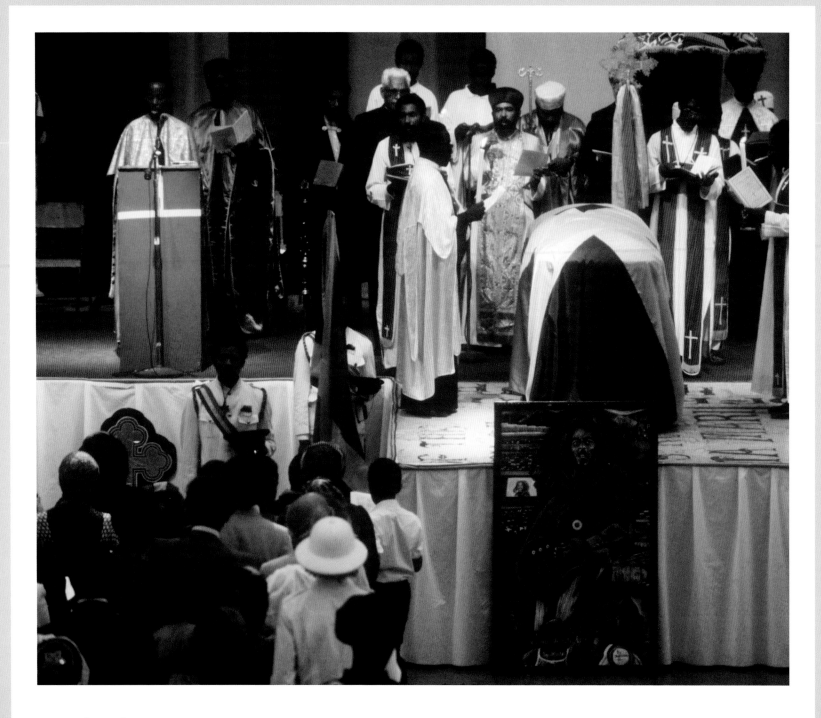

Heroes funeral

Jamaica plunged into shocked mourning for its most famous son, with parliament going into recess until after the state funeral which took place on 21 May. Lying in state in his coffin, Bob received the respects of an estimated 500,000 mourners; this was the biggest funeral event ever seen in the Caribbean.

Above and opposite: Bob's funeral service was held appropriately in Kingston's National Heroes Arena, scene of the artist's many local triumphs; it was conducted by leaders of several faiths.

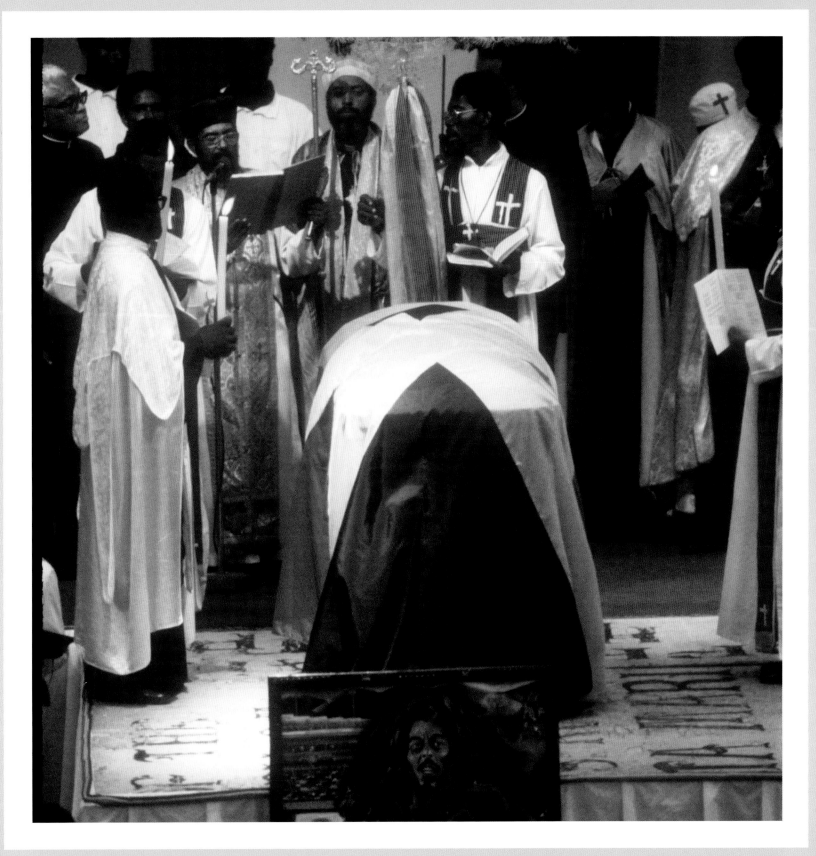

Indelible imprint

Opposite: The ceremony combines elements of the Ethiopian Orthodox Christian rites with the local Rastafari tradition. The state also takes part, as officers take the role of pall-bearers. Prime Minister Edward Seaga, now in power after winning recent elections, delivered the eulogy. "Bob," he said, "was an experience which left an indelible imprint with each encounter. Such a man cannot be erased from the mind. He is part of the collective consciousness of the nation".

Above: Bob's mother, Cedella, mourns her son; wife Rita has a protective arm around nine-year-old Stephen.

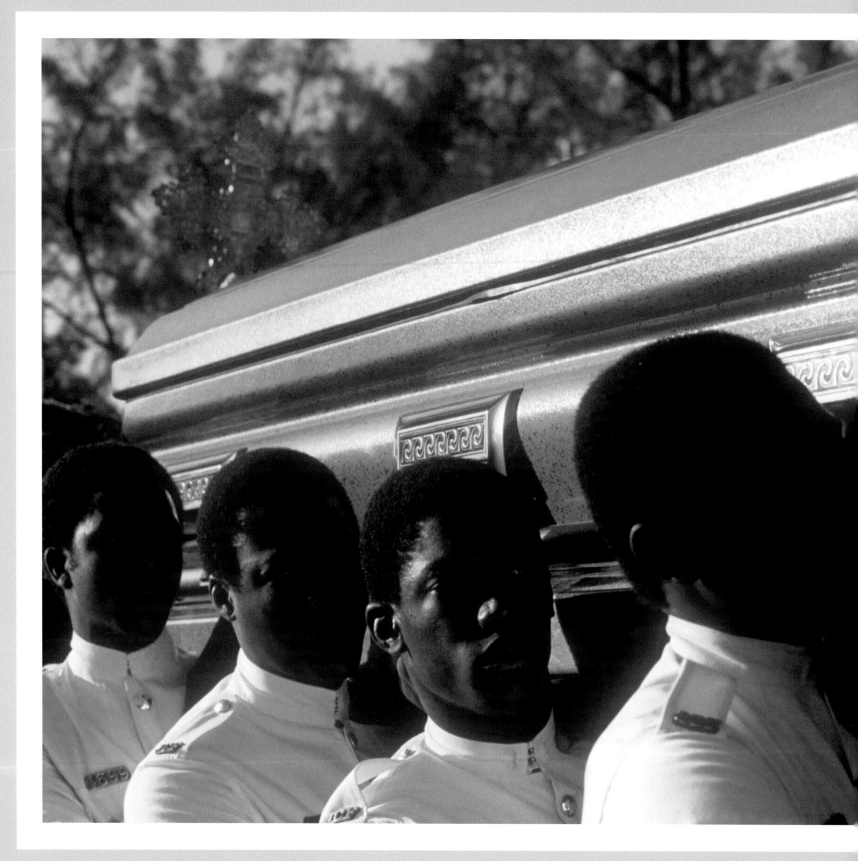

Handing down the legacy

Rock stars who die early continue to make their presence felt – eerily – as if they haven't died at all but have simply become reclusive. Bob was more than a Morrison or a Hendrix because he had connected himself so strongly with a spiritual movement, of which he considered himself to be a leader, prophet and disciple. Many of Bob's followers embraced not just his music but the whole package. And to add to the musical legacy was a generation of heirs carrying Bob's DNA both physically and musically. The next decades would see Bob's legacy flourish, with his unpublished music being released, his early music compiled and his heirs taking The Wailers' music back into live performance, becoming reggae stars in their own right.

Three months after he died, Bob's last child came into the world, symbolic of his continuing stardom.

Just as *Kaya* was the product of the sessions that also gave *Exodus*, Bob had left sufficient material for a third album in the trilogy, *Survival*, *Uprising* and then, in May 1983 on the second anniversary of his death, *Confrontation*. Released on Tuff Gong and Island, it included "Buffalo Soldier", a song that particularly attracted Chris Blackwell's attention, hearing many reverberations of meaning as well as its hit sound.

Left: Bob is buried at a chapel close to his birthplace in the parish of Nine Mile, St Ann. With his body, so the legends go, are his bible, his guitar and the distinctive black ring once worn by Haile Selassie himself.

Reggae royalty

Above: Judy Mowatt and Rita sing at Bob's funeral. Following Bob's death both Rita and Cedella develop their musical careers, having being rather overshadowed by Bob during his lifetime. They proclaimed themselves Queen and Queen Mother of Reggae, both of them releasing their own records and, in Rita's case, setting up her own label.

Opposite: Five years to the day after Bob's death the Bob Marley Museum, aka 56 Hope Road, opens to the public.

Taking care of business

Marley died intestate. He had become a wealthy man but by all accounts his wealth didn't interest him and he left its management to others. Although he had a longstanding trusted family lawyer, she had apparently not provided him with a will. After Bob died Rita took over the bulk of Bob's estate, producing papers signed in 1978 in the possession of Bob's corporate attorney, David Steinberg; these showed Bob had transferred most of his financial assets to Rita.

Above: Rita Marley photographed with daughter Cedella in 2002. Cedella sports a tee-shirt made by her own manufacturing company Catch A Fire which she started up in 2000. Her role continues as CEO of Tuff Gong International.

Opposite: The Africa Unite concert – day of celebration for Bob Marley's 60th birthday is held on 7 February 2005 in Mesquel Square, Addis Ababa. Ethiopia.

Melody Makers to Mobo

In 1983, a quartet of Bob's children, Sharon, Cedella, Ziggy and Steve released their album *The Trip*, their name the Melody Makers. The youngest was 11-year-old Stephen, the oldest 17-year-old Sharon. Bob's musical legacy was set to continue via his children, notably Ziggy, Stephen and Damian – all going on to become multiple Grammy winners.

On 8 May 1984 the Bob Marley and The Wailers compilation album *Legend* was released on Island/Tuff Gong; it went straight to No. 1 in the UK album charts and remained there for 19 weeks, going double platinum in the same month it was released.

Concluding a longstanding legal wrangle Bob's estate was instructed to be put up for auction by the Jamaican authorities, directed by Judge Clarence Walker, Supreme Court Justice. Marley's recording and publishing assets were eventually acquired by Chris Blackwell, Rita, and Marley's children for $11.5m in December 1991.

Opposite: Rita and three of Bob's sons attend the 10th Anniversary Mobo (Music of Black Origin) Awards at the Royal Albert Hall on 22 September 2005. Damian (far right) wins Best Reggae with his "Welcome to Jamrock". Julian stands to the left of Rita and Stephen next to Damian. Bob Marley receives a posthumous lifetime achievement award at the ceremony.

Right: The blue plaque marking Bob's first London residence in Ridgmount Gardens, Bloomsbury is unveiled on 26 October 2006.

MAYOR OF LONDON

ROBERT NESTA MARLEY

1945 - 1981

SINGER, LYRICIST AND RASTAFARIAN ICON

LIVED HERE 1972

NUBIAN JAK COMMUNITY TRUST

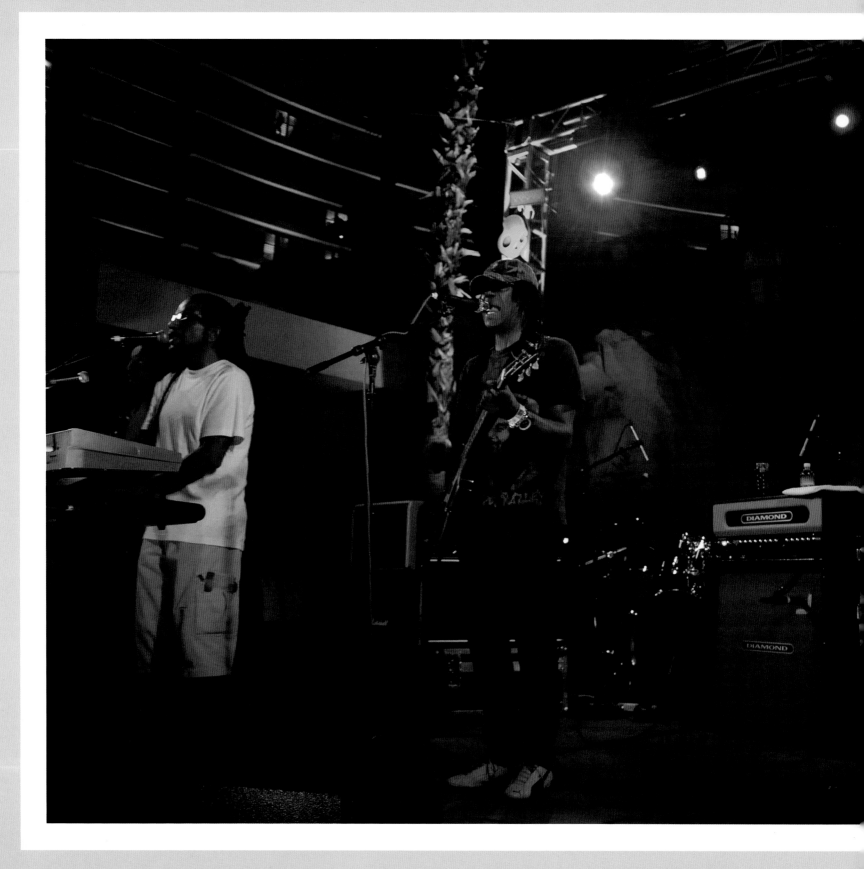

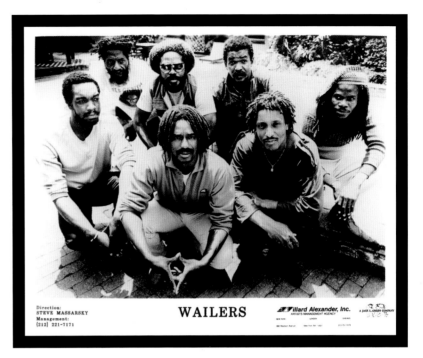

Hall of Fame

In 1994 Bob Marley was inducted into the Rock and Roll Hall of Fame by Bono – Rita accepted on Bob's behalf at the 9th Annual Dinner held in New York's Waldorf-Astoria Hotel.

In 1999 *Time* magazine chose Bob Marley & The Wailers' *Exodus* as the greatest album of the 20th century beating Miles Davis's *Kind of Blue* and Hendrix's *Are you Experienced.*

In 2001, Marley was posthumously awarded a Grammy Lifetime Achievement Award and received a star on Hollywood's Walk of Fame.

In succession a commemorative statue of Bob was inaugurated sited close to the national stadium on Arthur Wint Drive in Kingston and the BBC nominated "One Love" song of the millennium.

Most recently, in 2010, *Catch A Fire* was inducted into the Grammy Hall of Fame.

Left: The Original Wailers perform poolside at the Hard Rock Hotel, Las Vegas as part of Rogue's Friday Night Summer Concert Series, 10 June 2010. Junior Marvin and Al Anderson formed this band in 2008 after breaking away from The Wailers, which continued after Bob died and was headed up jointly by Family Man and Junior Marvin. Bunny Livingston and Beverley Kelso are the only surviving members of the original Wailers, making Junior Marvin's band something of a misnomer. Without Bob's leadership and in the wake of what members of The Wailers felt was an unequal distribution of earnings, the modern history of The Wailers since Bob's death has been turbulent and a far cry from the spirit of the band under Bob.

Chronology

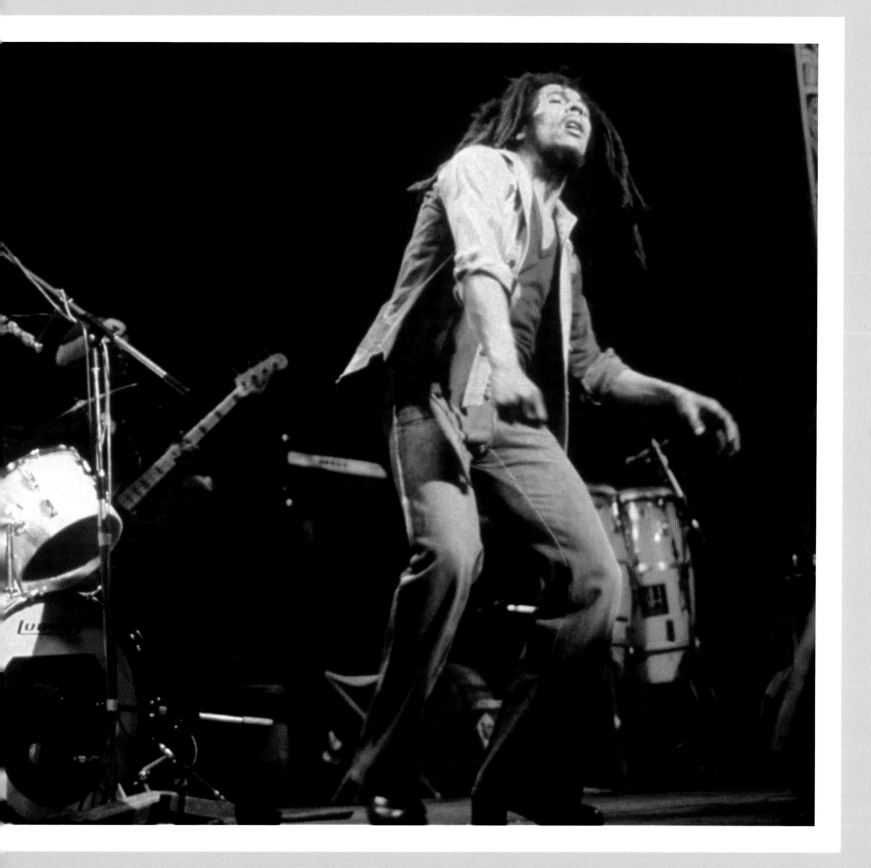

1945

February 6: Birth of Robert Nesta "Bob" Marley. His father is in his 50s, a white Jamaican named Norval Marley. His mother is the 19-year-old Cedella Malcolm.

1946

July 25: Birth of Alvarita Constantia Anderson in Cuba to Jamaican father and Cuban mother.

November 22: Birth of Aston "Family Man" Barrett in downtown Kingston.

1956

Nine-year-old Neville "Bunny" Livingston moves to Nine Mile where Bob is living and strikes up a fast friendship, strengthened as Bob's mother moves in with Bunny's father. Eventually, the new "family" moves together to Kingston.

1959

Bob leaves school at the age of 14 to make music with Joe Higgs, a local singer and devout Rastafari. At a jam session with Higgs and Livingston, Marley meets 15-year-old Peter McIntosh (later known as Pete Tosh).

1962

Marley records his first two singles, "Judge Not" and "One Cup of Coffee", under the pseudonym of Bobby Martell, with local music producer Leslie Kong. After giving birth to baby Pearl Livingston, half-sister to Bunny Wailer, Marley's mother Cedella leaves for Wilmington, Delaware, intending Bob to follow when she's settled.

1963

Bob Marley, Bunny Wailer, Peter Tosh, Junior Braithwaite, Beverley Kelso and Cherry Smith form a ska and rocksteady group, calling

themselves "The Teenagers". They later change their name to "The Wailing Rudeboys", then to "The Wailing Wailers".

1964

Alvin "Seeco" Patterson introduces the band to leading producer Clement "Coxsone" Dodd who auditions them during the summer and immediately inaugurates their recording career as The Wailers with "Simmer Down". The single is an immediate number one in Jamaica and goes on to sell over 80,000 copies. Junior Braithwaite leaves The Wailers to work in the USA and Bob takes over lead vocals.

1965

The band's first album, produced by Coxsone Dodd, *The Wailing Wailers*, a compilation of their 1960s singles, is released on Studio One label. By the end of the year, The Wailers have five tunes in the top ten at the same time but Beverley Kelso can't take the pressure from Bob and leaves the band.

1966

February 10: Bob marries Rita Anderson, and leaves the following day for his mother's home in Wilmington, Delaware.

April 21: Emperor Haile Selassie visits Jamaica and Rita becomes Rastafarian.

October: Bob returns to Kingston. He and Rita move in with Rita's Aunt Viola. Bob also becomes Rastafarian. The Wailers start their own record label Wail 'n Soul 'm. During the day they sell records from the front of the house.

1967

The Wailers open a tiny shop in Kingston; Bob delivers Wail 'n Soul 'm records around the island by bicycle.

June: Bunny is jailed for three months on false charges of ganja possession.

August 23: Bob and Rita's first child Cedella is born.

1968

January 7: American soul singer Johnny Nash discovers Marley at a Rasta grounation: he and his partners Danny Sims and Arthur Jenkins sign Peter and Bob to writing contracts, and The Wailers to performing agreements. They start recording on the JAD label.

October 17: Bob and Rita's second child David "Ziggy" is born. With Rita's first child, Sharon by another father, born in 1965, they are now a family of five.

1969

In the summer Bob and Rita visit Bob's mother in Delaware so Bob can earn some money. Bob prophesies to a couple of young American friends, Ibis Pitts and Dion Wilson: "I am going to die when I am 36." Bob writes "Comma Comma" which becomes an international hit for Johnny Nash.

1970

In the spring, The Wailers agree to record an album for Leslie Kong, Bob's original producer, now a millionaire from the sales of such songs as "My Boy Lollipop" and "The Israelites." The Wailers make the world's first real reggae album released as *The Best of the Wailers*; Bunny urges Kong not to title the album this way, claiming that one never knows one's best until the end of one's life.

Now The Wailers join with another rising star migrant of Coxsone's Studio One, Lee "Scratch" Perry. Their time together is less than a year, but

it produces what many consider to be some of the original Wailers' finest work, backed by the Upsetters' pulsing rhythm team, brothers Aston "Family Man" Barrett on bass and Carlton "Carly" on drums. They record such classics as "Soul Rebel", "400 Years", "No Sympathy", "Kaya", "Brand New Secondhand", "Mr. Brown", Dreamland", and "African Herbsman. Perry sells their tapes to Trojan in England, who release them as the albums *Soul Rebels*, *African Herbsman*, and *Soul Revolution Part II* .

December: *Soul Rebels* released on Upsetter in Jamaica and Trojan in UK.

1971

Understandably upset with Perry, the Wailers start another label, Tuff Gong. with Alan "Skill" Cole as business manager. The Barrett brothers leave Perry and become a permanent part of The Wailers. Producing themselves, the Wailers begin a new series of local hits, including "Screw Face", "Trench Town Rock", "Concrete Jungle", "Guava Jelly" (also successfully recorded by Barbra Streisand and Johnny Nash), and "Lively Up Yourself".

August: *Best of The Wailers* released on Beverley's label; Kong, ignoring Bunny's warning about its title, drops dead from a heart attack.

Bob spends much of the year in Sweden where he helps Johnny Nash write the soundtrack to a movie, *Want So Much to Believe* in which the American singer is starring. The film flops, and only two instrumentals by Bob make it onto the score.

Mid-December: The Wailers play a gig in Cuba with The Soulettes, Rita's vocal group.

December 31: The Wailers play the Concourse Plaza Hotel in New York City's Bronx. Dates continued in the East until the New Year including Delaware and Pennsylvania.

1972

Mid-February: Bob leaves Kingston for London with a possible contract waiting for him, lined up by Danny Sims. Initially Bob worked with Johnny Nash recording his new album *I Can See Clearly Now*. Living in a flat in Ridgmount Gardens in London until The Wailers joined him for extensive touring with Johnny Nash around the UK.

April 20: Stephen born to Rita in Wilmington, Delaware, where she is staying with Cedella Booker.

Nash releases Bob Marley's "Stir It Up" as a single giving him his first chart success since 1969 and Bob's first hit single outside Jamaica.

May 16: Bob's third son, Robert "Robbie", born to Pat Williams.

May 19: Bob's fourth son, Rohan, born to Janet Hunt.

Despite Johnny Nash doing his best to help Marley get a break during the summer, Bob feels he has achieved little so arranges to meet Chris Blackwell of Island Records; Marley was not unknown to Blackwell and on impulse he advances £4,000 to Bob and Tosh to go back to Jamaica and record their next album.

September: Late in the month, The Wailers return to Kingston to record in Harry J's studio. The base tracks are completed in a month. Blackwell improves the mix with additional artists, advances another £4,000 and pays off existing recording contracts.

December: four months ahead of the US release Island distributes *Catch A Fire* in UK, Tuff Gong in Jamaica. Initial sales are slow.

1973

In early 1973 Bob is pretty much living in Island Records' Jamaican HQ, 56 Hope Road; other residents are Lee Jaffe, Esther Anderson and Cindy Breakspeare. Bob moves into a regular

relationship with Esther while Rita supervises house building at Bull Point.

April 13: *Catch A Fire* worldwide release

April 27: Catch A Fire tour kicks off in UK with around 30 performances to the end of May including broadcast on BBC's influential *Old Grey Whistle Test*.

May-June: Bob and the band work on their next album, recording in Island's London studios.

July 11: US leg starts in Boston followed on 18th by four nights in New York City opening for Bruce Springsteen. Bunny Wailer objected to touring Babylon and was replaced by Joe Higgs.

October 19: The Wailers' second Island album, *Burnin'* is released with the US leg of the promotion tour already started – badly! Opening for Sly and the Family Stone simply didn't work; The Wailers were dropped from Sly's tour and rapidly made new dates.

November 19: The UK leg also began badly with four cancellations because Tosh was ill. Miserable weather made the band give up the tour when Tosh took a plane back to Jamaica.

1974

Early in the year Bob sets about reconstructing the band as Bunny and Tosh are pursuing separate interests, both having set up their own record labels. The Barretts stay on; Al Anderson is brought in on lead guitar to support Bob on rhythm; Bernard "Touter" Harvey on keyboards; lead vocals remain with Bob but Rita Marley is joined by Judy Mowatt and Marcia Griffiths performing backing vocals as the I-Threes. Other musical talent is ready to fill in as necessary: Seeco Patterson on percussion and Lee Jaffe on harmonica.

This is the line-up that records the new album which will give the band its international breakthrough: *Natty Dread*.

May 28: Bob Marley and The Wailers open for Marvin Gaye at the Carib Theatre in Kingston, Jamaica; Bob meets Don Taylor the event's organizer and persuades him to become his manager. Bunny and Tosh play on stage with Bob.

August 17: Stephanie born to Rita but Bob is unsure whether he is the father. This brings the total to eight children formally recognized by Bob –the seventh, Karen was born to Janet Bowen the year before.

September: Eric Clapton's cover of "I Shot the Sheriff" from *Burnin'* gives Slowhand his first US hit single and raises Marley's international profile.

October 25: *Natty Dread* is released on Island and Tuff Gong.

1975

March 8: Bob Marley and The Wailers support the Jackson 5 at National Heroes Stadium, Kingston. Bunny and Tosh join Bob on stage.

June 4: Lucy Pounder gives birth to Bob's ninth child Julian.

June 5: The Natty Dread tour began in Miami, Florida and ended in Manchester, England, on July 20; during the England leg the first live album *Live!* was recorded at the Lyceum Ballroom in London.

September: "No Woman No Cry" released in UK peaks at 22 in singles chart.

October 4: The Wailers open for Stevie Wonder's "The Wonder Dream Concert" at the National Arena in Kingston; it's the last performance in which Tosh and Bunny play with Bob.

December: Release of *Live!* album.

1976

February 26: Anita Belnavis, Bermudan table tennis champion, gives birth to Bob's 10th child, son Ky-Mani.

April 30: *Rastaman Vibration* album released in the USA, giving Bob Marley and The Wailers their breakthrough, spending four weeks on the Billboard Hot 100. The Rastaman Vibration tour kicks off in USA on April 23. Line-up now includes Earl "Chinna" Smith and virtuoso Donald Kinsey on lead guitars with Tyrone Downie on Keyboards. The Wailers make their first break into Europe and return to the UK to wrap the tour in Manchester on June 27.

November 19: After returning to Jamaica Bob gets a phone call from Cindy Breakspeare in London telling him she has just won the Miss World Competition – he paid her air fare.

December 3: Gunmen enter 56 Hope Road and shoot Bob who is wounded in chest and arm. Don Taylor is less lucky with shots to the lower abdomen and a bullet lodged near his spine. The assassins are trying to stop Bob performing in an important concert that had become politicised as elections drew near.

December 5: After emergency treatment Bob appears for the Smile Jamaica concert and shows his wounds to the audience. Rita, who was also shot performs in her hospital gown, others of The Wailers have disappeared in fear of their lives. Immediately afterwards Bob leaves Jamaica for two years of exile, mostly in the UK.

1977

After a month recovering in the Bahamas, Bob arrived in London in January, The Wailers joined him there in February. Fearful for Bob's safety Island kept his presence very secret at first, this helped The Wailers to focus on the recording sessions which would provide the tracks for two more highly successful albums. Changing influences arrived in the form of Junior Marvin

who replaced Donald Kinsey and more input from Tyrone Downie. Also Bob recognized the mood and message of punk rock which prompted the song "Punk Reggae Party".

May 9: The Exodus tour set out to play the first date at Pavillion Baltard in Paris the next day. While playing a friendly football match with journalists, the big toe on Bob's right foot was badly injured. The European dates went ahead but the toe didn't heal. When Bob returned to the UK in June he consulted a specialist and the next month was diagnosed with acral lentiginous melanoma, a malignant form of cancer.

June 1-4: Bob Marley & The Wailers perform four legendary shows at London's Rainbow Theatre. Two other shows were cancelled in the UK leg.

June 3: *Exodus* is released on Tuff Gong and Island.

July 20: Don Taylor announces postponement of the North American leg of the Exodus tour which was due to start in August.

August 7: At the Cedars of Lebanon Hospital in Miami surgeons remove cancerous tissue from the toe and graft healthy skin over the wound. Bob spends around 5 months in Miami recuperating.

October: Bob's mother, Cedella, moves into a big house he has bought her in Miami which will provide a base during convalescence and between tours.

1978

February 25: Bob returns from exile and, flying into Kingston, receives a massive welcome from thousands of fans.

March 23: Worldwide release of the new album, *Kaya*.

April 22: Bob had been asked to come home

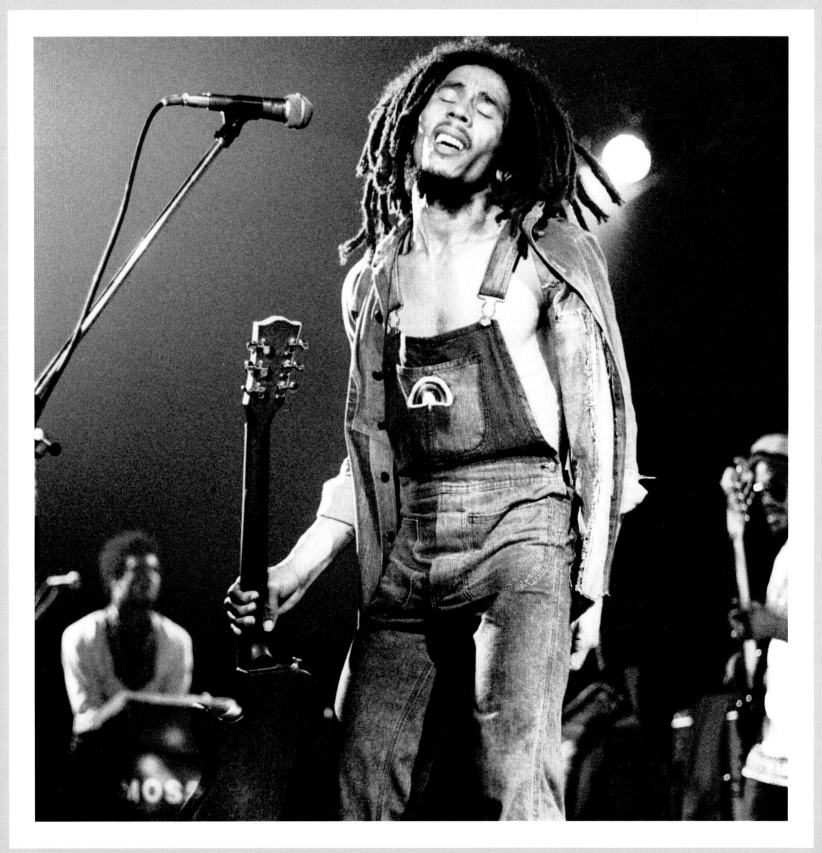

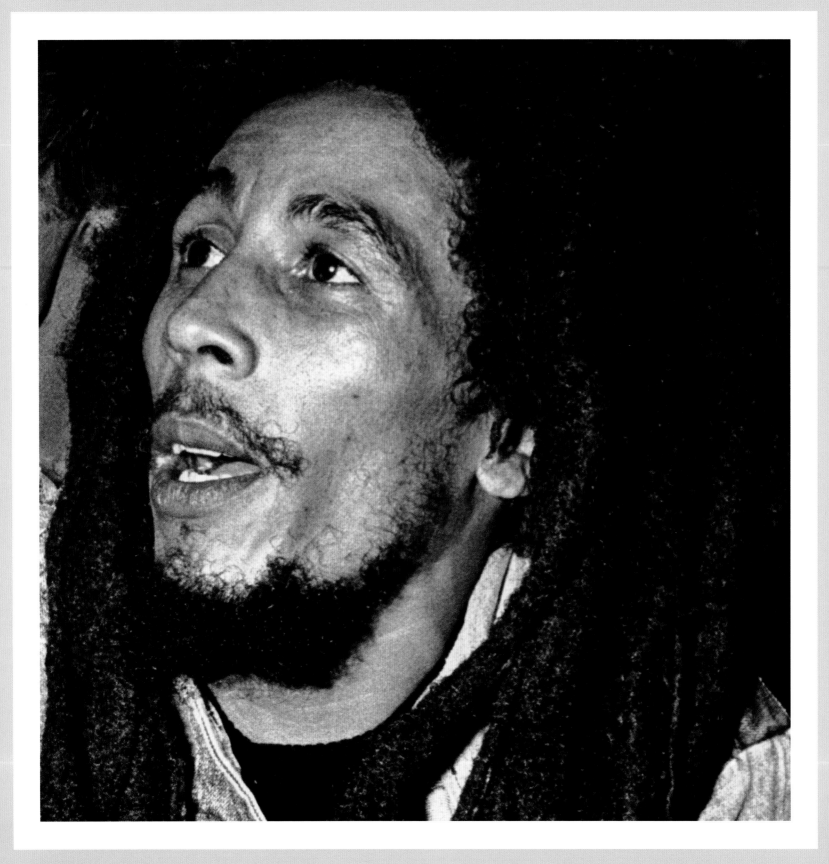

to headline the "One Love Peace Concert." The event is intended to cement a truce declared by the warring factions in Kingston's ghettoes. On this day, the 12th anniversary of Selassie's visit to Jamaica, under a full moon, Bob is the final performer in an eight-hour concert featuring 16 local acts at the National Stadium. In the finale, Bob calls on Prime Minister Manley and his political enemy of the opposition party, Edward Seaga, making them shake hands in front of 30,000 people in the audience.

May 18: The Kaya tour began in Ann Arbor, Michigan and ended in Miami, Florida, on August 5. The tour was divided into three legs, two in North America and one European leg between.

June 15: In a ceremony at New York's Waldorf Astoria hotel Bob accepts the Peace Medal of the Third World from the United Nations presented by the UN Youth Ambassador, Senegalese Mohammadu Johnny Seka.

July 21: The Wailers perform at Burbank's Starlight Bowl and news comes through that Cindy has given birth to Damian, bringing the number of children acknowledged by Bob to 11.

August 5: Kaya tour ends and Bob returns to Jamaica for a few days before heading off to Ethiopia to visit Skill Cole for four days. There he composes "Zimbabwe".

November 11: *Babylon by Bus*, a double live album with 13 tracks, is released to mixed reaction.

1979

February: Bob starts work on the next album in his Tuff Gong studio; Tuff Gong also opens its own pressing plant.

April 5-May 6: The Babylon by Bus tour covers Oceania, starting in Japan, travelling through Australia and New Zealand and ending in Hawaii.

July 7: Bob performs in Reggae Sunsplash II staged in Jarrett Park, Montego Bay – his first public performance in his home country since One Love.

July 21: Marley and The Wailers top the bill at the Amandla Festival of Unity a benefit concert for Relief and Humanitarian Aid in Southern Africa at Harvard Stadium, Cambridge, Mass.

October 2: *Survival* is released, returning to a sense of grass-roots urgency and behind it Bob's sense of time running out. Before going into the Tuff Gong studio, Bob had reunited with Scratch Perry to make four new tracks. The new album was intended to be first in a trilogy. Bob would only live to see two of the three released.

October 25: Survival tour commences with 4 dates at NYC's Apollo Theater in Harlem. During the tour, which ended December 15, Bob would perform 45 shows.

November 7: Performs with Stevie Wonder in a benefit concert for the Black Music Association in Philadelphia during the Survival tour. They sing "Get up, Stand Up", and "Exodus" together.

November 25: The performance at Santa Barbara Bowl is recorded and later released as the music video Bob Marley *The Legend Live*.

December 15: The Survival tour ended in Nassau, Bahamas and Bob flies to Miami to spend time with his mother.

1980

January: Bob and The Wailers take up an invitation to the Gabon Republic in Africa to perform at birthday celebrations for the ruling family. Bob is disappointed that his first African performance is to a small elite audience.

After two weeks in Gabon Bob returns to Jamaica to work on the next album, to be called *Uprising*.

February: Bob flies to Miami to conclude his business with Don Taylor and discuss management issues with Danny Sims.

March: Chris Blackwell flies with Bob, Junior Marvin and Jacob Miller to Brazil on a 5-day promo visit to help the new local record company publicize the planned autumn tour of South America.

April 17: Bob headlines a concert in Harare that ushers in Zimbabwe's Independence. His enthusiasm for the nation's struggle leads him to pay all travel costs (some say as much as $250,000) himself, including hiring a jet to fly in all the band's equipment. The free concert is by ticket only and chaos ensues when people without tickets try to break into the open air venue. In a cloud of tear gas, Bob is led from the stage; he finishes the performance once the gas clears. The following day he puts on another free concert for those were unable to gain entry.

Returning to London via Paris, the band are photographed by Adrian Boot in a London hotel. One of the photographs, used on the *Uprising* album cover, shows a very ill-looking Bob.

May 30: The Uprising tour kicks off in Zurich and will run with a US leg through to September. It will be Bob's last tour.

June 7: The Wailers headline Summer of 80 Garden Party at London's Crystal Palace Bowl; they fly in from Cologne, Germany for the concert and return to their next German date straight after their performance. The European leg of the tour is a huge success with sell-out stadium venues.

June 10: *Uprising* is released and enters the UK album chart in the top ten. Most of the tracks resulted from the same early studio sessions as *Survival* but it is said that when Blackwell heard the final tapes he pushed for something better. Bob took this on board and came back with the haunting acoustic piece, "Redemption Song", that in a way would become his own epitaph.

July: The first half of July finds Bob back in the UK after wrapping up the European leg of the Uprising tour in Dublin. He does half a dozen gigs and by day plays football in a quickly organized tournament involving teams made up from the media; he wasn't giving them interviews.

The original plan was to return to Jamaica prior to the US leg of the tour but the political situation there was deemed too dangerous so he flew instead to Miami, Florida, to prepare for the strains and stresses of the tour ahead – much of this done on the soccer field.

September 16: The US leg of the Uprising tour starts in Boston.

September 19 & 20: The Wailers open for The Commodores on consecutive nights at New York's Madison Square Garden. Bob's performances show him on top form but they take every ounce of his energy.

September 21: Bob tries to regain some energy by jogging in Central Park. Without warning he collapses in pain, unable to move his neck. Skill Cole and Danny Sims get him back to his hotel.

September 22: Bob visits a neurologist in New York and is diagnosed with a brain tumour. He is told his cancer is incurable and he will die.

September 23: The rest of the band are in Pittsburgh for the concert that night, unaware of the severity of Bob's condition. When Rita hears she wants to cancel the tour immediately but Bob wants to go on. The Pittsburgh show went ahead but a press release, citing Bob's exhaustion, announced the cancellation of the rest of the tour.

A media blackout now descends as Bob checks into a specialist Manhattan clinic; then when his condition becomes common knowledge he checks out to become an outpatient. Making little progress he travels down to his trusted

Cedars of Lebanon Hospital in Miami then to Mexico to the clinic recently used by Steve McQueen. None of these treatments helps his worsening physical condition as the cancer spreads through his body.

Carl Fraser, a Jamaican doctor respected by the Rasta community suggests Bob try the controversial Bavarian clinic run by Dr Josef Issels. With an entourage of close friends, family and advisors, Bob travels to Germany.

By the end of the year, Issels' treatment is having some effect and Bob's condition improves but not for long.

1981

February 6: Bob celebrates his 36th birthday in the Bavarian clinic. His condition is worsening steadily and eventually Dr Issels says there is nothing more he can do. As the spring wears on with continuing decline, Bob decides to return to Jamaica.

April 17: Marley is awarded Jamaica's Order of Merit. He is only the sixth recipient; son Ziggy accepts it on Bob's behalf.

May 9: On the flight home Bob's vital functions go into decline; at Miami he needs emergency medical treatment and is admitted to hospital.

May 11: At the Cedars of Lebanon Hospital Bob's struggle with cancer finally ends and he passed away with family at his bedside. His last words to his son Ziggy were reported to be, "Money can't buy life."

Jamaica is plunged into mourning with parliament going into recess. Bob's body lies in state to receive the respects of hundreds of thousands of mourners.

May 21: Robert Nesta Marley receives a state funeral the National Heroes Arena in Kingston which mixes traditions of the Rastafarian faith with those of the Ethiopian Orthodox Church.

Politics are never far away and newly elected Prime Minister Edward Seaga delivers an eulogy at the funeral. Marley is entombed with his guitar and bible in a mausoleum in Nine Mile in his home parish of St Ann.

May 22: Birth of Makeda Jahnesta Marley to Yvette Crichton, Bob's last child.

1983

May 11: On the second anniversary of his death, the last album in the trilogy, *Confrontation*, is released.

1984

May 8: The compilation album *Legend* is released on Island/Tuff Gong; it goes straight to number 1 in the UK album charts and remains there for 19 weeks, going double platinum the same month it is released.

1986

May 11: Five years to the day after Bob's death the Bob Marley Museum, aka 56 Hope Road, opens to the public.

1987

April 17: On Good Friday Carly Barrett is shot dead outside his home.

September 11: Peter Tosh, along with several of his associates, is killed in his own home, shot by armed robbers.

1990

February 6: Bob Marley Day initiated as a national holiday – on what would have been his 45th birthday.

June: Chris Blackwell inaugurates The Bob Marley Memorial Fund, presenting a cheque for $75,000 to Amnesty International in New York City.

Island re-releases 13 Marley albums on CD.

1994

February: In 1994, Marley was inducted into the Rock and Roll Hall of Fame by Bono – Rita accepted on Bob's behalf at the 9th Annual Dinner at NYC Waldorf-Astoria.

1999

Time magazine chooses Bob Marley and The Wailers' *Exodus* as the greatest album of the 20th century beating Miles Davis's *Kind of Blue* and Hendrix's *Are you Experienced*.

2006

October 26: A blue plaque in Ridgmount Gardens, London, is unveiled to commemorate Bob's first UK residence. Across the Atlantic the State of New York renames a portion of Church Avenue from Remsen Avenue to East 98th Street in the East Flatbush section of Brooklyn "Bob Marley Boulevard".

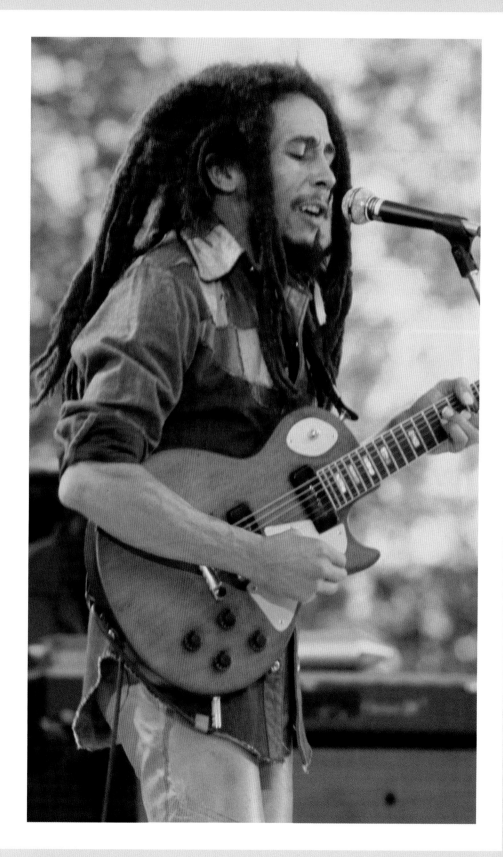

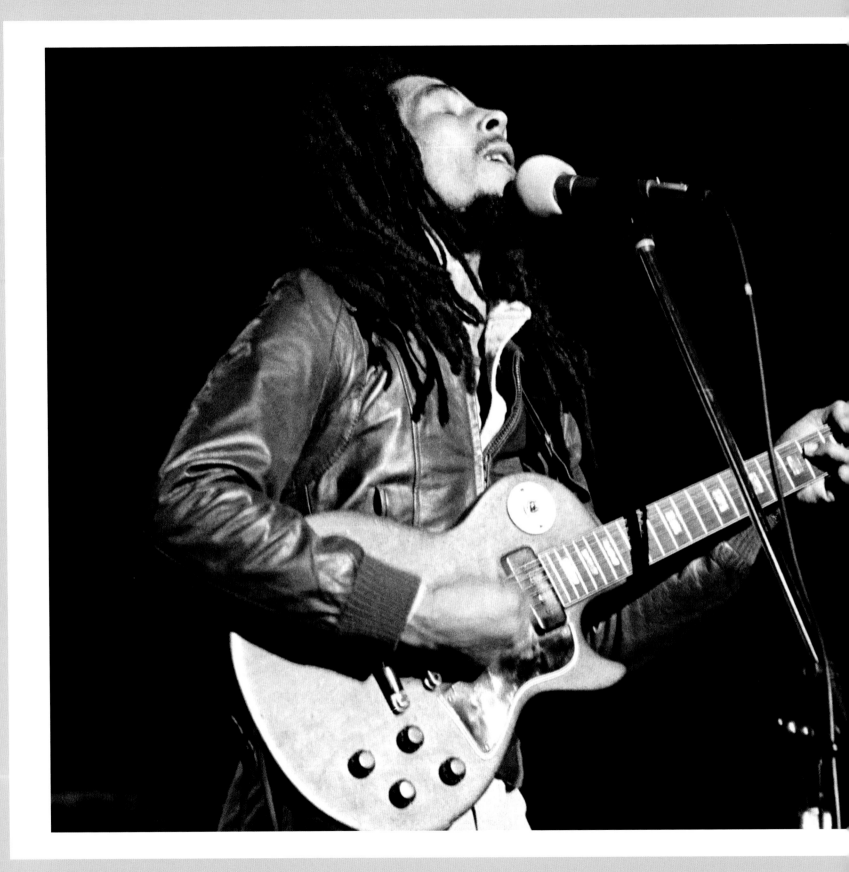

Discography

The recording history of Bob Marley and The Wailers is complicated and diverse thanks to the many different arrangements with various record labels during Marley's lifetime and that continued after his death. During their period with Coxsone Dodd's Studio One label The Wailers had a string of hit singles in Jamaica, performing covers of the latest R&B hits out of the US, The Beatles and Tom Jones and even traditional classics such as "White Christmas" – and of course their own compositions. The following discography focuses only on the internationally distributed albums and singles and lists first issues not re-issues of which there are many across the range of Bob Marley and The Wailers' labels.

The albums are listed chronologically up to *Legend* in 1984 as this gives the most complete picture of the best known of Bob's music. The album title is shown followed by the labels on which it was released and the producer credit.

The singles are identified to the albums on which the songs were recorded but generally the singles had their own mix. The compilation album *Legend* (listed here) genuinely used the singles mixes in its first issue but when digitally remastered, album tracks were mistakenly used. The singles are listed by their year of issue.

ALBUMS

1965

The Wailing Wailers

Studio One: Clement Dodd

(I Am Gonna) Put It On (Marley)
I Need You So (William Robinson)
Lonesome Feeling (Marley/ Livingston)
What's New Pussycat (Bacharach/ David)
One Love" (Marley)
When The Well Runs Dry" (Tosh/ Livingston)
Ten Commandments of Love" (Paul/Woods)
Rude Boy (Wailers)
It Hurts to Be Alone (Marley)
Love and Affection (Marley/ Livingston)
I'm Still Waiting (Marley)
Simmer Down (Marley)

1970

Soul Rebels

Upsetter/Trojan: Lee Perry

Soul Rebel
Try Me
It's Alright
No Sympathy
My Cup
Soul Almighty
Rebel's Hop
Corner Stone
400 Years
No Water
Reaction
My Sympathy

1971

Soul Revolution

Upsetter/Trojan: Lee Perry

Keep On Moving
Don't Rock My Boat
Put It On
Fussing And Fighting
Duppy Conqueror
Memphis
Soul Rebel
Riding High
Kaya
African Herbsman
Stand Alone
Sun Is Shining
Brain Washing
Mr. Brown" (aka "Dracula")

The Best of the Wailers

Beverley's: Leslie Kong

Soul Shakedown Party
Stop The Train
Caution
Soul Captives
Go, Tell It On The Mountain
Can't You See
Soon Come
Cheer Up
Back Out
Do It Twice

1973

Catch A Fire

Island/Tuff Gong: Chris Blackwell

Concrete Jungle
Slave Driver
400 Years (Peter Tosh)
Stop That Train (Tosh) –

Baby We've Got a Date (Rock It Baby)
Stir It Up
Kinky Reggae
No More Trouble
Midnight Ravers

Burnin'

Island/Tuff Gong:
Chris Blackwell/The Wailers

Get Up, Stand Up (Marley/Tosh)
Hallelujah Time (Livingston)
I Shot the Sheriff (Marley)
Burnin' and Lootin' (Marley)
Put It On (Marley)
Small Axe (Marley)
Pass It On (Livingston)
Duppy Conqueror (Marley)
One Foundation (Tosh)
Rastaman Chant (Trad., arr. Marley/Tosh/Livingston)

1974

Rasta Revolution

Upsetter/Trojan: Lee Perry

Mr. Brown
Soul Rebel
Try Me
It's Alright
No Sympathy
My Cup
Duppy Conqueror
Rebel's Hope
Corner Stone
400 Years
No Water
Reaction
Soul Almighty

Natty Dread

Island/Tuff Gong: Chris Blackwell/ The Wailers

Lively Up Yourself (Bob Marley)
No Woman, No Cry (Vincent Ford)
Them Belly Full (But We Hungry) (Lecon Cogill/Carlton Barrett)
Rebel Music (3 O'Clock Roadblock) (Aston Barrett/Hugh Peart)
So Jah Seh (Rita Marley/Willy Francisco)
Natty Dread (Rita Marley/Allan Cole)
Bend Down Low (Bob Marley)
Talkin' Blues (Lecon Cogill/Carlton Barrett)
Revolution (Bob Marley)

1975

Live

Island/Tuff Gong: Bob Marley & The Wailers, Steve Smith and Chris Blackwell

Trenchtown Rock
Burnin' And Lootin'
Them Belly Full (But We Hungry) (Lecon Cogill/Carlton Barrett) -
Lively Up Yourself
No Woman, No Cry (Vincent Ford)
I Shot The Sheriff
Get Up, Stand Up (Bob Marley/ Peter Tosh)

1976

Rastaman Vibration

Island/Tuff Gong:
Bob Marley and the Wailers

Positive Vibration (Vincent Ford)
Roots, Rock, Reggae (Vincent Ford)

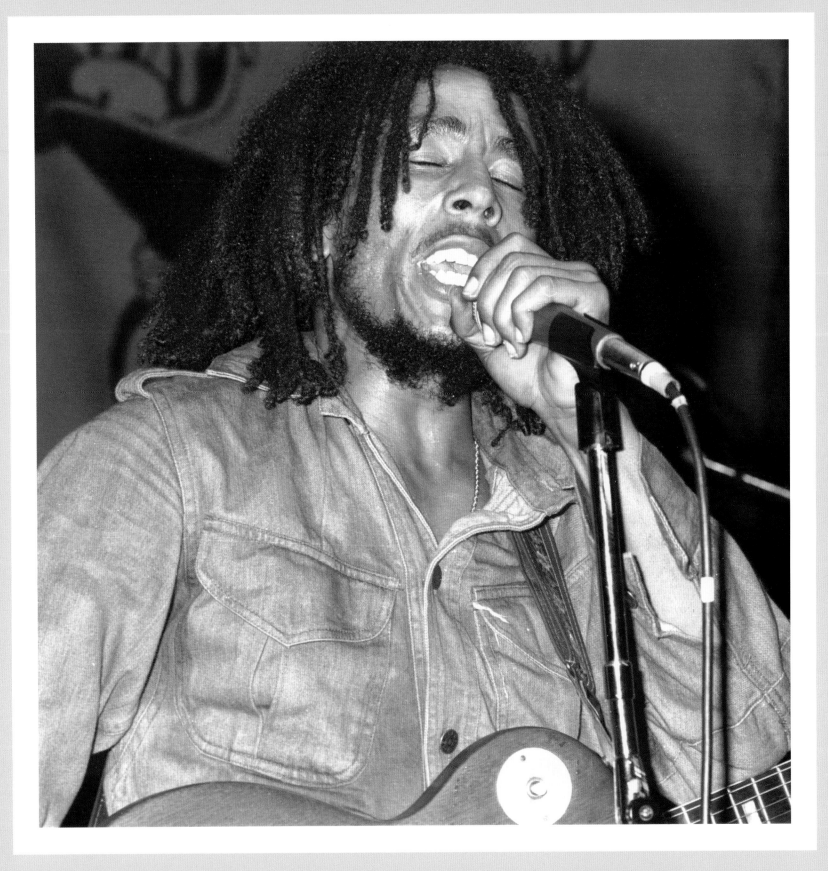

Johnny Was (Rita Marley)
Cry to Me (Rita Marley)
Want More (Aston Barrett)
Crazy Baldhead (Rita Marley/
Vincent Ford)
Who the Cap Fit (Aston Barrett/
Carlton Barrett)
Night Shift (Bob Marley)
War (Allan Cole/Carlton Barrett)
Rat Race (Rita Marley)

1977

Exodus

Island/Tuff Gong:
Bob Marley & The Wailers

Natural Mystic
So Much Things to Say
Guiltiness
The Heathen
Exodus
Jamming
Waiting in Vain
Turn Your Lights Down Low
Three Little Birds
One Love/People Get Ready
(Marley, Curtis Mayfield)

1978

Kaya

Island/Tuff Gong:
Bob Marley and the Wailers

Easy Skanking
Kaya
Is This Love
Sun Is Shining
Satisfy My Soul
She's Gone
Misty Morning
Crisis

Running Away
Time Will Tell

Babylon By Bus

Island/Tuff Gong: Double album
Bob Marley and the Wailers

Positive Vibration (Vincent Ford)
Punky Reggae Party (Bob Marley,
Lee Perry)
Exodus
Stir It Up (Recorded July 18, 1975 at
The Lyceum, London, England)
Rat Race (Rita Marley) (Recorded
1976, Hammersmith Odeon,
London, England)
Concrete Jungle
Kinky Reggae
Lively Up Yourself
Rebel Music (3 O'Clock Roadblock)
(Aston Barrett, Hugh Peart)
War / No More Trouble (Alan Cole,
Carlton Barrett, Bob Marley)
Is This Love
Heathen
Jamming

1979

Survival

Island/Tuff Gong:
Bob Marley and the Wailers/Alex
Sadkin

So Much Trouble In The World
Zimbabwe
Top Rankin'
Babylon System
Survival
Africa Unite
One Drop
Ride Natty Ride

Ambush In The Night
Wake Up And Live (Marley/Davis)

1980

Uprising

Island/Tuff Gong:
Bob Marley and the Wailers

Coming in from the Cold
Real Situation
Bad Card
We and Dem
Work
Zion Train
Pimper's Paradise
Could You Be Loved
Forever Loving Jah
Redemption Song

1983

Confrontation

Island/Tuff Gong:
Bob Marley and the Wailers

Chant Down Babylon
Buffalo Soldier (Bob Marley, Noel
G. 'King Sporty' Williams)
Jump Nyabinghi
Mix Up, Mix Up
Give Thanks And Praises
Blackman Redemption (Bob
Marley, Lee Perry)
Trench Town
Stiff Necked Fools
I Know
Rastaman Live Up! (Bob Marley,
Lee Perry)

1984

Legend

Island/Tuff Gong:
Bob Marley and the Wailers

Is This Love
No Woman, No Cry (Live) (Vincent
Ford)
Could You Be Loved
Three Little Birds
Buffalo Soldier (Bob Marley/N.G.
Williams)
Get Up, Stand Up (Bob Marley/
Peter Tosh)
Stir It Up
One Love/People Get Ready (Bob
Marley/Curtis Mayfield)
I Shot the Sheriff
Waiting in Vain
Redemption Song
Satisfy My Soul
Exodus
Jamming

SINGLES

Kinky Reggae , 1973 (Catch a Fire)

Get Up Stand Up, 1973 (Burnin')

I Shot the Sheriff, 1973 (Burnin')
Roots, Rock, Reggae 1975
US only (Rastaman Vibration)

No Woman, No Cry, 1975 (Natty
Dread)

Exodus, 1977 (Exodus)

Waiting in Vain, 1977 (Exodus)
Jammin', 1977 (Exodus)

One Love, 1977 (Exodus)

Is This Love, 1978 (Kaya)

Satisfy My Soul 1978 (Kaya)

So Much Trouble in the World
1979 (Survival)

Stir It Up, 1979 (Babylon by
Bus)

Could You Be Loved,1980
(Uprising)

Redemption Song, 1980
(Uprising)

Three Little Birds, 1980
(Exodus)

Buffalo Soldier, 1983
(Confrontation)

VIDEO RELEASES

**Bob Marley and the Wailers –
Live! at the Rainbow**: recorded
in 1977 at London's Rainbow
Theatre.

Bob Marley – the Legend Live:
recorded in 1979 at the Santa
Barbara Bowl, California

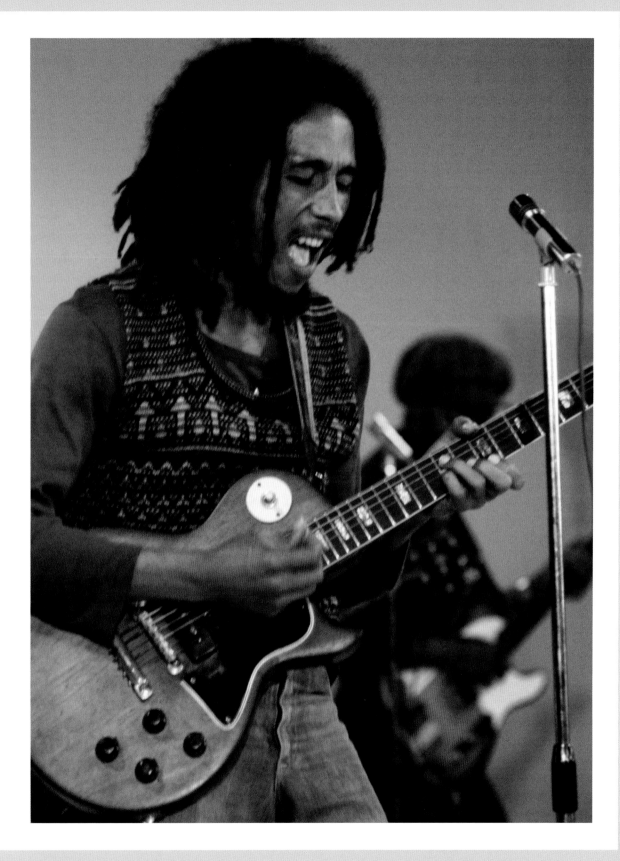

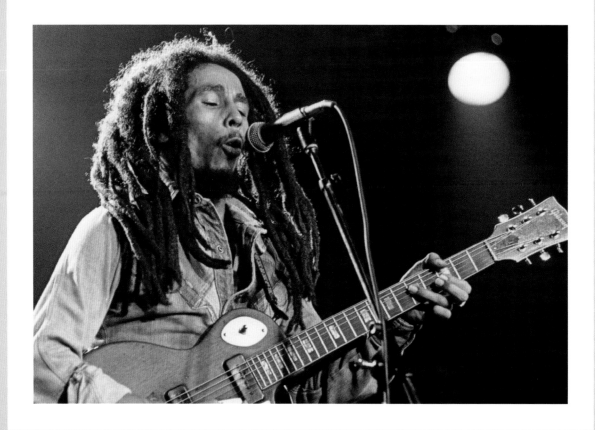